About Michael Baxandall

About
Michael
Baxandall

Edited by
Adrian Rifkin

BLACKWELL
Publishers

Copyright © The Association of Art Historians 1999

First published in 1999

Blackwell Publishers
108 Cowley Road, Oxford OX4 1JF, UK

and
350 Main Street
Malden, MA 02148, USA

British Library Cataloguing in Publication Data

A CIP catalogue record for this book is available from the British Library

Library of Congress Cataloging-in-Publication Data applied for

ISBN 0 631 21191 8

Printed and bound by The Alden Press, Oxford

CONTENTS

Editor's Introduction

> [O]n the one hand that such a process penetrates our language so deeply
> does suggest that causal explanation cannot be avoided and so bears
> thinking about. On the other, one may want to be alert to the fact that the
> description which, seen schematically, will be part of the object of
> explanation already embodies preemptively explanatory elements ...
> (Michael Baxandall)[1]

When the dust settles, we are left with text. I fancy this as an epitaph for the *new art history* or the *social history of art*, or however it is that we wish to name the last three decades of art-historical achievement.

This is not to argue that there was no point to the theoretical and political confrontations of Marxian, feminist or post-colonial art histories. Nor that it is now so utterly impossible to conceive of a project that we should, as a result, consign the old politics of scholarship as having been nothing more than a random spatter of fantasmatic ideals, projected out of the desire or the delusion that art history might help to save the world. Before and after the Berlin Wall, so to speak, the tired old notion of an 'end of history' re-run. If nothing else, art history must remain a site for the realization and even engendering of all kinds of difference, the refusal of intellectual entropy or the routines of enlightened prejudice.

Yet it is to hope that, if text indeed be our remainder, then it is in text that difference can be realized, perhaps against the grains of its delusion or its disillusion. Hence my epigraph from Michael Baxandall's *Patterns of Intention* (1985), a book that so radically typifies his refusal of any delusion of a secure plenum of equivalences between our knowledge or art and its eventual 'causes' – a refusal later perfected in the disabused curiosity of *Shadows and Enlightenment* (1995). I want therefore to suggest that the reader attend less to the reticent positivism of his formulation, floating as it does between a problematic of seventeenth-century theories of being and knowledge and a modern, critical ethnology, and more to the cadence of the phrase *cannot be avoided and so bears* ...

If *cause* is theoretically undesirable and, in consequence, unbearable, its penetration of our language nonetheless grounds a desire for closure. And if it does bear thinking about, this is only because it is unavoidable, not because it ought to be desired. So if the writerly mode of inferential criticism, that Baxandall develops in *Patterns* ... seeks a beginning without an end, perhaps with that withoutness as its sole finality, then it must nonetheless admit that this beginning has a cause, which is *unavoidably* an end. The phrase, in its resistant

1

tone as in its almost elegiac mode, configures pleonasm masquerading as oxymoron – a wholly suitable linguistic dilemma for the author of *Giotto and the Orators* (1971), which book is, in all probability, the only anglophone writing of its moment to offer an equivalent to the work of, for example, a Jean Louis Schefer in France.[2]

But this aporia is also, if you like, the aporia of the Freudian body. A body that is never, to the best of my knowledge, invoked by Baxandall, but one which, in so far as it lives through the curiosity of the desires that travail it on the one hand and the desire to escape from this excitation on the other, might be the body, or a body, of his text as text.[3] Despite intention.

If Baxandall does not write of Freud or Saussure or Foucault, nor of Derrida, it is not that his work does not belong to some spirit of the age, a concept that we all hope to avoid, but that it really is of a *period* discursivity. The enigma of this belonging is that if it is not eliptical, then where and what is the elipse or the elision?

Text as text is intertext and overdetermination, or it is *différance*, or rhizome. These are some of the words that we have at our disposition to name a procedure without an end, a play with possibility and purpose. A play with which we might engender or unpiece an archive, or bring to the fragile description of a pictorial sign and its making. That such terms or concepts as these can hardly be made to sustain a conventional antinomy, either to idealism or to positivism and materialism, is evident in the work of Michael Baxandall. Taken in the actually complex historiography of a discipline, there are few stranger books than his. Just to glance at the plates inserted at the end of *Patterns* ... or of *Shadows* ... is to enter an argument without a telos, a play with historical estrangement and contingency that paradoxically eschews anachronism. Sufficient unto the period the means that it offers for its representation. Saussure nowhere interrupts the unpicking of the *Quattrocento*'s productive rhetorical deficiencies, nor does Foucault figure in the great 'Market' chapter (V) of *Limewood Sculptors* ..., that triumphant demonstration of one and one only, possible specificity of the authorial function.

No. For Foucault to intervene would have been to turn something that we might say about a moment in history into something we should say about the concept of an author. And that would take us from Locke to Kant without even the modesty of reflecting on the irony of such an half-intended shift. For Baxandall the slippage from the philosophers' optics to the painter's brush can never quite be followed at this level. If the work of Piero and Picasso and the Forth Bridge rustle against each other, it is not because we can determine them precisely, because we may not be sure which of them is the closest or the strangest to us.

So, if I insist that it is a kind of certainty that when the politics of the new art history have themselves gathered historical patina, the nature of elision is far from clear, then the dynamics of Baxandall's work as an integument of what has happened is both evidently crucial and evidently enigmatic. The status of *Painting and Experience* ... and *Limewood Sculptors* ... as textbooks masks the repeated resistance to canonicity that lies at the heart of the writing. For while this resistance is clear enough in the two sets of plates that I have just mentioned, it is less obvious that the reiterated methodological tropes of these two books, such as

that of *The Period Eye*, at no point assert a generalization – that is to say, the instatement of a canonical method. This is one reason why, when Georges Didi-Hubermann takes Baxandall to task, in his *Fra Angelico*, for an insufficiently expansive understanding of the words *devoto* and *contemplatio*, he is rather missing the point about what precisely there is to be proved, without recognizing his own need of this proposed expansion for his particular foray into another mode of inferential criticism.[4]

Moreover, in the chapter of *Patterns* ... entitled 'Truth and Other Cultures'. in supposing what we would call the 'Western canon' as itself other to its inheritors, Baxandall locates strangeness within the forms of this culture's *imago* – another psychoanalytic term that I bring to him, but one that seems to match his problematic.[5] In this sense the canon is no more, nor less, than an imagined community fabricated and split by skills and expectations. If this gesture were to turn one's back on post-colonial or feminist critiques of art, it is nonetheless almost more Kristevan than Kristeva.[6] Maybe it is just a matter of decorum, or *commensurazione*, this adequacy of a self-otherness to one's supposed self, but no less significant for that.

Baxandall's writing is haunted – the word is better than driven – by a deeply contemplative passion for art. Or, rather it is driven by a passion for art, but haunted by a different kind of passion for its history. Whichever, the certainty of this relation between the love of art and love of discourse seems like both an ontology and an ethic, Cartesian and Kantian all at once, despite the empiricism of his procedures. Possibly, it is this tension that radiates the attractive melancholy, that often strikes one in his writing, the affect on an introjected aporia. But this is to begin to say that his work, in its very status as art history poses a problem or a question for a discipline of that name.

This is why, in assembling the present collection, I have sought to maintain the meaning of the word *about* as both an adverb and a preposition. The essays concern Michael Baxandall and they are also outside his work. If Molly Nesbit's offers an *imitatio* or perhaps *ekphrasis*, tangentially on a terrain of *knowing* where MB comes to equal MD, Paolo Berdini's piece is a critical supplement on another ground, working with and without his Renaissance, out of it and against it. Alex Potts and Michael Anne Holly reflect on the strange location of his words in histories of modern thought and contemporary artistic practice, tracing or locating him in radically different discursive spaces. While Holly takes his melancholy as his very starting point and even as if his essence, Potts discloses another Baxandall in his own contemplation of minimalist sculpture. Allan Langdale and Malcolm Baker scrupulously map his *figura* and his writing in the contexts that they specifically articulated and motivated, and which in part produced his historical significance both as an artisan of the discipline and as a reluctant model.

What I have written in this introduction has been made possible by what follows, and I have echoed some of its implications rather than commenting upon that which needs no support from me. I want to thank all the authors for their generosity and their commitment to the project and their contribution to what is now to become the first *Art History* book. I am struck by the beauty with which their texts hang together in such a felicitous supplementarity.

I want to thank Michael Baxandall for agreeing to our undertaking, and to offer him this volume on behalf of the Journal and the Association of Art Historians.

Adrian Rifkin
June 1998

Notes

1 Michael Baxandall, *Patterns of Intention, On the Historical Explanation of Pictures*, London, 1985, p. 11.

2 For example, Jean Louis Schefer, *Scénographie d'un tableau*, Paris, 1967, or the recent collection of his writings from the early 1960s to the present, *Figures peintes. Essais sur la peinture*, Paris, 1998. I suggest Schefer as an equivalent for Michael Baxandall, despite very obvious dissimilarities, on the grounds of their comparable engagement in a play with the relation between a systematic theory of meaning on the one hand and a sense of the delicate imbalance between historicity and a critical *jouissance* on the other.

3 See S. Freud, *Beyond the Pleasure Principle*, in *The Essentials of Psychoanalysis*, selected, with an introduction and commentaries, by Anna Freud, London, 1986.

4 See G. Didi-Huberman, *Fra Angelico, dissemblance et figuration*, Paris, 1995, pp. 41–5.

5 For a fine definition of the term, see Elisabeth Roudinesco and Michel Plon, *Dictionnaire de la psychanalyse*, Paris, 1997, p. 483f.

6 As in Julia Kristeva, *Étrangers à nous mêmes*, Paris, 1988.

Patterns in the Shadows:
Attention in/to the writings of
Michael Baxandall

Michael Ann Holly

Nearly a quarter of a century ago I entered my first year of graduate training in art history, pretty sure of what I hoped to find. I wanted to read canonical Renaissance monuments as documents, as visual embodiments of certain cultural and social attitudes, and to do so I sought an education in the word and image studies of the Warburg school. That first semester brought several shocks to the secure investigative paradigm I had devised: encountering a text by Jacques Derrida in a late medieval literature course, being assigned the task of writing all that I could possibly 'see' in the details of a seventeenth-century allegorical painting, and hearing Michael Baxandall (straight from the Warburg Institute, no less) present a startling lecture on why the engineering ingenuity that led to the construction of the Firth of Forth bridge might have implications for writing the history of art.

Disparate as these challenges may have seemed at the time, in retrospect it is easy to regard them as historically intertwined. It was a disciplinary moment pregnant with the possibilities of what was to come, a time in which both the published essays and the public musings of Michael Baxandall were poised to play a crucial role. The treachery of language, the unsettlement (for good or ill) of deconstruction, the anguish over objectivity in historical writing, all were issues that would clearly motivate his many and varied writings. The perplexing irony that confronts the historiographer of this recent disciplinary past, however, is Baxandall's reluctance, even principled refusal, to situate his work – at least overtly – inside this larger field of debate. Consequently, one of the intriguing issues about his corpus of writing for me is the question of why sustained attention to problems in historical explanation always appears grounded in the conviction that one can seek clarity only by remaining in the shadows, in the reflected light of contemporary theory. His muteness is most suggestive, not only for understanding his particular evolution as an historian and critic of the visual arts, but also for considering how his work could itself be read as an allegory of the desires and insufficiencies of a poststructuralist history of art. Ironically, Baxandall has earned this commendation – with which he might not be so comfortable – in the process of arguing how the discipline is destined to remain forever 'sub-theoretical.'[1]

Rather than pedantically try to locate some of the many sites in his texts upon which I can trace the ghostly footprints of an engagement with critical initiatives from speech act to discourse theory, I would prefer to consider Baxandall's

collected essays as a powerful exercise in the art of melancholy.[2] All his work is grounded in an acknowledgement of loss, in the recognition of time's passing. And critical theory, he seems to suggest, only serves to distance us further from the 'superior' objects that seduce our imaginations into eternally unconsummated encounters.[3] Among many other things, Baxandall's scholarly career has been a sustained reflection on the impossibility of closing the gap opened up between words and images in the practice of art history which he inherited, the discipline that supposedly exists in order to bring the two realms of experience into some sort of congruency.[4] In this awareness, I would argue, he has been as sensitive as Derrida to the incapacity of language to make contact with its referent, although this position has not inhibited him from trying. The sage conscience of the discipline of art history, the intelligent voice that has for a long time tempered critical excess, put interpretive issues into historical perspective, and reminded us all of how we should and should not proceed when it comes to the historical explanation of works of art, is nevertheless philosophically committed to an act of renunciation, to the futility of ever actually being able to write the history of art. In this sentiment, I would reiterate, Baxandall's is a fundamentally postmodernist point of view. The elegiac motives of his historical narratives are as transparent as his historical insights.

On the other hand, Baxandall really does believe that art history, as a humanistic discipline, stands apart from other fields of contemporary inquiry. His defence of its distinctiveness – grounded in the fundamental distinction between words and images – is evident in everything he has ever written.[5] The visual arts demand different modes of attention (a key concept in every text)[6] than other historical artefacts. If the critic or historian is unaware of this raw truth, then he or she is severely deficient in what he would call in another context 'pictorial intelligence'.[7] Part of the explanation for this conviction lies in his awareness of the paradox that although visual objects created in the past continue to exist in the present, their original meanings have been almost forever lost to time. The result of this kind of condition, as Giorgio Agamben has phrased it in reference to the poetry of mourning, is a 'loss without a lost object. . . . in melancholia the object is neither appropriated nor lost, but both possessed and lost at the same time.'[8] The recognition of near defeat, however, is that which initiates the process of consolation, aimed towards the achievement of what contemporary psychoanalytic theorists might call 'elegiac reparations'.[9] The implications of this state of affairs for delving into the historiographic unconscious of the word and image studies of the Warburg tradition are obvious. The only way to 'recover' the meanings of the objects that always already exist, even in part, is through linguistic endeavours. 'The humanities', Erwin Panofsky once poignantly remarked, 'are not faced by the task of arresting what otherwise would slip away, but enlivening what otherwise would remain dead.'[10]

The intellectual tradition out of which Baxandall comes can thus be identified as playing a crucial role in both how and what he writes, but with a twist. It is the inexorability of early modern works of art both being here and not being there simultaneously that has generated not only the allegorical excitement of his writing, but also two generations of Warburg Institute scholars who preceded him. And to an historian, not so surprisingly, they were iconographers of both the figure and

trope of melancholy. In Baxandall's own reflections on the representational afterlife of the Renaissance, I want to argue, the subject matter of melancholy has become less significant than its translation into an historiographic point of view.

As far as predecessors go, the most demonstrative in his fascination in general with visual artefacts as psychic repositories of time, and the astrological embodiment of the melancholic temperament in particular, was, of course, Aby Warburg. In his desperate lifelong project of proving how the forces of enlightenment and reason should ultimately triumph over the forces of darkness and irrationality, he charted the accomplishments of Luther, Ficino and Dürer, each of whom was able to overcome superstitious speculation by transmuting the ancient demonic influences of Saturn into emblems of Renaissance creativity. The iconological enterprise which Warburg 'invented' was devoted to tracing the *Nachleben*, or afterlife, of antique images as they re-emerged in supposedly more domesticated guises in later ages. One could claim that the Warburg Institute itself was founded on the premise that the survival of images (however elusive) provides us with the only (indirect) access we (might possibly) have to the shadowy and potentially threatening legacy of the past. In his library's *Mnemosyne* project, Warburg compulsively arranged and re-arranged assorted reproductions of visual artefacts, both historical and contemporary, on large exhibition screens in the hopes of detecting underlying connections among them. While his 'aspiration ... to present something like a basic vocabulary, the *Urworte* of human passion'[11] might well have been an iconologically ambitious one (and a telling 'supplement' to the library's emphasis on the written word), there is no doubt that the impulse behind it had as much to do with Warburg's own legendary psychic turmoil as it did with the scholarly understanding of archetypal energies coursing through Renaissance pictorial motifs.

A similar fascination with both the presence and absence of cultural memory from the ancient to the early modern world was perpetuated in Warburg's successors' more sober academic interests. Refining the iconological 'method' of monitoring the migration of a pictorial theme from one social and intellectual world to another, Fritz Saxl and Panofsky published their influential monograph on Dürer's engraving of *Melencolia I* in 1923. Extending Warburg's investigations into the fortunes of this centuries-old astral personification, the two Institute collaborators were able to trace the iconographic route through which the medieval conception of a saturnine and debilitating temperament had meta-morphosed in the Renaissance into an allegory of the incapacity of genius to put its theories into practice.[12] By 1966, when Frances Yates wrote her erudite survey on *The Art of Memory* from the ancients to the moderns, in which the paradoxical traits of melancholy are invoked for characterizing contradictory impulses towards historical recollection, the psychically charged edge with which Warburg had once approached the topic had waned.[13] Nevertheless, I would argue that some live fragment of Warburg's awe of the power of past images and his hesitancy for confronting them except on their own visual terms – as evidenced in his inclination only to show or to indicate through pictorial collages and illustrative comparisons – has its own afterlife in Michael Baxandall's intellectual penchant for what he calls 'ostensive' criticism.

Perhaps the thinker who can best map the psychic terrain upon which I wish to locate Baxandall's idiosyncratic brand of melancholic history writing, however, is

Walter Benjamin, the perennial outsider. Try as he might to gain the recognition of the scholars of the Warburg Institute (Panofsky in particular), Benjamin was fated to pursue his inquiries into melancholia in isolation. Composing *The Origin of German Tragic Drama*[14] in the mid-1920s, he generously acknowledged Warburg, Panofsky and Saxl as sources. The intellectual home, however, that he had hoped to attain from these contemporary allies, who, one commentator charges, might even have 'averted his early death', was not forthcoming.[15] But that is another, more sorrowful story. What makes the ideas of Benjamin so suggestive for a late twentieth-century reading of the works of Michael Baxandall is not so much his lack of institutional support from thinkers in early twentieth-century Germany with whom he shared a fascination with the historical vicissitudes of the figure of Melancholy, as is his poignant understanding of the transhistorical connections between the 'discarded' ruins of the past and their contemplation by melancholic historians on the other side of time.

Ostensibly, Benjamin's *Origin of German Tragic Drama* is about Baroque 'mourning plays' (*Trauerspiel),* convoluted productions in which martyrs are sacrificed to ancient values which they themselves are doomed never to fulfil. A deeper reading quickly reveals, however, that the text (unrecognized except by a few for the first thirty years of its existence) comprises a 'chain of reflections on the nature of aesthetic objects, on the metaphysical presumptions of allegory, on language in general, and on the problem, obsessive to Benjamin, of the relations between a work of art and the descriptive–analytic discourse of which it is the target'.[16] Today the work is heralded as one of the most significant texts in twentieth-century literary criticism, principally because of its explorations into both the impossibility of achieving 'objective' meaning on the part of the 'subjective' interpreter, and, nevertheless, the absolute necessity of doing so. The phenomenology of the ways in which sentiments become bound to objects (or fail to) was, for Benjamin, a study in the dynamics of the melancholic disposition:

> Melancholy betrays the world for the sake of knowledge. But in its tenacious self-absorption it embraces dead objects in its contemplation, in order to redeem them. ... The persistence which is expressed in the intention of mourning, is born of its loyalty to the world of things. ... The concept of the pathological state, in which the most simple object appears to be a symbol of some enigmatic wisdom because it lacks any natural, creative relationship to us [had been memorably emblematized for him by Dürer's portrayal of *Melencolia*, in which] ... the utensils of active life are lying around unused on the floor, as objects of contemplation. This engraving anticipates the baroque in many respects. In it the knowledge of the introvert and the investigations of the scholar have merged as intimately as in the men of the baroque. The Renaissance explores the universe; the baroque explores libraries. Its meditations are devoted to books.[17]

While Benjamin's own meditation on the ruins of the contemplative life has nothing directly to do with thinking about the connectedness of an archival art historian (Baxandall or otherwise) to the material objects that are the raison d'etre of professional inquiry, its metaphorical suggestiveness for this most primal of

disciplinary obsessions is undeniable. There is nothing self-evident about the compulsion to write present words about past works of art. In Benjaminian terms, such activity could be construed as an allegorical enterprise (saying one thing while attempting to grasp a very different other) of the first order. Words will unceasingly misrepresent images, and in their mismatch unlock the gates of an interpretive hell through which the demons of ambiguity, indeterminancy and meaninglessness come tumbling out. Images are inevitably lost to the forms of intelligibility with which the world of the humanities has grown most epistemologically secure: that is the essential paradox of writing the history of art. Of this predicament, Michael Baxandall is acutely aware. A history that is rooted in written documents is difficult enough to execute; a narrative written out of a 'loyalty to the world of [visual] things' is an assignment in exasperation. The very tactility of objects that have survived the ravages of time in order to exist in the present confounds the historian who must retroactively turn them back into past ideas, social constructs, documents of personality, or whatever a couple of generations of Warburg scholars have traditionally been up to in the variety of their iconological quests. Ransacking the holdings of libraries and archives in order to provide context is an accepted disciplinary pursuit, but its legitimacy masks something of its basic absurdity. In their obdurate resistance to such an easy mediation between past and present, the still stilled works of art are capable of provoking an heuristic despair that is difficult to overcome. The 'contemplative paralysis' that arises from the recognition of an inability to write definitive history (or, even more perhaps to act in it) is, for Benjamin, the essential trait of the mournful sensibility.

Because of the futility of its efforts to make the impermanent permanent (which is to say the permanent more permanent), to arrest the flux of time into images that both defy and glorify its passing, the allegorical understanding has been assured the status of the quintessential postmodernist art, an achievement which places this literary trope on a par with a variety of late twentieth-century art practices devoted to ruins, fragments, hybrids and supplements. Such is the thesis of Craig Owens, who not so long ago elaborated an insightful and persuasive theory of postmodern art on the basis of the return of the 'allegorical impulse'. 'From the will to preserve the traces of something that was dead, or about to die', he claimed, 'emerged allegory.' Drawing its 'nourishment' from melancholy, the postmodern sensibility of the late twentieth century revels in the awareness of its own mortality: 'the inevitable dissolution and decay to which everything is subject'.[18]

Though profoundly melancholic, such an interpretive sentiment, as Benjamin had both hoped and anticipated, is not devoid of redemptive possibilities. 'An appreciation of the transience of things, and the concern to rescue them for eternity', which happens to be 'one of the strongest impulses in allegory' can also yield its own scholarly consolations: 'Pensiveness', as he moralized, 'is characteristic above all of the mournful.'[19] Mourning does not necessarily obviate – in point of fact, it might be responsible for – the ecstasy that can arise from a confrontation with the lost 'other'. The melancholic attitude is not only responsible for acts of renunciation; it can also ultimately engender an historical practice that is founded on an ethical obligation to the past in all of its reality, however fragmentary and incomplete its afterlife in the library may be. The

opacity which is the hallmark of the allegorical sensibility is precisely that which motivates the unceasing efforts to activate the past over and over again: 'Allegory [is] the arbitrary rule in the realm of dead objects.'[20] Past objects are 'dead' only until they are enlivened by present understanding; yet, on the other hand, it is always their presence in the first place that provokes the contemporary historian into interpretive action. The relationship is one of dialogue, 'where the present is real but the past is also real.'[21]

The resonance of these sentiments for thinking about Michael Baxandall's lifelong work seems to me to be patent. It is this allegiance to the thing itself, and not its discursive explanations in the philosophical, historical and theoretical words that have a tendency to envelop and thereby seal away the visual immediacy of a work, that might explain Baxandall's reluctance to make any interpretive move that does not take its cue from the representation itself. The inadequacy of language and the impossibility of historical recovery are the two negatory premises from which his ultimately affirming work derives. 'The basic absurdity of verbalizing about pictures',[22] has been a theme coursing through all his writing, but so too has been the clear commitment to the inexorability of doing so. It is the tension between the two that has generated both melancholic resignation and methodological caution as two sides of the same coin. His *Patterns of Intention* obviously represents the culmination of this attitude, but it has, in one guise or another, been there from the start.

Ostensibly, Baxandall's *Giotto and the Orators: Humanist Observers of Painting in Italy and the Discovery of Pictorial Composition, 1350–1450* of 1971 is, as the lengthy subtitle suggests, about the rise (or recovery) of art criticism in the early Renaissance.[23] A deeper reading quickly reveals, however, that the text, like Benjamin's, comprises a chain of reflections on the nature of language, the concept of pictorial composition, the art of classification, and, on the problem, obsessive to Baxandall, of the relations between a work of art and the critical discourse of which it is the target. The problematic is a straightforward one: 'Any language, not only humanist Latin, is a conspiracy against experience in the sense of being a collective attempt to simplify and arrange experience into manageable parcels.'[24] Attending to paintings is the product of naming rather than looking. This is the most primal, unavoidable, and irrevocable loss. What does not fall within the purview of established schemes stays in remainder, always on the outside of the framing propensity of language:[25]

> To exercise a language regularly on some area of activity or experience, however odd ones motives may be, overlays the field after a time with a certain structure; the structure is that implied by the categories, the lexical and grammatical components of the language. For what we can and do conveniently name is more available to us than what we cannot.[26]

That absence is then deepened by time's distancing. Language makes vanish what it first sought to preserve: the compelling visuality of the work of art. As it struggles to signify what once was, the rhetoric of the art historian represents, in the terms of deconstruction, 'not the thing but the absence of the thing and so it is implicated in the loss'.[27]

Yet surely that is overstating the case. Despite late twentieth-century critical theory's obsession with the emptiness and meaninglessness at the heart of language, Baxandall still carries something of the faith in its recuperative powers. To paraphrase Freud, an acknowledgement of loss initiates the authentic 'work of mourning' the past. The salvation of historical discourse in both Benjamin and Baxandall depends on it. At the same time as it takes something away from the beholder of works of art, language offers the powerful consolation of 'a system of concepts through which attention might be focused'.[28] Embracing 'dead objects in its contemplation in order to redeem them', attention (in Baxandall the concept nearly merits capitalization) serves as the temperate historian's antidote to melancholia, or 'pharmakon' in Derrida's terms: both the poison and the cure.[29] What he had found so admirable about the humanist enterprise was its ability to think 'tightly' in words about visual matters, a mission that eventuated in the giant historical leap forward in art criticism between 1300 and 1500. 'The difference', he says, was 'measurable in categories and constructions lost and found.'[30] Finding something is better than losing it. It is just easier to talk about some things than others.

As his next book *Painting and Experience in Fifteenth-Century Italy* set out to demonstrate, one of those things was addressing Quattrocento paintings as a 'deposit' of 'a commercial relationship', or as 'fossils of economic life'.[31] Of course, one could read this popular empirical text as an elaborate defence against the brooding contemplativeness of *Giotto and the Orators*. There are no dark unknowables lurking here, only manifest pictorial codes derived from vernacular conventions, such as traditions of measurement, the economic worth of paints, and habits of gesture in sermons and dance. Perhaps that is what makes this text so accessible. Categories of experience are highlighted so as to enable the viewer to 'attend' to Quattrocento works of art in 'distinctly Quattrocento ways'.[32] Language here clarifies rather than obfuscates, and its careful use assures the student of the Renaissance that she or he can actually gain access to this 'special intellectual world'.[33] The idiom of this text always promises transparency. There actually once was an historical world out there, whose visualizing activity became embodied in its works of art. Deciphering it is fundamentally a matter of recognizing the brightness of the signs.

It is the shadows, however, that I prefer to attend to in the work of Baxandall, no doubt taking my cue from his own fascination with the penumbral as most recently manifested in his *Shadows and Enlightenment* of 1995. 'How', he asks there, 'do shadows work, not just in the physical world, but in our minds?'[34] – an interesting question not only for perceptual psychologists but for historiographers as well. In *Limewood Sculptors of Renaissance Germany* of 1980 there is a wonderfully descriptive passage that provides some insight into Baxandall's own capacity for paying attention to the ephemerally perceived. Trying to capture in words the visual effect of a Tilman Riemenschneider wooden altarpiece in a dusky church interior, he sits in front of it for many hours in order 'to let the sun run its course'. From the shadows of early morning, to the 'dead period in the middle of the day' that causes it to look 'rather like its photographs', to the crepuscular aura of late afternoon, he watches the *Last Supper* change not only in illumination but also in significance.[35] Given my predisposition to heed the pensive melancholy in

11

so many of Baxandall's words, I cannot but read the description of his physical experience here as a metaphor for his own metaphysical preoccupations. The easy mediation between present and past in *Painting and Experience* has metamorphosed in this text into a dimmer, more resigned affair, but one not without its compensatory satisfactions. Even though the analytic confidence in the retrieval capabilities of language is sustained in this stunning study of a neglected artistic genre, at the same time Baxandall demonstrates no reservations about delighting in what remains unnameable:

> It is becoming more difficult to find categories of visual interest within which to address the forms of the sculpture. ... The problem is partly that our ways of addressing works of art are quite limited by our own place in the great Franco-Italian artistic tradition of the last millenium, to which the sculpture is really no more than marginal. ... but it is often useful and enjoyable to go to works of art exotic to our own tradition with a few additional categories authentic to them. There is no question of fully possessing oneself of another culture's cognitive style, but the profit is real: one tests and modifies one's perception of the art, one enriches one's general visual repertory, and one gets at least some intimation of another culture's visual experience and disposition. Such excursions into alien sensibilities are a main pleasure of art.[36]

Melancholic joy, in other words, need not be an oxymoron. In Roland Barthes's last book, the bittersweet *Camera Lucida*, written at the same time as Baxandall's *Limewood Sculptors*, he invokes what he calls the 'punctum,' the unnamable something frequently present in old photographs and which for him was embodied in an ideal photograph of his dead mother. The punctum is that which testifies to a kind of 'subtle *beyond* – as if the image launched desire beyond what it permits us to see'.[37] A similar sentiment seems to underwrite all the varied topics and periods upon which Baxandall has turned his own attention. It is as if he himself has scanned the artistic canon, seeking, like Barthes, for that insight or moment of contact which he already knows is forever foreclosed. 'What I can name', Barthes remarks, 'cannot really prick me. The incapacity to name', however, 'is a good symptom of disturbance.'[38] 'A good symptom of disturbance', of course, is most likely either the cause or the effect of melancholic yearning. It is the source of a similar 'subtle beyond' in the works of Baxandall that I am struggling to name: the attitude or conviction that eludes definition but yet seems to shadow all the many things he has had to say. Fortunately, he has left a couple of clues lying around – it is tempting to picture them as the discarded objects in Dürer's engraving of Melencholia – in a curiously 'ruined' historiographic exercise of 1985.

In a remarkable essay in an issue of *Representations* on the assigned topic of 'Art or Society: Must We Choose?' Baxandall boldly drew attention to the shortcomings to which his particular brand of historiography was subject. Setting out to parallel Ambrogio Lorenzetti's fourteenth-century pictorial allegories of good and bad government in the Siennese town hall with political and social events surrounding their execution, he ends up writing a consciously fragmented

allegory about good and bad art-history writing. His original essay on art-in-context, he claimed, in short, could not be written. Plagued by the sense that 'there was something wrong about anything approaching a one-to-one relation between pictorial thing and social thing', he despairs of ever making matches between 'analytical concepts from two different kinds of categorization of human experience', which is, essentially, to return to the futility of explaining works of vision through verbal constructs.[39] It all comes back to the perfidy of language and the inevitable melancholy it trails in its wake. Short of descending into sheer inactivity – the psychic state of Dürer's personification of Melancholia – there are only two solutions: either write a poor and perfunctory social history of art or retreat to the basics and attempt to sort out the use of incongruous analytic concepts: 'I hope ... that we might do what we do rather better if we were clearer about what it is we are doing.'[40] In this disingenuously simple statement, the hidden agenda for the apparently confident *Patterns of Intention* (published in the same year, 1985) was laid down.

The book is a wonderfully provocative, but maddeningly cautious, meditation on trying yet once again to make words say something authentic about images. That it both masterfully succeeds and self-consciously falls short (after a formidable number of constraints are levied upon what can legitimately be claimed) is entirely consonant with Baxandall's wry sense of what it means to try and write an art historical narrative:

> What one offers in a description is a representation of thinking about a picture more than a representation of a picture. ... Our emotions are less about the object itself than about the history of our minds' engagement with the object. ... The problem [as always] is the interposition of words and concepts between explanation and object of explanation. ... we explain pictures only in so far as we have considered them under some verbal description or specification.[41]

As Baxandall is chronically aware, what gets left out of this habitual disciplinary praxis is the 'authority of pictorial character, forms and colours', and other such crucial aspects of visuality. The solution of 'inferential criticism' – that which 'entails the imaginative reconstruction of causes, particularly voluntary causes or intentions within situations'[42] – which he proposes is typically one borne on the margins of pictorial intelligibility:

> ... their authority is primary, if we take the visual medium of pictures with any seriousness at all; they, not symbols, are the painter's language. Good inferential criticism observes this authority even if it is not up to invoking it. It is possible to give a shadow-account of articulation by not flouting it.[43]

Yet indirection is not the only course of action open to the savvy critic: concepts and objects 'should reciprocally sharpen each other'[44] at every turn, with one revealing qualification. Whatever we infer historically about works of art – which is to say however much we reconstruct 'briefs', contexts, circumstances and situations – in the end the narrative's ostensive relation to the historical picture is

itself mediated by the present: 'We are interested in the intention of pictures and painters as a means to a sharper perception of the pictures, *for us* [my italics]. It is the picture as covered by a description *in our terms* [his italics] that we are attempting to explain'.[45] On this unacknowledged poststructuralist foundation of subjectivity, Baxandall's interpretive edifice stands.

What it refuses to sacrifice to the demands of self-reflexivity, however, is the conviction that the past, though lost, merits every one of its serious attempts at comprehension. While the gulf between past and present, word and image, assures the historian of art that her or his enterprise will always be an incomplete, and hence melancholic, one, the quest for pictorial meaning is far from nugatory. What Baxandall and Svetlana Alpers mutually admired about Tiepolo's pictorial intelligence as they ascended the triumphant staircase at the Treppenhaus in Würzburg, is the way 'the world ... presents a conundrum and his painting makes us conscious of having to work to make things out' pictorially.[46] While 'the starting point' in any art-historical narrative, as he claimed in *Patterns of Intention*, 'is a sense that there is some sort of affinity between a kind of thought and a kind of painting',[47] when it comes to some art ('only superior paintings will sustain explanation of the kind we are attempting: inferior paintings are impenetrable'[!][48]), neither historical nor critical words of explanation are sufficient: 'Painting persist[s] against, or simply despite, the grain of theory.'[49]

Like Walter Benjamin, Baxandall finds himself 'marooned' in a world of 'stranded objects' that demand recognition, and oftentimes that translates into 'reading' them from a vantage point on the other side of time.[50] Heeding the intellectual and social contexts that have enveloped works of art through history is one of the routes towards appreciating their primary intentions.[51] But, and this must be emphasized, such historical understanding will never quite take us there. The chasm between words and images, past and present, can never – unlike the Firth of Forth – be bridged by a dazzling act of ingenuity. In the midst (and mists) of loss, the perceptive historian must above all keenly attend to the paintings themselves and focus on their distinctly pictorial constructions of meaning. In the process, she or he will put into effect a fair critical, though inevitably flawed, programme:

> What we have in [for example, Chardin's] *A Lady Taking Tea* is an enacted record of attention which we ourselves, directed by distinctness and other things, summarily re-enact, and that narrative of attention is heavily loaded: it has foci, privileged points of fixation, failures, characteristic modes of relaxation, awareness of contrasts and curiosity about what it does not succeed in knowing.[52]

* * *

In the concluding paragraph to her essay on 'Beauty' in her own book on melancholy, *The Black Sun*, Julia Kristeva memorably remarks that the imaginative capacity 'of Western man' discovers itself anew through its 'ability to transfer meaning to the very place where it was lost in death and/or nonmeaning'.[53] A more eloquent evocation of the motives underlying Michael

Baxandall's rhetorics of loss than that – however 'irrational and wild'[54] he would consider my historiographic sentiment to be – I cannot imagine. I will finally go so far as to appropriate his own appreciative words on Tiepolo's achievement to characterize his own body of insight: '[He] worked with an intricate and shifting sum of various sources of reflected and re-reflected light. ... In short, the world of [his] shadows feels bright and enlightened. ...This is art made out of art.'[55] Continuing curiosity about what the scholar will never be able completely to know seems to me to be the most noble, though undeniably melancholic, critical endeavour of all.

<div align="right">

Michael Ann Holly
University of Rochester

</div>

Notes

1 *Patterns of Intention: On the Historical Explanation of Pictures*, New Haven and London, 1985, p. 13; later in this same text (p. 35) he refers to his deliberately 'very low and simple theoretical stance'. In an early review of this book, Adrian Rifkin remarks how Baxandall always manages to convey 'a tone of boredom and disdain at the engagement with philosophical difficulty ... discharging his involvement as an unwelcome obligation. ... but as he is anyway deeply implicated in a complex of debates, he may as well have been more open about their terms of reference', *Art History*, vol. 9, June 1986, p. 275.

2 Freud, of course, in 'Mourning and Melancholia' of 1917 [trans. James Strachey, *Standard Edition of the Complete Psychological Works of Sigmund Freud*, London, 1953, XIV, pp. 239–58] drew a very deliberate distinction between the symptoms, causes and effects of these two psychic states. I have chosen to elide them here in order to characterize a more generalized historiographic attitude.

3 *Patterns of Intention*, p. 120.

4 Svetlana Alpers was aware of this predicament from the start: 'The most commanding definition of meaning in the visual arts in this century – iconography according to Panofsky – has a textual base. ... But is there really no difference between an image and a text, such that one's attention to it, and hence one's account of it, would be different? Baxandall's answer is, clearly, yes.' *The New Republic*, 14–21 July 1986, p. 36.

5 Here he forecasts W.J.T. Mitchell's preoccupation with the same issues in his *Iconology: Image, Text, Ideology*, Chicago, 1986.

6 In his recent *Shadows and Enlightenment*, New Haven and London, 1995, pp. 135–6, Baxandall uses the concept of attention to emblematize his general approach to the social understanding of art: 'A viable model for thinking about some aspects of art and culture is precisely as a market in attention itself, an exchange of attentions valuable to the other. We and the artist collude in a socially institutionalized assignation to barter our respective attentions. He values our attention for many reasons, and not only because it may be associated with whatever sort of material reward the culture offers: his social identity and his sense of his own humanity are complexly involved in the transaction. We, on the other hand, attend to the deposit or representation of his attention to life and the world because we find it enjoyable or profitable, sometimes even improving. The transaction is not symmetrical: he values the attention we direct at him and his; we value the attention he directs at life and the world. He values us as representatives of a general humanity; we value him for a specialised faculty, even if perhaps articulating a general human quality. But the pattern is still that of a market, with choice on both sides and reciprocal agency.'

7 *Tiepolo and the Pictorial Intelligence*, with Svetlana Alpers, New Haven and London, 1994.

8 Giorgio Agamben, *Stanzas: Word and Phantasm in Western Culture*, trans. Ronald L. Martinez, Minneapolis, 1993, pp. 20–1.

9 Wendy Wheeler, 'After Grief: What Kinds of Inhuman Selves?' *New Formations* 25, 1995, p. 90.

10 Panofsky, 'The History of Art as a Humanistic Discipline', *Meaning in the Visual Arts*, Garden City, 1955, p. 24.

11 Ernst Gombrich, *Aby Warburg: An Intellectual Biography*, 2nd edn., London, 1986, p. 287.

12 'Dürers 'Melencolia I': Eine quellen- und typengeschichtliche Untersuchung', *Studien der Bibliothek Warburg* 2, Leipzig/Berlin, 1923.

13 *The Art of Memory*, London, 1966.

14 *Ursprung des deutschen Trauerspiels*, 'conceived

<div align="right">15</div>

1916, written 1925' (published 1928), translated by John Osborne as *The Origin of German Tragic Drama*, London, 1977.

15 George Steiner, in his 'Introduction' to *The Origin of German Tragic Drama*, p. 19. For a history of this 'non-encounter' between Benjamin and the Warburg Institute, see the footnotes to Max Pensky's account in his *Melancholy Dialectics: Walter Benjamin and the Play of Mourning*, Amherst, 1993, pp. 263–4, as well as Thomas Levin, 'Walter Benjamin and the Theory of Art History', *October* 47, Winter 1988, pp. 77–83. For a study of Benjamin's connections (or lack of) to both the Warburg Institute and the Vienna School of Art History, see Wolfgang Kemp, 'Walter Benjamin und die Kunstwissenschaft. Teil 1: Benjamins Beziehungen zur Wiener Schule', and 'Walter Benjamin und Aby Warburg', *Kritische Berichte des Ulmer Vereins für Kunstwissenschaft*, vol 1, no. 3, 1973, pp. 30-50 and vol. 1, no. 3, 1975, pp. 5–25, respectively.

16 Steiner, p. 15.

17 Benjamin, pp. 157, 140.

18 'The Allegorical Impulse: Toward a Theory of Postmodernism', parts 1 and 2, reprinted in S. Bryson, B. Kruger, L. Tillman, and J. Weinstock (eds), *Beyond Recognition: Representation, Power, and Culture*, Berkeley, 1992, pp. 60, 77.

19 Benjamin, pp. 223, 139–40.

20 ibid., p. 232.

21 Michael Steinberg, 'Introduction: Benjamin and the Critique of Allegorical Reason', in M. Steinberg (ed.), *Walter Benjamin and the Demands of History*, Ithaca and London, 1996, p. 3.

22 'The Language of Art Criticism' in Salim Kemal and Ivan Gaskell (eds), *The Language of Art History*, Cambridge, 1991, p. 73. The essay is an abbreviated version of 'The Language of Art History', published in *New Literary History* 10, 1979, pp. 453–65.

23 *Giotto and the Orators: Humanist Observers of Painting in Italy and the Discovery of Pictorial Composition*, Oxford, 1971.

24 ibid., p. 44.

25 In acknowledging this descriptive excess, Baxandall anticipated Derrida's more iconoclastic claims on the same subject several years later. See his *The Truth in Painting*, trans. Geoff Bennington and Ian McLeod, Chicago, 1987, which was first published as *La Vérité en Peinture* in Paris in 1978. One indeed could make the claim that Baxandall was himself one of the first art historians to evince the 'linguistic turn', at the same time he abjured it.

26 *Giotto and the Orators*, p. 47.

27 Richard Stamelman, *Lost Beyond Telling: Representations of Death and Absence in Modern French Poetry*, Ithaca and London, 1990, p. 39. Paul de Man, Maurice Blanchot and Louis Marin – as Stamelman points out in lengthy quotations – have evocatively made use of the dependence of language on the 'void'. In Demanian discourse, in particular, Eric Santner has remarked, 'the speaking subject is perpetually, constitutionally, in mourning: for the referent, for beauty, for meaning, for home, for stable terms of orientation, because these losses are always already there as soon as one uses language.' See his *Stranded Objects: Mourning, Memory, and Film in Postwar Germany*, Ithaca and London, 1990, p. 15.

28 *Giotto and the Orators*, p. 49.

29 And the beginning, perhaps, to a twelve-step recovery programme (like the twenty-four 'cause-suggesting features' in the construction of the Firth of Forth bridge, or the appropriation of Cristoforo Landino's sixteen terms which 'constitute a compact Quattrocento equipment for looking at Quattrocento paintings'!). See the first chapter in *Patterns of Intention*, p. 26, and last chapter in *Painting and Experience in Fifteenth-Century Italy*, Oxford, 1972, p. 111.

30 *Giotto and the Orators*, p. 6.

31 *Painting and Experience*, pp. 1–2.

32 ibid., p. 27.

33 ibid., p. 86.

34 *Shadows and Enlightenment,* p. 9.

35 *The Limewood Sculptors of Renaissance Germany*, New Haven and London, 1980, pp. 189–90.

36 ibid., p. 143.

37 Roland Barthes, *Camera Lucida: Reflections on Photography*, trans. Richard Howard, New York, 1981, p. 59.

38 ibid., p. 51.

39 'Art, Society, and the Bouguer Principle', *Representations* 12, Fall 1985, pp. 39–40.

40 ibid., p. 43.

41 *Patterns of Intention*, pp. 5, 45, v, 1.

42 The definition comes from his 'The Language of Art History', p. 463.

43 *Patterns of Intention*, pp. 132–3.

44 ibid., p. 34.

45 ibid., p. 109.

46 *Tiepolo*, p. 40.

47 *Patterns of Intention*, pp. 76–7.

48 ibid., p. 120.

49 *Tiepolo*, p. 2.

50 The terms are Santner's, p. 12.

51 'Intention', he asserts, 'is referred to pictures rather more than to painters. ... It is not a reconstituted historical state of mind, then, but a relation between the object and its circumstances,' *Patterns of Intention*, p. 42.

52 ibid., p. 102.

53 Kristeva, *Black Sun: Depression and Melancholia*, trans. Leon Roudiez, New York, 1989, p. 103.

54 *Patterns of Intention*, p. 135. These are the two characteristics of historical and critical analysis that Baxandall manifestly shuns.

55 *Tiepolo*, pp. 84, 81, 45.

Aspects of the Critical Reception and Intellectual History of Baxandall's Concept of the Period Eye

Allan Langdale

Art historians have often examined the critical reception of works of art, yet few have evaluated art history's reactions to some of its own products. This paper examines aspects of the intellectual history and scholarly responses to Michael Baxandall's *Painting and Experience in Fifteenth-Century Italy* (1972) as a case through which to reveal some relevant tensions in art history during the early 1970s, a moment when the discipline was exposed to powerful stresses and a time, moreover, quite formative of our present way of doing things. The reasons for choosing *Painting and Experience* – and more particularly Baxandall's concept of the Period Eye – include the fact that the book is, even after twenty-five years, an art-historical bestseller, having gone through numerous printings and having been translated into several languages, most recently into Chinese. It is thus an ambassador of western art history. From a historiographic perspective, more telling than the book's broad and enduring popularity is that initial responses to it were particularly varied and strong, and analysis of these reactions generate maps of the discipline around 1972. Today it is easy to forget that this well-liked book drew fire from disparate quarters in art history, condemnations symptomatic of growing pains resulting from such things as the pressures of radical revisionism and accelerating intellectual cross-fertilization. What one gets from looking at some of the responses is an idea of what was at stake for certain individuals in specific institutions. The purpose of this essay is twofold: to examine aspects of the intellectual heritage of the central theoretical concept of *Painting and Experience*, the Period Eye, and to trace some of the various academic responses to the concept, notably the art-historical and – broadly defined here – the anthropological.

Painting and Experience elicited sympathetic attention from Clifford Geertz and, later, Pierre Bourdieu. In 1976 Geertz gave a laudatory synopsis of the Period Eye chapter of *Painting and Experience* in an article called 'Art as A Cultural System',[1] while in 1981 Bourdieu printed a French translation of the Period Eye chapter of *Painting and Experience*, which he prefaced with an essay entitled 'Pour une sociologie de la perception'.[2] Both were approving evaluations representing an exceptional reversal of intellectual capital during a period when art historians were much more apt to be looking outside their discipline for intellectual stimulation and few disciplines, certainly, were looking to art history for exemplary models. Within art history, however, Baxandall's book was

regarded by some with suspicion. For émigrés like E.H. Gombrich, the Period Eye seemed like a slippery new version of *Zeitgeist*, a notion which Gombrich abhorred, while T.J. Clark and others publishing in places like the Marxist *Histoire et critique des arts* attacked the book for not dealing with issues of class, ideology and power.[3]

Geertz's aforementioned 'Art as a Cultural System' took Baxandall's concept of the Period Eye as paradigmatic of a rigorous and deep anthropological analysis of a society's visual culture. For Geertz, *Painting and Experience* represented an advance in the analysis of visual culture's embeddedness in the myriad activities of a society.[4] Geertz saw the book as a work which, more than many other studies attempting to link the styles of works of art with society or culture, meticulously articulated the mediating elements out of which such transformations were made. Earlier attempts at analysing the relationships between styles of art and other structures of a society had left these vectors of dissemination largely undetermined, contenting themselves with the identification of homologies without closely examining the mechanisms, social and institutional, which regenerated the forms of something like family structure to town planning, from styles of writing to painting, and so on.

One such earlier structuralist model is represented by 'A Native Community and its Life-Style', a chapter of Lévi-Strauss's *Tristes Tropiques*,[5] where Lévi-Strauss attempted to ascertain the significance of the styles of the facial tattoos of the Caduveo natives (plate 1). He noted their formal attributes and the organizations of Caduveo society and concluded that Caduveo culture was generally characterized by a 'double opposition', which consisted of an '... opposition between a ternary and a binary organization, one symmetrical, the other asymmetrical'. The motif of the double opposition – graphically represented in the tattoos by crossing lines which double-back in spirals – was also evident in the hieratic physical and social organization of the villages as well as the odd social practice of arranging marriage with enemies rather than betray their caste.[6] Lévi-Strauss attempted to identify the salient features of this system and demonstrate its symmetry throughout the culture. But he could not articulate truly definitive mediations or practices transmitting the structures of the facial tattoos, so that at the conclusion of his essay Lévi-Strauss found it necessary to hypothesize that the designs were expressions which unconsciously represented resolutions of repressed societal dialectics.[7] His vocabulary of undefinable linkages is telling: the art of the facial tattoo in Caduveo art is a 'remedy' (*remède*)[8] which resolves contradictions which 'haunt' (*troubler*) the Caduveo; it had 'mysterious appeal' (*mystérieuse seduction*); it is a 'phantasm' (*phantasme*) of a society; the tattoos are the traces of a 'collective dream' (*rêver* and *songe*).[9] Even though a complex homology was identified and ingeniously articulated, the social practices or activities which facilitated the transferences were, for Lévi-Strauss, mysterious and intangible.

As an anthropologist interested in refining this early structuralist model, Geertz saw in Baxandall's concept of the Period Eye a sophisticated account of the practices by which organizational and stylistic aspects of a society might be projected or read, consumed and reproduced, in another part of that same society. Homologies or isomorphisms were no longer enough for the structural anthropology of the mid-1970s. As Geertz notes:

1 From Claude Lévi-Strauss, *Tristes Tropiques*, fig. 20. Face painting of the Caduveo consisting of two opposed spirals which are represented – and are applied on – the upper lip.

A theory of art is thus at the same time a theory of culture, not an autonomous enterprise. And if it is a semiotic theory of art it must trace the life of signs in society, not in an invented world of dualities, transformations, parallels, and equivalences.[10]

The Period Eye was, however, neither derived from nor meant to address problems in structuralist anthropology; more relevant for Baxandall were the socio-psychological theories of Melville Herskovits and his followers.[11] Herskovits was much involved in that problematic issue with which Baxandall grapples in his prolegomena to his Period Eye section in *Painting and Experience*: the balance of the constitutive roles of society and the individual. Herskovits was interested in wedding aspects of psychology with a structuralist anthropology, a concern best summarized by Herskovits's followers:

If culture includes the complex of accumulated behaviour patterns of a people, and if an individual's habits constitute the residues of his experience, then the study of culture and the study of habit-development are necessarily related. ... We do not refer here to the casual half-truth that psychology is concerned with the individual, while anthropology is concerned with groups. Rather we have in mind the psychologist's emphasis on process and the anthropologist's concern for pattern and structure.[12]

We can recognize the correspondence in these objectives and the Period Eye. For Herskovits, 'visual experience is *mediated* by indirect inference systems', while the 'phenomenal absolutists'[13] (Gombrich in *Art and Illusion* might have been so

19

classified) accept the assumption that the visual world presents itself, as reality, to human perception.[14] The emphasis here is on the nature and scope of enculturation in perception.[15] Though the symmetry between this position and Baxandall's is clear, Baxandall departs from these notions by directing his attentions to those inculcative social practices constitutive of cultural difference.

To illustrate Baxandall's shift in emphasis we might consider a model which the followers of Herskovits accepted as viable, but which Baxandall thought too rigid. The 'carpentered-world hypothesis' refers to the tendency of people living in highly 'carpentered' (that is to say urban) environments to 'see' right angles:

> For people living in carpentered worlds, the tendency to interpret obtuse and acute angles in retinal images as deriving from rectangular objects is likely to be so pervasively reinforced that it becomes automatic and unconscious. . . . For those living where man-made structures are constructed without carpenters' tools . . . the inference habit of interpreting acute and obtuse angles as right angles extended in space would not be learned, at least not as well.[16]

Instead of simply describing an environment as an entity programming and patterning the passive beholder to certain cues, as in the carpentered world hypothesis, Baxandall's emphasis is on particular social activities which engage and train the individual's cognitive apparatuses. The difference is subtle; Baxandall's individual in culture is seen as the site of a compilation of socially relevant and active skills rather than the programmed automaton implied by the carpentered-world hypothesis. Baxandall's contribution is located in that zone of mediation found in the practice of everyday life rather than on the spectral poles of the practices' manifestations.[17] Geertz's enthusiastic response to Baxandall's concept of the Period Eye lay very much in the recognition of the anthropological antecedents, which had also formed Geertz's own anthropological perspective on art, a perspective that analysed aspects of the forms of art with the aim of finding out something about the culture in which the art objects travelled.

In the first chapter of *Painting and Experience*, 'The Conditions of Trade', Baxandall recruits a series of geological terms to describe the relationship between society and paintings. A 'painting is the *deposit* of a social relationship';[18] the 'economic practices of the period are quite *concretely* embodied in the paintings';[19] '. . . paintings are among other things *fossils* of economic life' (my italics).[20] The language graphically insists on a solid – virtually petrified – directly imprinting connection between a culture's economic practices and paintings. The lapidary confidence conveyed by the geological rhetoric comes from the fact that several mediating documents, artists' contacts, survive from this period, and these present the historian with a tangible and more or less clearly functioning arbitration between two cultural agents: the artist and the paying customer. The artist is executor, to recognizable extents, of a degree of fairly definable instructions of which some 'concrete' evidence exists. Baxandall's elaboration of the structures of the art market, the social relationships between artist and client, the intermediary functions of guilds, workshop practice and the cultural valuations of certain materials, such as gold and high grades of blue, presents

one with a number of fairly determinable kinds of social things which are 'concretely embodied' in paintings, partially because they operate and circulate so closely to the orbit of the production of painting itself. The last section of the first chapter (subtitled 'Perception of Skill') moves the discussion into far more indeterminate zones, farther away from practices surrounding the production of painting and into the less tangible realm of the beholder's subjectivity and tastes. There is a shift from more to less distinct purchasable pictorial elements; from things like numbers of figures, qualities of pigments, amounts of gold, and dimensions of works, to the far more elusive and indefinable commodity of skill.

The concept of the Period Eye, developed in the second chapter of *Painting and Experience* (yet taking up half the book), is Baxandall's most interesting and controversial notion, and it worried Gombrich and other scholars for whom the Period Eye invoked the *Zeitgeist* and all its ominous associations.[21] The Period Eye seemed to argue that the Italian Quattrocento was a unified psychological entity whose articulated, empirical entirety would define the explicit parameters of an historical period. Gombrich had uncategorically stated his views on such tendencies in *Art and Illusion*:

> I have discussed elsewhere why this reliance of art history on mythological explanations seems so dangerous to me. By inculcating the habit of talking in terms of collectives, of 'mankind', 'races', or 'ages', it weakens resistance to totalitarian habits of mind. I do not make these accusations lightly.[22]

Indeed, it was partly against just such explanations of various artistic styles that Gombrich had undertaken *Art and Illusion*. Gombrich's discussion of the 'Beholder's Share' in *Art and Illusion*[23] used what were then contemporary theories in experimental psychology to examine how the beholder projects when seeing.[24] In Gombrich's discussion, tradition and conventional codes or schemata are two fundamental factors determinative of the psychology of vision, and he examines the degree to which the viewer projects in concert with or by using the schemata.[25] Changes in styles are generated by technical innovations or subtle alterations of the conventional schemata, but the way in which Gombrich discusses these innovations is by observing artistic production as a practice sealed off from other social activities. It is, to use the title of another of his books, a 'story of art', and *only* of art, which radically dehistoricizes artistic transformations by locating them in an isolated and specialized practice.[26] One of the most distinguishing features of Baxandall's *Painting and Experience* is how it integrates painting by embedding it in a much greater number and broader range of social practices, activities removed from the world of visual art, though not removed from the world of visuality. But in doing so Baxandall had to confront the labyrinth of problems his project generated: the individual versus the collective, the innate versus the conditioned, and so on. It is worthwhile to examine some of his strategies.

After establishing the physiological universality of human ocular equipment at the beginning of the chapter on the Period Eye, Baxandall notes that this is where commonality between people ends, and the way each brain interprets or decodes impulses is variable.

21

It is at this point that the human equipment for visual perception ceases to be uniform, from one man to the next. The brain must interpret the raw data about light and colour that it receives from the cones and it does this with *innate skills and those developed out of experience.* It tries out relevant items from its stock of patterns, categories, habits of inference and analogy – 'round','grey', 'smooth', 'pebble' would be verbalized examples – and these lend the fantastically complex ocular data a *structure and therefore a meaning.*[27] [my italics]

Two elements of this passage have been emphasized. What is meant by *innate* skills? Is Baxandall talking about something strictly psychological (universal) or behavioural (conditioned)? The difficulty with the use of this term is that it suggests something *inherent* and *inborn* in the individual's mind, since he clearly states: '... innate skills *and* those developed out of experience'. The 'and' suggests that there are skills of two different orders here. There may be an attempt to map an escape from the prison-house of visual culture, but these 'innate' skills are ultimately too elusive to articulate and are therefore cast aside while those 'developed out of experience' are the ones ultimately elaborated.

The second emphasis on structure and meaning, however, is more manageable, and it is this structure and how it might lend meaning which is really what Baxandall is undertaking. Throughout, we note the tension developing between agency and collectivity, between individuality and society, and between intention and rote imitation. Baxandall invokes the individual:

But each of us has had different experience, and so each of us has slightly different knowledge and skills of interpretation. Everyone, in fact, processes data for the eye with different equipment ... yet in some circumstances the otherwise marginal differences between one man and another can take on a curious prominence.[28]

Then he shifts away from the individual, subtly invoking a group but concealing the shift by posing the problem as hypothetical:

Suppose the man looking at plate 13 [my plate 2] is well equipped with patterns and concepts of shape like those in plate 14 [my plate 3] and is practised in using them. (In fact, most of the people plate 13 [2] was originally made for were proud of being so equipped.)[29] [my italics]

Despite the emphasis on differences at the level of the individual, Baxandall has worked himself into a quandary, because while evoking difference at the level of the individual, he is working against the very thing he wants to posit here, and that is that there are differences between *cultures* and their mental 'equipment'. When he gets to the point of saying: 'Suppose a man is shown the configuration in plate 13 ...', he really – as is made clearer a page or two later – means to say: 'Suppose a man from a *certain culture* is shown the configuration in plate 13 ...' (my plate 2). The assumption is that a significant degree of intellectual and hence perceptual homogeneity exists among a group who share a culture or subculture,

2 From Michael Baxandall, *Painting and Experience*, p. 30, fig. 13. Santo Brasca, *Itinerario ...
di Gerusalemme* (Milan, 1481), p. 58 v, woodcut.

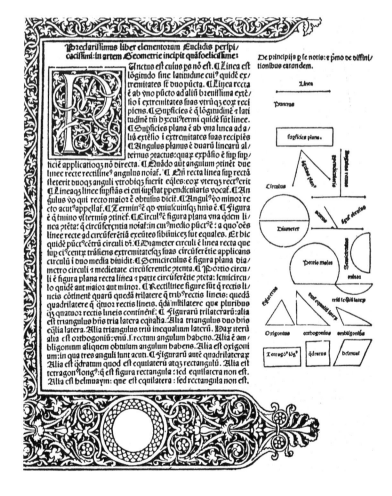

3 From Michael Baxandall, *Painting and Experience*, p. 31, fig. 14. Euclid. *Elementa geometriae*
(Venice, 1482) p. 2r, woodcut.

and that the skills and habits of that group operate in the unconscious as a sort of culturally regulated instinct.

Baxandall introduces his Period Eye chapter with the diagram reproduced here as plate 2.[30] He uses the diagram to talk about his version of cognitive style (a synonym for the Period Eye which he derived from anthropology and experimental psychology[31]) and points out that how one understands, what one *sees*, in this diagram is very much dependent upon 'the interpreting skills one happens to possess, the categories, the model patterns and the habits of inference and analogy ...'.[32] Baxandall posits that if a viewer is 'well equipped with patterns and concepts of shape like those at left [plate 3] and is practised in using them', they will tend to understand the diagram as a circle superimposed on a rectangle rather than, say, 'just as a round thing with projections'.[33] The tendentiousness of a certain way of seeing involved here is determined by experiences which elicit stock responses and valuations. Culture and social experiences programme the individual.

> So here are three variable and indeed *culturally relative* kinds of things the mind brings to interpreting the pattern of light plate 13 [2] casts on the retina: a stock of patterns, categories and methods of inference; training in a range of representational conventions; and experience, drawn from the environment, in what are plausible ways of visualizing what we have incomplete information about.[34] [my italics]

And later, an even more direct statement of his cultural relativism:

> ... some of the *mental equipment* a man orders his visual experience with is variable, and much of this variable equipment is culturally relative, in the sense of being determined by the society which has influenced his experience.[35] [my italics]

The use of the term 'mental equipment' echoes Panofsky in his *Gothic Architecture and Scholasticism*, where Panofsky desired to articulate

> a connection between Gothic architecture and scholasticism which is more concrete than a mere 'parallelism' and yet more general than those individual ... 'influences' which are inevitably exerted on painters, sculptors *etc* ... What I have in mind is a genuine cause-and-effect relation ... It comes about by the spreading of what may be called, for want of a better term, a *mental habit* ... Such mental habits are at work in all and every civilization.[36]

With these passages we are very much tempted to take note of Panofsky's 'mental habits' or *habitus*, and consider as well Lucien Febvre's *outillage mental*, or 'mental equipment'. To compare both of these to Baxandall, here is Febvre's comment in his book on Rabelais of 1942:

> Each civilization has its own mental tools; and furthermore, each epoch of a given civilization, each bit of progress, be it in techniques or sciences –

requires a renewed set of tools, more highly developed for certain needs, less for others.[37]

And Panofsky, on the structures of the scholastic *Summa*:

It was this technique of reconciling the seemingly irreconcilable, perfected into a fine art through the assimilation of Aristotelian logic, that determined the form of academic instruction ... Needless to say, this principle was bound to form a mental habit no less decisive and all-embracing than that of unconditional clarification.[38]

What unfolds in the Period Eye chapter of *Painting and Experience* are uniquely detailed considerations of several examples of socio-visual experiences which help form this mental equipment, and this is something which Febvre, at least, does not do in great detail. Roger Chartier, for example, finds Panofsky more sophisticated:

Febvre's notion of mental equipment differs in a number of ways from the idea that Panofsky developed at about the same time. First of all, the very word equipment (*outillage*) and the expression *outils mentaux* that Febvre sometimes used – which suggest the quasi-objective existence of a panoply of intellectual instruments (words, symbols, concepts, and so on) at the disposition of thought – contrast with Panofsky's manner of defining the mental habit, the group of unconscious schemes, of internalized principles that give their unity to an epoch's way of thinking no matter what the object of thought might be.[39]

Further, and this bears on our evaluation of Baxandall's method, Chartier also believes Panofsky's concept turns out to be more 'social' than Febrve. For Panofsky,

... mental habits point back to their conditions of inculcation, thus to be the 'habit forming forces' – for example, the institution of the school in its different modalities. From thence it is possible to understand, in the unity of their production, the homologies of structure existing among different intellectual 'products' of a given milieu and also to conceptualize the variations among groups as differences in systems of perception and appreciation, themselves issuing from differences in modes of education or formation.[40]

The above could easily be a description of Baxandall in *Painting and Experience* (or, for that matter, *Giotto and the Orators*) and it is in his elaboration of the Period Eye that Baxandall grounds the mental habits in the inculcation of social practices generated by individuals' relationship with their culture's institutions. The scope of Baxandall's inculcative factors is simply much broader than in Panofsky, and therefore provides us with a more detailed and, ultimately, a more convincing picture.

Because of this, however, there come moments in the book where Baxandall worries that his net is cast, sociologically, too widely, so he attempts to tighten the circle:

> One is not talking about all fifteenth-century people, but about those whose response to works of art was important to the artist – the patronizing classes, one might say. In effect this means a rather small proportion of the population: merchantile men, acting as members of confraternities or as individuals, princes and their courtiers, the senior members of religious houses.[41]

It is interesting to observe the care and eloquence with which Baxandall negotiates the snares inherent in the approach. He maintains a precarious balance by implicitly conceding, at key stages in the development of his argument, that a society may be thought of as groups with numerous subgroups or subcommunities, and that one may articulate ever more specialized and particularized groups until, theoretically, one arrives at the individual, unique and exceptional; embedded in, yet separate from, society. But of course a decision has to be made as to the orbit of attention, so Baxandall sets the parameters of his discussion within the group of persons – not necessarily of the same classes – who are likely to have had access to a range of 'generally accessible styles of discrimination'.[42] This range of shared visual experience is also a datum for the painter. As Baxandall puts it, the 'public's visual capacity must be his [the painters'] medium.'[43]

Given Baxandall's sophisticated elaboration of the Period Eye, one quite naturally asks to what ends the notion might be put, ends beyond the mere explaining of the styles of pictures. It is here where we might consider reasons why Pierre Bourdieu liked the Period Eye so much, since he, perhaps more that anyone else, appreciated the potentials of the concept. The earlier considerations of Panofsky and his concept of the *habitus*, indeed, also raises an intellectual historical bridge to Bourdieu, who adopted and reworked Panofsky's *habitus* into a much more complex and socially resonant paradigm. In terms of articulating a theoretical framework, Bourdieu offers insights into the kinds of problems inherent in Baxandall's elision of issues of domination and power[44] and offers several hints about how Baxandall's analyses might be pushed into wider, more inclusive discussions.[45] A synopsis of some key concepts of Bourdieu's will help reveal the reasons behind his warm reception of the Period Eye.

In a general sense, Bourdieu has been involved in developing a social theory of practice which has also been called 'generative structuralism'.[46] At the core is a concern for the reproductive aspects of culture and the relative roles institutions and agents play in this propagation. Two terms are central to Bourdieu's theory of practice: *habitus* and field (*champ*),[47] terms which Bourdieu uses generously in his introductory essay to the French translation of the Period Eye chapter mentioned previously.[48] Bourdieu's *habitus*, though adapted from Panofsky's use of the term, is more complex. The Bourdieuan *habitus* is a system of 'durable, transposable dispositions, structured structures predisposed to function as structuring structures, that is, as principles which generate and organize practices and representations'.[49] As Randal Johnson notes,

The *habitus* is sometimes described as a 'feel for the game' a 'practical sense' that inclines agents to act and react in specific situations in a manner that is not always calculated and that is not simply a question of conscious obedience to rules. Rather, it is a set of dispositions which generates practices and perceptions. The *habitus* is the result of a long process of inculcation, beginning in early childhood, which becomes a 'second sense' or a second nature.[50]

One can see in this a number of resonances with Baxandall, such as inclinations, dispositions and habits derived through training, experience, and formal education.[51] The concept of the field (*champ*) refers to the regulatory yet dynamic set of social relations within, say, the economic or educational field. The field is tied to and defined by the institution, and thus Bourdieu's attention to how institutions operate. For Bourdieu, the institution reproduces itself through forms of education and it is here that Bourdieu's concept of 'capital' comes into play. Bourdieu accepts a materialist view of capital as goods and products, but an equally important type of capital is 'symbolic capital' which works in concert with 'cultural capital'.

> Two forms of capital are particularly important in the field of cultural production. Symbolic capital refers to the degree of accumulated prestige, celebrity, consecration or honour and is founded on a dialectic of knowledge (*connaissance*) and recognition (*reconnaissance*). Cultural capital concerns forms of cultural knowledge, competences or dispositions.[52]

If we take these notions and apply them to some of the issues raised by Baxandall in *Painting and Experience*, we are able to see how they might locate themselves more directly in questions of social domination, and, indeed, why Bourdieu found Baxandall's elaboration of the Period Eye so congenial to his own concerns. For example, a 'Bourdieuan' reading of Baxandall might conclude that one reason so many people in Florence during the fifteenth century were taught the Rule of Three and gauging volumes 'by the eye' was because Florence was a banking centre and had a lively mercantile community which served as a hub for the products of the surrounding territory. The large and complex commercial and financial institutions of Quattrocento Florence generated fields in which people who lived there were obliged to operate. It was a game they more or less had to play and the dominant classes patronized the schools which trained groups of people in the types of skills which could be directly or indirectly exploited by the dominant classes.[53] Skilled labour becomes part of and partakes of the social infrastructure. A specific commercial and physical environment creates the need for a labour pool with certain competencies, institutions which reproduce those skills are created, and a populous with a definite range of aptitudes and values is generated and regenerated. The Period Eye, in Bourdieu's terms, would refer to the inculcative skills reproduced in the educational institutions (including apprenticeships, both secular and religious) which perpetuated the ideas, values and morals – that is to say the ideology – of those who controlled capital.

One of the only diachronic elements that Baxandall observes – in an otherwise elegant synchronic swathe through Quattrocento Florentine visual culture – is a shift from an appreciation of gold and high grades of blue in paintings to an appreciation of skill. This is a significant adjustment in Bourdieuan terms, for it is a translation from material to symbolic capital. The shift is exemplified by the waxing cultural capital of the painter, which works in concert with the cultural capital of the patron, who is able to appreciate or 'read' the new symbolic and cultural capital of skill in the works produced. It represents a reorientation of the terms, indeed the conceptual language, by which painters and patrons spoke to each other and was a central factor in the rise of the social status of the painter during the fifteenth century. If we consider the question of Albertian perspective, using a Bourdieuan conceptual frame, we see how it might not be simply a symbolic form in Panofsky's sense but a product of symbolic goods or symbolic capital. Since the execution of this type of perspective suggests a constellation of intellectual and executive skills, both in terms of the producer and viewer's skills (Euclidean geometry, mathematical proportion, high theory), we can see perspective as a common ground upon which Quattrocento people who shared these mathematical propensities could communicate and exchange symbolic goods. What we may conclude, then, is that what Baxandall articulates in the Period Eye chapter of *Painting and Experience* is very much a logical extension of his first chapter on economic relationships, rather than just supplementary to it. The economic (material) relationship becomes one of symbolic and cultural capital. A painting is not just a material object but, indeed, is art because it is overdetermined, one could say, since it partakes, represents and reproduces cultural capital. One might even speak of a 'pictorial excess' in characterizing the multiple meanings which might be generated by such considerations.

Although I have hoped that it might serve a clarifying purpose, there is admittedly an awkwardness in trying to get at certain potentials and inferences in *Painting and Experience* through notions elaborated by Bourdieu, since it is true that by deriving his problems from very closely defined parameters (visual skills of a certain class of early fifteenth-century urban Italians) Baxandall, by a perhaps necessary tactic of exclusion, skirts a number of problems central to his approach. By focusing on microsocial practices, macrosocial elements – ideological ones, for instance – are left either only vaguely defined or suppressed altogether. Bourdieu has attempted a synthesis of these macro- and microsocial elements. These problems are acknowledged, firstly, to affirm the critical problem of interpreting Baxandall through Bourdieu (something I have done for elucidation rather than to suggest a range of Baxandall's objectives, and of course to show why Bourdieu liked the book so much) and, secondly, to lead to aspects of the critical reception of *Painting and Experience* by some Marxist art historians who pounced on this very suppression of the social element that they were most interested in, the ideological.

The relationship between Leftist art historians and Baxandall was one of mutual frustration, with the art-historical Left taking him to task for circumventing any discussion of ideology. Instead of mining the methods of Baxandall's book for potential tools very adaptable to considerations of ideology, some chose to throw the baby out with the bathwater while, in turn, Baxandall

accused the Marxist camp of being narrow and attempting to close up the objectives of the discipline, of trying to create an art history which had only one purpose.

The best-known statements defining the interests and orientations of the new social history of art were made by T.J. Clark, first in his introduction to his *Image of the People. Gustave Courbet and the Second French Republic 1848–1851*,[54] and in a London *Times Literary Supplement* article.[55] Clark, perhaps more than anyone else at the time, was responsible for setting the parameters of interest for the social history of art.[56] Firstly, he made it clear that:

> ... I'm not interested in the social history of art as part of a cheerful diversification of subject, taking its place alongside the other varieties – formalist, 'modernist', sub-Freudian, filmic, feminist, 'radical', all of them hot-foot in pursuit of the New. For diversification, read disintegration.[57]

This passage, a little odd-sounding today, is distinctive in that it posits the pursuit of a social history of art as the only legitimate course in art-historical scholarship. The primary goal of exposing the ideological in that social history was made explicit when he stated that 'the work of art stands in a quite specific relation to ... ideological materials. Ideology is what the picture is, and what the picture is not.'[58] Clark makes clear in the *Times Literary Supplement* essay that representations are always a problem of ideological structures. He poses some fundamental questions for the new art history:

> The first kind of question has to do with the relation between the work of art and its ideology ... I mean by ideologies those bodies of beliefs, images, values and techniques of representation by which social classes, in conflict with each other, attempt to 'naturalize' their particular histories.[59]

The issue of ideology, then, is central to the definition of Clark's branch of the new art history, and it was to form the division between the Marxists and Baxandall, which was made explicit by Clark in 1976. It is worth quoting at length to get both the point and the tone.

> Our task is made the easier, I reckon, by one current fashion in the history of art. All the books, I mean – even as good a one as Michael Baxandall's – which have Art and Experience in their titles. *'Experience' being the code word for a kind of art history which feels the need to refer to those historical realities with which artist and patron are constantly in contact, but which dares not name those structures which mediate and determine the nature of that contact – ideology, class, the conflict of classes, the contradictions within any ideological view of the world.* So that 'Quattrocento man' floats safely somewhere above the 'churchgoing business man, with a taste for dancing' – the *actual* mover, who is referred to only to be conjured away. And several levels below, a whole host of Greeks ... medieval men and nineteenth-century Americans waits in the wings, ready to act out its part in a painless and absurd 'social history of

art'. Surely that soap opera cannot last long – at least, not for those who take the question of 'experience' seriously. After experience, ideology? Perhaps – but even that, remember, is a concept which could be recuperated, on its own.[60] [my italics]

Baxandall produces the best of what Clark sees as a unconscionable mode of scholarship. Clark's irritation here is not only that this type of work does not extend its discussions into the level of the ideological, but he suggests that it indeed plays an ideological role within art history that it does not recognize by naturalizing the concept of experience. But Clark's seemingly rigid adherence (seemingly, because his own art history was so much more intellectually flexible than these terse comments might indicate) to the aim of articulating the structures of ideology seemed at that time to offer little room for discussions of agency and the multi-directional and reciprocal nature of production and consumption without necessarily coming to conclusions about the ideological implications thereof.[61]

It is perhaps unfortunate that some on the Left dismissed *Painting and Experience*, for the germ of his method, whatever its conclusive shortcomings, offered a sophisticated resource for getting at the ideological.[62] Through this period most Marxists recognized numerous fundamental problems in the old formulations of ideology.[63] In the search for the patterns of the bourgeois political economy, Marx digressed, perhaps necessarily, on his own larger, original project of a unitary knowledge of society.[64] Marx and Engels's own early pronouncements in works like *The German Ideology* emphasized that the products of a culture are the products of living and that 'life is not determined by consciousness but consciousness by life.' For Marx, the 'production of ideas, of conceptions, of consciousness is at first directly interwoven with the material activity and the material intercourse of men, the *language of real life*'.[65] Recalling these notions from *The German Ideology*, and reading Baxandall's *Painting and Experience*, we find in Baxandall, I think, a useful account of practices, of how consciousness is enmeshed with material activity.

Painting and Experience also tangentially engages one of the fundamental problems of Marxist cultural criticism: that of the relations between base and superstructure. An impression of Baxandall's oblique yet significant contribution to these problems can be gained by noting some of the ideas elaborated by Raymond Williams in his 'Base and Superstructure in Marxist Cultural Theory' of 1973.[66] In dialogue with Althusserean revisions of the concept and mechanisms of ideology, Williams proposed an amended definition of superstructure as a reflection and preferred to adopt the notion of mediation, where the superstucture does not mirror the base, but is bound to the base through mediating activities and social practices.[67] The base is also not stable, rather it is in flux and characterized by processes and contradictions rather than being in a monolithic, determining state.[68] Williams sees Gramsci's notion of hegemony to be rich in possibilities:

> For hegemony supposes the existence of something which is truly total, which is not merely secondary or superstructural, like the weak sense of ideology, but which is lived at such a depth, which saturates the society to

such an extent, and which, as Gramsci put it, even constitutes the limit of common sense for most people under its sway, that it corresponds to the reality of social *experience* very much more clearly than any notions derived from the formula of base and superstructure.[69] [my italics]

In some respects, *Painting and Experience* can be seen as articulating a range of practices making up the hegemony of visual culture in quattrocento Italy.

Crucial too are Williams's comments on 'experience', not only in the quote above but in the following:

[hegemony] is a whole body of practices and expectations ... it is a set of meanings and values which as they are *experienced* as practices appear as reciprocally confirming. It thus constitutes a sense of reality for most people in the society, a sense of absolute because *experienced* reality beyond which it is very difficult for most members of the society to move ...[70] [my italics]

Baxandall articulates the first part of 'experience' but does not, as Williams does, go the extra step to suggest that this 'experienced reality' is a limit 'beyond which it is very difficult for most members of the society to move'. Baxandall's work presents 'experience' as constitutive of pictures and vice versa, but this constitution is otherwise seen as natural, the very point of departure for Marxists. What Baxandall articulates is the formation of 'experience' and the practices which revolve around visual culture, but, otherwise, 'experience' does not *do* anything, one just experiences it. In other words, experience is naturalized and is not moderated by issues of class or power.

Yet the parameters of experience and practice that Baxandall articulates do represent an example of the deep structural kind of social analysis which leads one up to the doorstep of any deep readings one might want to make of the workings of power and ideology in fifteenth-century Florence. To harry Baxandall for not pressing conclusions about power in society misses the fundamental purpose of the book, that it is a tool, a primer for the analysis of synchronic visual culture from which one is meant to move on in whatever direction one wishes.

As we look back from our present postmodern perspective, the early negative criticisms of the Period Eye from within art history seem neither to have been strongly heeded nor widely held, while the anthropological and sociological points of view exemplified by Geertz and Bourdieu, and echoed in Baxandall, seem to have been embraced. The generally positive responses from within art history, then, mark a moment when the discipline was clearly amenable to taking an anthropological turn, and was also keen, in the long run, to adopt a kind of depoliticized point of view regarding the analysis of visual culture. The adoption of the visual culture model finds its parallels in other disciplines as well, as do the failures of 1970s' Marxism,[71] and one might also keep in mind that this is also the time of the rise of cultural studies. In hindsight, it seems more appropriate to classify *Painting and Experience* as a cultural studies primer on visual art than as an art history book. It is interesting also to consider how the book and its receptions inflected Baxandall's subsequent work. Like Raymond Williams for

literature and Marxism and Stuart Hall for Cultural Studies, Michael Baxandall became both provocative gadfly and watchful guardian to the practice of art history.

Allan Langdale

Notes

1 Clifford Geertz, 'Art as a Cultural System', *Modern Language Notes*, vol. 91, 1976, pp. 1473–99. In the same year Enrico Castelnuovo published an article on the social history of art in Bourdieu's *Actes de la recherche en sciences sociales*, where Baxandall was included, positively, within what now seems the unlikely constellation of Antal, Hauser, Klingender, Schapiro and others. See Enrico Castelnuovo, 'L'histoire sociale de l'art', *Actes de la recherche en sciences sociales,* vol. 6, December 1976, pp. 63–75.

2 Michael Baxandall, 'L'oeil du quattrocento', *Actes de la recherche en sciences sociales,* vol. 4, November 1981, pp. 10–49. And the introductory essay by Pierre Bourdieu and Yvette Desault, 'Pour un sociologie de la perception', pp. 3–9.

3 See Timothy J. Clark, 'Preliminary Arguments: Work of Art and Ideology', in *Papers Presented to the Marxism and Art History Session of the College Art Association Meeting*, Chicago, Feb. 1976, p. 5. See also Adrian Rifkin, 'No Particular Thing to Mean', *Block,* vol. 8, 1983, p. 36; and critiques of *Painting and Experience* in Tom Cummins, Deborah Weiner and Joan Weinstein, 'Le rôle de l'historien d'art marxiste dans un société capitaliste', *Histoire et critique des arts,* vols. 9–10, 1979, pp. 97–102.

4 The paper was published in a special section of the *Modern Language Notes*, vol. 91, 1976, which reprinted a number of essays from The Charles Sanders Peirce Symposium on Semiotics and the Arts. Other contributors included Umberto Eco, Thomas A. Seboek and Lionel Gossman.

5 Claude Lévi-Strauss, 'A Native Community and its Life-Style', in *Tristes Tropiques*, trans. John and Doreen Weightman, New York, 1984 (original 1955), p. 178. A related essay is Claude Lévi-Strauss, 'Split Representation in the Art of Asia and America', in *Structural Anthropology*, trans. Claire Jacobson and Brooke G. Schoepf, New York & London, 1963, pp. 245–68.

6 In this article the author concentrates on aspects of social hierarchy and connections through marriage. He writes: '... the asymmetry of the classes was, in a sense, counterbalanced by the symmetry of the moieties'. See Lévi-Strauss, *Tristes Tropiques*, op. cit. (note 5), p. 196.

7 ibid., pp. 196–7.

8 Recall Plato's *pharmakon* and Derrida's deconstruction. The notion is interesting in this case where we have a culture without written language. In this case, do the facial tattoos serve some function like that of a written language? A graphic 'language' which operates as a 'remedy' to certain collective anxieties?

9 Lévi-Strauss, *Tristes Tropiques*, op. cit. (note 5), pp. 196–7. The original French terms may be found in Claude Lévi-Strauss, *Tristes Tropiques*, Paris, 1955, p. 203.

10 Geertz, op. cit. (note 1), p. 1488. Here is a clear critique of Lévi-Strauss.

11 See M.H. Segal, D.T. Campbell, and Melville J. Herskovits, *The Influence of Culture of Visual Perception*, Indianapolis, 1966. Herskovits was interested in applying psychological studies on what was called 'cognitive style'. Baxandall used this terminology synonymously with Period Eye.

12 ibid., p. v.

13 ibid., p. 5.

14 A view which they also saw as the root of ethnocentrism, which is an ironic turn on Gombrich, who saw relativism as a contributing factor in the very same type of thing. See quote on page 483 above from Gombrich, *Art and Illusion*, (2nd ed.), New York, 1961, p. 20.

15 Precursors of these types of studies include the work of Franz Boas, Bronislaw Malinowski, and A.I. Hallowell. See, for example the account of Boas by one of his followers, Ruth Benedict, 'Franz Boas as an Ethnologist', in *Franz Boas, 1858–1942, Memoirs of the American Anthropological Association*, new series, no. 61, 1943. Also A.I. Hallowell, 'Cultural Factors in the Structuralization of Perception', in *Social Psychology at the Crossroads*, J.H. Rohrer and M. Sherif (eds), New York, 1951, pp. 164–95; and by the same author *Culture and Experience*, Philadelphia, 1955.

16 M.H. Segal, D.T. Campbell, and Melville J. Herskovits, op. cit. (note 11), p. 84. The notion might well be used to hypothesize that the discovery of linear perspective was bound to happen in a culture that used accurate surveying and carpentry tools and where the physical environment was urbanized. That is to say, a location where right angles dominated the built environment and therefore the visual field.

17 Some of the early structural anthropology of

Claude Lévi-Strauss bears more than a few similarities to the work of Herskovits and his followers, but Lévi-Strauss focused to a much greater degree on the exposure of parallel systems or patterns of representation, with far less attention to psychological processes involved in perception. Baxandall claims not to have known much about Structuralism at the time of the production of *Giotto and the Orators* [Michael Baxandall, *Giotto and the Orators: humanist observers of painting in Italy and the discovery of pictorial composition, 1350–1450*, London, 1971] and *Painting and Experience*. Even so, he recalls hearing a talk by Lévi-Strauss and notes that he was close friends with several anthropologists in London, such as Jack Goody and Peter Ucko, who were sympathetic to French Structural Anthropology. See Baxandall interview, Appendix I in Allan Langdale, 'Art History and Intellectual History: Michael Baxandall's Work between 1963 and 1985', unpublished PhD dissertation, U.C. Santa Barbara, 1995, pp. 372–3 (hereafter Baxandall Interview).

18 Michael Baxandall, *Painting and Experience in Fifteenth-Century Italy: a primer in the social history of pictorial style*, Oxford, 1972, p. 1.

19 ibid.

20 ibid., p. 2.

21 A review outlining these concerns was Ulrich Middeldorf, review of Michael Baxandall's *Painting and Experience in Fifteenth-Century Italy* in *Art Bulletin*, vol. 57, no. 2, June 1975, pp. 284-5. Baxandall commented on Gombrich's suspicious reaction in an interview in 1994. Baxandall Interview, p. 346. See also pp 364–5.

22 Gombrich, op. cit. (note 14), p. 20.

23 ibid., pp. 181–287.

24 Especially the theories of Adelbert Ames and his followers, as well as J.J. Gibson, *The Perception of the Visual World*, Boston, 1950. For comments on Gombrich's use of Amesian perceptualism, see the review by the perceptual psychologist John Beloff, 'Some Comments on the Gombrich Problem', *British Journal of Aesthetics*, vol. 1, no. 2, March 1961, p. 64. See also the objections in Rudolf Arnheim's review in *Art Bulletin*, vol. 44, no. 1, March 1962, pp. 75–9. See especially pp. 77–8.

25 For an attack on the logic of the schemata, as well as other concepts argued by Gombrich in *Art and Illusion*, see the review by Richard Wollheim, 'Art and Illusion' *British Journal of Aesthetics*, vol. 3, no. 1, January 1963, pp. 15–37. See especially pp. 21–3.

26 Perry Anderson, 'Components of the National Culture', *New Left Review*, vol. 50, July/August 1968, p. 39. See also the extensive critique of Gombrich's ideas and method in Norman Bryson, *Vision and Painting. The Logic of the Gaze*, New Haven and London, 1983.

27 Baxandall, op. cit. (note 19), p. 29. The position is ultimately Kantian. I do not give an overview of the philosophical history of these notions, but I refer the reader to the introduction of Michael Ann Holly, *Panofsky and the Foundations of Art History*, Ithaca and London,1984, pp. 21–45.

28 Baxandall, op. cit. (note 18), p. 29.

29 ibid., p. 30.

30 ibid. Baxandall's discussion of the diagram parallels in some respects the famous duck-rabbit drawing dealt with by Gombrich in *Art and Illusion* and, not unimportantly, Wittgenstein in his *Philosophical Investigations*, trans. G.E.M. Anscomb, New York, 1953, p. 194e.

31 A good overview of related methods can be found in Kenneth M. Goldstein and Sheldon Blackman, *Cognitive Style. Five Approaches and Relevant Research*, New York, 1978. See Baxandall Interview, p. 12. In *Painting and Experience* Baxandall cites H. A. Witkin's 'A Cognitive Style Approach to Cross-Cultural Research', *International Journal of Psychology*, vol. 2, 1967, pp. 233–50.

32 Baxandall, op. cit. (note 18), pp. 29–30.

33 ibid., p. 30.

34 ibid., pp. 31–2.

35 ibid., p. 40.

36 Erwin Panofsky, *Gothic Architecture and Scholasticism*, Cleveland and New York, 1967 (original 1951), pp. 20–1.

37 This translation is from Roger Chartier, 'Intellectual History or Sociocultural History? The French Trajectories', in *Modern European Intellectual History: Reappraisals and New Perspectives*, Dominick LaCapra and Steven L. Kaplan (eds), London and Ithaca, 1982, pp. 18–19. See Lucien Febvre, *Le problem de l'incroyance au XVIe siècle. La religion de Rabelais*, Paris, 1968, pp. 141–2. Chartier also comments on this aspect of Febvre: 'What defines mental equipment in these pages is the state of language, its lexicon, its syntax, the scientific language and instruments, and also the "sensitive support of thought" represented by the system of perception, whose variable economy determines the structure of affectivity.' See p. 19.

38 Panofsky, op. cit. (note 36), pp. 67–8.

39 See Chartier, op. cit. (note 37), pp. 20–1.

40 ibid., p. 21. See the somewhat hedging criticism of Panofsky in Meyer Shapiro's, 'Style', in A.L. Kroeber (ed.), *Anthropology Today: An Encyclopedic Inventory*, Chicago, 1953, pp. 305–306, where Shapiro writes: 'The attempts to derive style from thought are often too vague to yield more than suggestive *aperçus*; the method breeds analogical speculations which do not hold up under detailed critical study. The history of the analogy drawn up between the Gothic cathedral and scholastic theology is an example ... Yet one hesitates to reject such analogies in principle, since the cathedral belongs to the same religious sphere as does contemporary theology.'

41 Baxandall, op. cit. (note 18), pp. 38–9. Baxandall also mentions that there is also a probable variation in this group as to profession, such as physicians 'trained ... to observe the relations of member to member of the human body as a means to diagnosis', p. 39.

42 ibid., p. 40.

43 ibid.

44 It should be noted that other sociologists, who, like Bourdieu, are indebted to Durkheim and Weber (such as Anthony Giddens and Erving Goffman) could have been used to compare with the 'sociological' aspects of *Painting and Experience*. Bourdieu's concepts, however, offer richer resonances.

45 My account is derived mostly from essays in Richard Harker, Cheleen Mahar and Chris Wilkes (eds), *An Introduction to the Work of Pierre Bourdieu*, London, 1990; Derek Robbins, *The Work of Pierre Bourdieu: Recognizing Society*, Boulder and San Francisco, 1991. See also the informative introduction by Randal Johnson in Pierre Bourdieu, *The Field of Cultural Production. Essays on Art and Literature*, ed. Randal Johnson, New York, 1993, pp. 1–25. For a recent bibliography citing several overviews of Bourdieu's work, see p. 268, note 3 of Johnson's book.

46 *An Introduction to the Work of Pierre Bourdieu*, op. cit. (note 45), p. 3. There are some important levels of overlap with Bourdieu's theory of practice and Anthony Giddens's 'structuration theory'. For Giddens, see *The Constitution of Society. Outline of the Theory of Structuration*, Berkeley and Los Angeles, 1984. Giddens' central interest, like Bourdieu's, is to attempt a viable reconciliation between agency and structuralism.

47 See Pierre Bourdieu, 'The Genesis of the Concepts of Habitus and Field', trans. Channa Newman, *Sociocriticism*, vol. 2, December 1985, p. 5–20.

48 Pierre Bourdieu and Yvette Desault, op. cit. (note 2), pp. 3–9. Introductory article to Michael Baxandall, 'L'oeil du quattrocento', op. cit. (note 2), pp. 10–49.

49 Bourdieu, op. cit. (note 48), p. 14.

50 Johnson's introduction in Bourdieu, op. cit. (note 45), p. 5. Bourdieu also uses the term 'mastery' (*maitrise*) to refer to the 'practical mastery which people possess of their situations ...' See Robbins, op. cit. (note 45), pp. 141–8.

51 Pierre Bourdieu and J.-C. Passeron, *Reproduction in Education, Society and Culture*, London, 1977 (original 1970). For an account, see Richard Harkar, 'Bourdieu–Education and Reproduction', in *An Introduction to the Work of Pierre Bourdieu*, op. cit. (note 45), pp. 86–108.

52 Johnson's introduction in Bourdieu, *The Field of Cultural Production. Essays on Art and Literature*, op. cit. (note 45), p. 7.

53 The field of the academic is examined in Pierre Bourdieu, *Homo Academicus*, Cambridge, 1988.

54 Timothy J. Clark, *Image of the People. Gustave Courbet and the Second French Republic 1848–1851*, Greenwich, Conn., 1973, pp. 9–20. In the next year Clark published *The Absolute Bourgeois*, London, 1974.

55 Clark, 'The Conditions of Artistic Creation', *Times Literary Supplement*, 24 May 1974, pp. 561–2.

56 O.K. Werckmeister was also a central figure. See his 'Marx on Ideology and Art', *New Literary History*, vol. 4, no. 3, Spring 1973, pp. 501–519. Significant for its generally negative critical reception, even among Marxists, was Nicos Hadjinicolaou's *Art History and Class Struggle*, trans. Louise Asmal, London, 1978, which was originally published in French in 1973. See the review by Alan Wallach, 'In Search of A Marxist Theory of Art', *Block*, vol. 4, 1981, pp. 15–17. Another figure in the debates was Kurt Forster. See his 'Critical History of Art or Transfiguration of Values?' *New Literary History*, vol. 3, no.3, 1972, pp. 459–70. See as well John Tagg, 'Marxism and Art History', *Marxism Today*, vol. 21, no. 6, June 1977, pp. 183–92.

57 Clark, 'The Conditions of Artistic Creation', op. cit. (note 55), p. 562.

58 ibid., p. 561.

59 The work of art, in this structure, is directly linked to the fundamental relationship between classes. Clark, op. cit. (note 55), p. 562. See also T.J. Clark, *The Painting of Modern Life: Paris in the art of Manet and his followers*, New York, 1984, pp. 7–8.

60 Clark, 'Preliminary Arguments: Work of Art and Ideology', op. cit. (note 3), p. 5. See also Rifkin, op. cit.(note 3), p. 36. Clark and Baxandall are similarly juxtaposed – to the benefit of Clark – in Tom Cummings, Deborah Weiner and Joan Weinstein, 'Le rôle de l'historien d'art marxiste dans un société capitaliste', op. cit. (note 3), pp. 97–102. This article's authors seem to share Clark's views; for them, the economic is the only crucial realm in which 'ideology' operates. Adrian Rifkin criticizes Gombrich and Baxandall together in 'Can Gramsci Save Art History?' *Block*, vol. 3, 1980, pp. 38–9.

61 With the publication of *The Painting of Modern Life* critiques of Clark's method were forwarded by Marxists as well as conservative art historians. For the range, from Left to Right, see these reviews: Klaus Herding, 'Manet's Imagery Reconstructed', *October*, vol. 37, Summer 1986, pp. 113–24; Adrian Rifkin, 'Marx' Clarkism', *Art History*, vol. 8, no. 4, December 1985, pp. 488–95; section from Richard Schiff 'Art History and the Nineteenth Century: Realism and Resistance', *Art Bulletin*, vol. 70, no. 1, March 1988, pp. 44–8; and, finally, Hilton Kramer's reactionary response in 'T.J. Clark and the Marxist Critique of Modernist Painting', *The New Criterion*, vol. 3, no. 7, March 1985, pp. 1–8.

62 Professor Clark, however, has said that, in many ways, Marxist art historians did not ultimately dismiss this book, and his own *Painting of Modern Life* was partly a response to problems and issues generated by *Painting and Experience*. This comment was made in Professor Clark's capacity of a respondent to my paper given at the Getty Center in November of 1996, 'The Rise and Fall of the Social History of Art'.

63 See the section 'The Poverty of Ideology' in Alex Callinicos, *Marxism and Philosophy*, Oxford, 1983, pp. 127–36. See also Keith Moxey, 'Ideology' chapter in *The Practice of Theory: Poststructuralism, Cultural Politics, and Art History*, Ithaca and New York, 1994, pp. 41–50. Moxey gives a brief survey which, unfortunately, does not mention Gramsci.

64 There are many positions regarding how Marx is used by historians; whether, for example, the 'key' to Marx, or the 'true' Marx, is to be found in the early or late writings. Althusser identified what he called an 'epistemological break', a 'rupture' in Marx in his attempt to locate a 'true' Marx. See Dominick LaCapra, *Rethinking Intellectual History: Texts, Contexts, Language*, Ithaca and London, 1983, p. 326.

65 I here depend on Perry Anderson's observations on Marx and on the revisionary work of Edward Thompson, particularly his *The Poverty of Theory and other Essays*, London, 1978. See Perry Anderson, *Arguments Within English Marxism*, London, 1980, p. 59.

66 Raymond Williams, 'Base and Superstructure in Marxist Cultural Theory', *New Left Review*, November/December 1973, pp. 3–16.

67 ibid., p. 5. See, as well T.J. Clark's later comments on ideology in *The Painting of Modern Life*, op. cit. (note 59), p. 8.

68 Williams, op. cit. (note 66), pp. 5–6.

69 ibid., p. 8.

70 ibid., p. 9.

71 Yet a recent experience of mine is surely played out many times in the art-historical world. A Marxian friend of mine got a job and was given the task of teaching Italian Renaissance art which was not really his field. He called me for suggested texts. '*Painting and Experience*,' I said. 'Obviously,' he replied, 'but what else?'

Limewood, Chiromancy and Narratives of Making. Writing about the materials and processes of sculpture

Malcolm Baker

Among the sculptures for which the curator, Michael Baxandall, was responsible at the Victoria and Albert Museum during the mid-1960s was a small boxwood figure of St George (plate 4). A carving of insistent virtuosity, it combines late Gothic-style drapery of the sort that the sometime curator was later to characterize in *The Limewood Sculptors of Renaissance Germany* as 'florid', with an Italianate pose that, using other examples, he was to describe as 'a rather flashy way of standing with the feet together, one leg carrying the weight and the other elegantly bent, "like a stork"'.[1] Executed in boxwood (not limewood) probably around 1520 by a Netherlandish-trained (but not necessarily South German) sculptor, this might seem a visually arresting but inappropriate image with which to begin an essay about Baxandall's writings on sculpture, most notably the *Limewood Sculptors* book.[2] But to confront this piece since the publication of Baxandall's book means approaching it with a heightened sense of the possible ways of viewing sculpture as well as of verbalizing our experience of viewing it. In particular, a consideration of the St George figure illustrates how Baxandall's work challenges us to approach a sculpture's material and facture in a new way.

As well as observing the virtuosity of drapery carving, we need to look at the way in which this contrasts so markedly with what we see on the back (plate 5). Mentioned in only one discussion in the considerable literature on the piece, the 'reverse' (for it is very much a sculpture with a front and a back) is not arbitrarily formed and demands attention from a modern viewer, as from a sixteenth-century spectator. While the piecing of the different component parts is masked at the front, our attention is drawn at the back to the joins between them by the way that some parts are left with their bark on while others are not. A glance at the back leaves us in no doubt that this is an assembled piece, perhaps made so as to demonstrate before the viewer's eyes the carver translating nature into art.[3] But to see this as significant – to follow, as it were, the narrative of the piece's making that is being related here – assumes a familiarity on the part of the viewer with the material and the ways in which it might be carved, assembled and treated. My concern here is to explore the ways in which Baxandall brings this issue to the fore and in the process prompts us to reconsider familiar modes of writing about materials and processes. In addressing this issue my aim is to draw attention to an aspect of Baxandall's work that has received far less attention than his approach to issues closer to the interests of a theorized art history.

Responses to *Limewood Sculptors*

One constant preoccupation within Michael Baxandall's work has been with modes of writing about visual experience. In *The Limewood Sculptors of Renaissance Germany* he addresses the question of how to write about a category of visual culture that lacks any contemporary descriptive or critical terms that can be appropriated in the way so familiar in art-historical writing about Italian art. Beginning with a recognition that 'We need terms', he offers us some, albeit in a tentative yet carefully judged manner, his tone alerting us to their limitations and inappropriateness.[4] These terms include not only words used by the contemporaries of Riemenschneider and Stoss to describe 'cognate activities' but also many that are characteristically his own.

In *Patterns of Intention* he comments that 'we explain pictures [and presumably sculptures too] only in so far as we have considered them under some verbal description or specification.'[5] In accord with this observation, a concern with language and the possibilities that 'terms' offer as alternative modes of approach, each tentative and oblique, to images, is central to *The Limewood Sculptors*. The choice of a category of material that, despite being the subject of a vast art-historical literature, could not be contextualized easily through direct reference to any tradition of contemporary description provided an opportunity to lay bare a continuity between Vasarian accounts and modern art history, a continuity that had become so familiar within other areas of the discipline as to be almost unrecognizable, or at least seemingly unavoidable. By offering an alternative model to this, Baxandall's *Limewood Sculptors* has had a resonance far beyond the rather restricted field of late Gothic German sculpture studies. The very unfamiliarity of the material and the lack of any accompanying language, other than that used by German art historians and practitioners of *Stilkritik*, made it ideal as a case study in which to explore in a sustained and detailed manner those questions about the language of art history that Baxandall has discussed, and continues to discuss, in a more abstract and less extended manner elsewhere.[6] As such, his *Limewood Sculptors* has proved a highly influential model.[7]

For many specialists working on South German wood sculpture of this period, on the other hand, the book's approach was not only oblique and idiosyncratic but difficult to relate to modes of inquiry primarily concerned with issues of attribution. Even by the late 1980s it remained, in Willibald Sauerländer's words, 'an exotic outsider full of unexpected suggestions' that had yet to be 'intellectually digested by the traditional inhabitants of the Late Gothic woods'.[8] Indeed, the late Jörg Rasmussen, who in a paper on Veit Stoss was perhaps the only German scholar in the field to have made use of Baxandall's approach, found himself asked if he was abandoning art history for journalism.[9] Yet, for those working outside this field, it not only gave what was formerly considered a peripheral, if complex, artistic category a new interest and significance, but prompted a widespread realignment of thinking about non-Italian and, more specifically northern, art. Like Svetlana Alpers's *The Art of Describing* in the field of seventeenth-century Netherlandish art, Baxandall's *Limewood Sculptors* has provided a central focus for debates about how northern art might be interpreted and has often been seen as offering a paradigm in the place of that provided by Panofsky's *Early Netherlandish Painting*.[10]

4 *St George*, boxwood, Netherlandish (?), *c.*1520. Victoria and Albert Museum, London.

The model offered by Baxandall, however, is of relevance not only for those concerned with northern art but far more widely. By writing with such subtlety and tact about the historical circumstances in which these sculptors worked and with equal sensitivity and closely observed precision about the sculptures themselves, Baxandall brought the two terms of art and society into a new and complex relationship with each other. As Thomas Puttfarken commented, 'Baxandall's account registers ... the complexity of history, the variety of

5 *St George* (back).

circumstances within which artists worked; it does not *explain* effects by reference to their causes.'[11] The *Limewood Sculptors* at once offered us an exemplary case study in cultural history and showed us how complex and ambitious such an undertaking was. While being one of the most admired art-historical texts of the past quarter century, it has also proved to be one of the hardest to imitate or emulate. In this respect it occupies a distinctive position in Baxandall's work. It differs markedly from his most frequently cited writings, such as *Patterns of Intention* or 'The language of art history' (see appendix, page 591), which deal

explicitly with abstract methodological issues, albeit in a distinctive way, enlivened and sharpened by the acute use of specific examples. While such methodological concerns are constantly being addressed in the *Limewood Sculptors*, this is done implicitly rather than explicitly. What we are offered here is an empirical study of 'a school of wood-carvers that blossomed in southern Germany between 1475 and 1525', involving a remarkably wide range of evidence and conceived on an impressively ambitious scale. More importantly, however, it is an empirical study conducted within an interpretive framework that demands on the part of the reader as well as of the author a constant reconsideration of the way we are looking, thinking and writing about a culturally specific phenomenon, a series of works and the economic and social circumstances registered in their production.

Developing an interpretive strategy employed in a less ambitious way in *Painting and Experience in Fifteenth-Century Italy* – he modestly subtitles it a 'primer' – and drawing on his earlier publications about particular sculptures, including his article in the *Münchner Jahrbuch* on 'Hubert Gerhard and the Altar of Christoph Fugger', Baxandall examines the specificities of what for most English-speaking readers remains an unfamiliar category of art production and a set of social, economic and devotional practices that were operative within an alien culture. Just as striking as the tact and subtlety with which he employs, usually without theoretical glossing, a complex series of interpretive approaches – strategies that are acknowledged to be imprecise or schematic – is the sustained and careful examination of particular works. The techniques and thinking of the writer on the language of art are here entwined with those of both the cultural historian and the curator.

Nowhere is this combination of close empirical engagement with the specific, on the one hand, and subtle interpretive strategy, on the other, more tellingly used than in Baxandall's discussion of the physical material of the sculpture and the processes involved in its design and making. If the use of 'Renaissance Germany' in the title might be understood to signal his concern with a set of specific cultural conditions in which the sculpture was produced, the term 'Limewood Sculptors' might be seen as registering the centrality in Baxandall's project of the material and the physical activity of making the sculpture with which he is concerned. Yet despite the emphasis on the material of sculpture in the title and, still more significantly, the awareness of the importance of sculptural technique shown not merely in a single chapter but throughout the book, this aspect of *Limewood Sculptors* has received very little attention. This essay sets out to examine the way in which Baxandall has considered the material and technical processes of sculpture, to discuss the relationship of his writing about this subject with other modes of writing about sculptural technique and to suggest the potential implications of Baxandall's approaches for the interpretation of sculptural practice and the viewing of sculpture.

One approach to assessing the book's significance might be to sketch out the circumstances in which it was produced and the way in which it draws on a less well-known aspect of the author's professional and intellectual activity.[12] To put it in less biographical terms, we might see in the book the use of a tradition of art-historical scholarship that draws less on debates within the academy than on the

working experience of a museum curator. While there was probably more interchange between art-historical scholarship within museums and that within universities and more shared interests thirty years ago, Baxandall's work frequently crosses this divide in the way it constantly plays between the empirical and the theoretical, the rhetorical and material.[13] Certainly it is clear how the concern with contemporary descriptive terms (and their absence) that runs throughout the *Limewood Sculptors* was continued from Baxandall's first book, *Giotto and the Orators*. On the other hand, the engagement with questions of material and technique in sculpture, that also runs through *Limewood Sculptors*, draws, as does the catalogue section, on Baxandall's experience as an Assistant Keeper in the Department of Architecture and Sculpture. Appointed by John Pope-Hennessy who, even as Director, continued to take responsibility for the collection of the Italian sculpture, Baxandall was encouraged to turn to the area of South German sculpture by the Keeper, Terence Hodgkinson. Taking this opportunity to familiarize himself with the Museum's collection, the holdings of the major German museums and the key works that remained *in situ*, as well as the vast specialist literature, he then went on to write short museum publications on German boxwood statuettes and South German sculpture and so map out the territory to be explored in the *Limewood Sculptors*.[14] Some hint of his approach and of the potential that the subject offered is already apparent in the article on Gerhard's Fugger altarpiece (plate 6), which has the subtitle, 'The Sculpture and its Making'.[15]

The Fugger article deals with a group of eight gilt bronze figures and a relief that were bequeathed to the Museum in 1964. These were identified as the main figurative components from an altarpiece produced in 1581–82 as a memorial to Christoph Fugger in the Dominican church of St Magdalena in Augsburg and last recorded when the church was secularized in 1807. This ensemble is important in part because the financial transactions relating to the casting of the 'bronzes' – they are brass rather than bronze – is meticulously tracked in the Fugger archives, making this the most detailed account of casting processes other than that given by Cellini in his *Autobiography*. Baxandall's aim in his article was 'mainly to make the sculpture and the account book jointly accessible for the sake of the light they together throw on the method of copper-alloy sculpture in late sixteenth-century Germany'. Modest though this might seem, his discussion is perhaps the most informative account of casting procedures available anywhere and deserves to be much more widely used than it is. What is interesting here, however, is the way that it not only works between documents and artefacts so as to construct a descriptive, narrative account of the sculpture's making but does so in a manner that hints at other possible approaches to material and process. When he comments, for instance, that the 'narrative centre of the account-book is therefore a mismatch between an Italianate mould and Augsburg methods of crucible-casting',[16] he was already signalling the way in which documents need to be regarded themselves as forms of representation and that any account based on them and the sculptures to which they relate is itself a constructed narrative.

In hinting in this way at how sculptural technique might be considered and in offering some terms in which it might be discussed, Baxandall was already enlarging the scope of what had usually been a resolutely empirical mode of

6 Hubert Gerhard, *The Resurrection*, gilt bronze relief from the Fugger Altar, 1581–82. Victoria and Albert Museum, London.

inquiry. In the *Limewood Sculptors* both the close observation of artefacts in all their materiality and the careful analysis of documentary evidence remain striking features, but the limits of the empiricism are stretched even further. In doing this, Baxandall draws on a long tradition of writing about sculptural technique while at the same time – at least implicitly – challenging and expanding it in a way that has not been widely appreciated.

Writing about the materials of sculpture

Before considering Baxandall's mode of engagement with issues of process and material in *Limewood Sculptors*, I shall look briefly at some other examples of writing about the techniques of sculpture, so providing a framework into which Baxandall's writing might be placed. The two most often cited accounts of technical procedures and materials employed by South German sculptors around 1500 are those by Wilm and Huth. Wilm's book, first published in 1923, is written from the standpoint of a restorer and collector.[17] His account of how limewood figures were hollowed, carved and polychromed is based on a first-hand knowledge of many individual pieces, many of which had been on the German art market. Huth's study, on the other hand, rested, above all, on the archival sources, mainly contracts which were gathered together in a very substantial appendix.[18] As a glance at the illustrations will make clear, the preliminary drawings (*Risse*), which were often attached to these contracts, receive as much attention here as the sculptures themselves. More recently, the work of conservators trained to follow more systematic and scientific procedures have produced detailed analyses of different types of polychromy and the treatment of the various woods and the profiles of the chisel employed.[19]

These various approaches to the materials and techniques used by the sculptors of Renaissance Germany need to be considered within the context of a wide range of texts about sculptural technique and practice. Although art history's literatures have been given much attention, especially over the past decade, the focus of this interest has consisted primarily of either the conventions used for artists' lives or the ways in which histories have been constructed within such texts.[20] The modes and conventions employed in writing about materials and techniques, particularly those of sculptors, has, to my knowledge, never been examined in any detail.

A significant proportion of the literature about sculptural processes is made up, unsurprisingly perhaps, of manuals for potential practitioners or digests of material from such manuals for wider lay readership. Among the former are works such as Edouard Lanteri's *Modelling: a guide for teachers and students* (1901–11) and more recent popular 'how-to-do-it' books, while the latter includes Félibien's 1690 treatise on sculpture and its less elevated successors.[21] The dominant model here is usually an arrangement according to materials, recalling that used by Pliny in Books XXXIV–XXXVII of his *Natural History*.[22] A focus on particular materials has long been the norm in the publications of sculpture conservators, on which, of course, art historians have drawn heavily. In almost all such books the mode of writing has been, above all, descriptive, and very often

descriptive in an uncritical way, or at least a way that assumes the issues concerned are unproblematic. Only recently has the consideration of sculptural practice in terms of the working of specific materials – each with its own qualities and problems that demand correspondingly specific techniques of the part of the sculptor – become more common among art historians rather than conservators or practitioners. A number of German articles have attempted what might be almost described as a iconography of materials.[23] On a larger scale, Nicholas Penny arranged his recent book on sculptural practice according to materials, so cutting across periods and cultures, while Suzanne Butters made the single material of porphyry in one culture – that of sixteenth-century Italy – the subject of a whole book. Here Butters provided much more than a simple account of the material and its working and instead examined the associations and meanings such a material could have within a highly specific cultural context.[24]

Another mode of writing about sculptural practice has been grounded in the archival rather than the material. These archivally based accounts of process are most often found embedded within passages of writing in that often unacknowledged, but much used, genre: the catalogue entry. Frequently assumed in a somewhat simplistic way to be mere compilations of data, the more ambitious catalogue entries, at their best, operate as subsidiary or complementary sets of texts, amplifying, reconfiguring and acting as a counterpoint to the discursive texts of the monographs of which they form a significant part.

Nowhere is this better exemplified than in Jennifer Montagu's discussion, in her monograph about Algardi, of the *Beheading of St Paul* (plate 7), placed within an aedicule on the high altar, and the bronze relief produced by the same sculptor fifteen years later.[25] The account of the Beheading group forms a substantial part of a chapter entitled, 'Rome: The Second Decade – Major Commissions', and so presents it within an overarching chronological narrative of Algardi's career. This discussion involves a close examination of the circumstances of the commission, including consideration of the role played early on by Bernini and how his sketches for the altar might be interpreted. Then follows an analysis of the part played by the patron Virgilio Spada, that rests on both careful assessment of the archival evidence for this and other projects in which he was involved, and consideration of his probable familiarity with Emilian groups composed to stand in the round. On this basis, Montagu goes on to speculate about Spada's practice of working independently with several architects and sculptors, including Algardi. The extended discussion of the group's relationship to its architectural setting alerts the reader/viewer to the way in which the sculptor conceived the composition to work on a large scale in marble. At the end of this telling passage – a characteristically incisive and perceptive example of formal analysis – the carved figures are contrasted with the fluently modelled protagonists in the narrative scene on the relief, in accord with Montagu's view of Algardi – indeed a central tenet in her interpretation – as an artist with a training in, and affinity for, modelling rather than carving. Only at this point is reference made to the two known terracotta models for the executioner.

In this discussion of the progress of the commission a concern with sculptural technique is certainly important but it is more evident in the sections devoted to formal analysis than in the primary narrative of the work's history. This part of

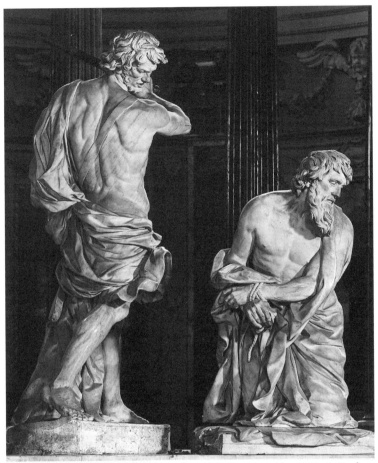

7 Alessandro Algardi, *The Beheading of St Paul*, marble, 1644, S. Paolo Maggiore, Bologna. (Photo: Alinari)

the main text is complemented, however, by one of the most rigorous and judicious catalogues yet attempted in a monograph about a sculptor. As well as giving the two terracotta models (not to mention the 15 versions of the bronze relief) detailed assessments, the entry for the *Beheading of St Paul* is prefaced by a very lengthy account of the evidence about the commission, quoting *in extenso* the various contracts and relating to this not only the surviving models but also lost stages such as the *legnetto* – a rough wood block giving the shape to which the marble should be carved – which was sent to the quarry. Arranged in the main to follow the line established by the catalogue, the photographs present these sequences and continuities visually, though they also open up the possibility of different readings. In this case, for example (plate 8), they amplify the author's point about the fluid modelling evident in the relief by juxtaposing the two models of the executioner with the relief, thereby suggesting a continuity that lies beyond the archivally supported arguments advanced in both text and catalogue.

 This account, consisting of two complementary sections of text and two genres of writing about sculpture, exemplifies one way in which sculptural

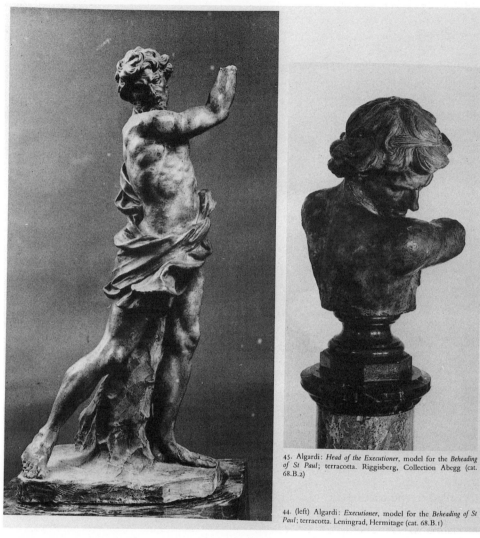

45. Algardi: *Head of the Executioner*, model for the *Beheading of St Paul*; terracotta. Riggisberg, Collection Abegg (cat. 68.B.2)

44. (left) Algardi: *Executioner*, model for the *Beheading of St Paul*; terracotta. Leningrad, Hermitage (cat. 68.B.1)

8 Plate illustrating models for the executioner from J. Montagu, *Alessandro Algardi*, New Haven and London, 1985. (Photo: Yale University Press)

technique and materials might be discussed and referred to. Montagu's work here, and even more so in *Roman Baroque Sculpture. The Industry of Art*, represents an approach to the production of sculpture that involves sustained viewing and careful consideration of the sculptures themselves and draws on an unrivalled knowledge of the models and drawings that were used in the processes of design and making.[26] It is also an approach that demands an alertness to the role of multiples and the techniques employed for the replication of three-dimensional images. Nonetheless, the primary narrative in all these discussions remains one not only based on the archival evidence but one in which the archival thread provides the central structure.

While materials and technique are, on the one hand, made the central focus of attention in some discussions of sculpture and are situated marginally within accounts, such as Montagu's, concerned with a sculpture and its commissioning, neither mode of writing gives primacy to the process of design and executing a sculpture and the relationship between two-dimensional designs and the work as realized in three dimensions, or the small-scale and the full-scale completed sculpture, although this is often indicated visually through the juxtaposition of images. Even in most catalogue entries – the genre of writing about sculpture perhaps best suited to accommodate the making of sculpture as a developmental process – the archivally based narrative remains dominant.[27] Nonetheless, a model for writing about sculptural process had already been offered by Vasari in his introduction to the 1568 edition of the *Lives*, where he writes 'Of the manner of making Models in Wax and Clay; how they are draped, and how they are afterwards enlarged in proportion in the Marble'.[28]

What Vasari is referring to here are the practices involved in the process of moving from two-dimensional to three-dimensional and from small-scale to large-scale and this has been a central concern in many recent books on sculpture, whether monographs or more wide-ranging discursive accounts. The most familiar example, as well as a much-used model, is Rudolf Wittkower's *Sculpture. Processes and Principles*, which not only cites Vasari but also takes his remarks on sculptural practice as a starting point. Wittkower's view of sculptural process – or processes since he sees distinctions between the practices of different periods, as well as common problems faced by most sculptors – is essentially proleptic in that his concern above all is with the finished work and the procedures involved in producing this.[29] In many cases he sees this in terms of a progression from the modelled to the carved and this relationship provides one of the central dynamics of a book that has conditioned much thinking about sculpture since it was published in 1977. The same focus on the process of transition from sketch or model to finished work has been evident in a series of more concentrated studies, exhibitions and colloquia, ranging from Irving Lavin's study of 'Bozzetti e modelli' to Peter Volk's exhibition catalogue, *Bayerische Rokokoplastik*, and the essays of the symposium, *Vom Entwurf zum Ausführing* that followed it.[30]

A number of models are available, then, for those writing about the materials and processes of sculpture. In writing about sculpture, as in that about painting, materials, technical procedures and the visible and tangible evidence of the different stages of the design processes have always figured in art-historical consideration of the ideation of works of art and their construction of both artists'

lives and broader historical narratives. But usually these have been incorporated as a subsidiary element within narratives which have some other central thread. The often more complex and varied procedures involved in the making of sculpture have made the introduction of any detailed accounts of process more difficult to accommodate within such contexts. Perhaps more importantly, a preoccupation with materials and techniques may also have appeared to have carried with it associations of the mechanical, an association that figured so prominently in the *paragone* and one that had made it so difficult for sculptors to have their art accepted alongside painting within the liberal arts. When writers have made discussion of sculptural process their primary focus, they have tended to do so in the form of insulated, self-contained descriptive accounts. And for these they have tended to adopt either Pliny's arrangement by materials or Vasari's approach – one that made much of the individual artist's powers of invention – of relating the linear development of composition through models.

Baxandall and the uses of chiromancy

Baxandall's *Limewood Sculptors*, of course, draws on these various traditions and conventions of writing about sculptural materials and processes but the book also extends and reformulates these various approaches. By foregrounding the material – limewood – used by the sculptors with which he is concerned, and devoting so much attention to the practice of carving, as well as the circumstances of commissioning and the procedures of design, he gives the specificities of sculptural practice a prominence that they have been accorded in few other books about sculpture, other than those that set out simply to describe techniques. But, more than that, *Limewood Sculptors* also provides us with a distinctive new model for addressing and writing about sculptural practice, albeit one that is hard to adopt without Baxandall's own breadth of learning and powers of perception.

The inclusion of limewood in the title signals the centrality that this material is given throughout the book. Following the introduction about the social and political history of Upper Germany, the second chapter – boldly titled just 'Material' – introduces limewood as the wood that was, in most cases, the chosen material for the figures of the altarpieces and devotional figures by the sculptors such as Michel Erhart, Tilman Riemenschneider, Veit Stoss and Hans Leinberger, with whom Baxandall is principally concerned. Material is here introduced as one of the six terms that he keeps in play throughout the book; the others, according to the chapter headings that follow, are Functions, the Market, Identities, the Period Eye and Individuals. And none of these others is kept more constantly or indeed more deftly in play than material. Underlying the discussion in all the following chapters, even if the reference is not explicitly made, is an assumption about the material and its properties, as described at the end of chapter 2:

> The properties of the material made limewood sculpture a special medium.
> It was a medium of the grand form and of the surface, whether polychrome
> or monochrome; it was not a positive medium of the middle forms, like
> oak, or even usually of the assertive instrument, as bronze can be. The

grand form offered a scale of more or less assimilation to the form hidden in the wood, the surface a scale of textures, on both of which the sculptors played, and they are the source of the specific qualities of the genre.[31]

This position has not gone unchallenged, especially in Germany. A long and detailed review by Eberhard König made much of the fact that the 'florid' style was manifested in stone as well as limewood and that recent analysis of works previously thought to have been carved in limewood were made of the harder walnut.[32] Developing König's arguments further, Thomas Da Costa Kaufmann has pointed out that limewood was used more widely than by the sculptors of South Germany with which Baxandall is almost exclusively concerned, and suggests that the underlying assumption of the *Limewood Sculptors* book is a Semperian view of the relationship between material and design that had been overthrown by Riegl in his *Stilfragen*.[33] Yet, while the framework employed by Baxandall is indeed just that and as such may be overschematic, his argument does not involve a causal relationship between the qualities of a material and the style and design of works made from it. What is proposed here is something more subtle, more tentative and more allusive, opening up a way of addressing these works and the circumstances in which they were produced.

From the start, Baxandall alerts the reader not only to the availability of the broad-leaved lime and the trade in limewood in South Germany but also to the associations that this tree and its wood carried. The respect for limewood shared by contemporary sculptors and those who viewed and performed their devotions before images made in this material is a central tenet underpinning much of what follows. We can sense too the author's respect for the material. As Baxandall himself insists, 'Limewood was no base material but one to be respected: a way to see the carver's treatment of it is as active respect.'[34]

As a means of understanding that 'active respect', Baxandall then looks for appropriate modes of description and analysis among contemporary texts. He turns, in particular, to the writings of Paracelsus and his notion of chiromancy. As Baxandall puts it, this was 'the art of reading the inner character of a person or thing from its external character', and Paracelsus used the term to mean 'a reading of the lines of disposition and experience on any natural object by a means rather similar to that of reading the lines on a hand'. Paracelsus's account of chiromancy is indeed especially apposite, in that he refers specifically to wood and those who use it:

> People who work wood, carpenters, joiners and such, have to understand their wood by chiromancy of it, what it is apt and good for.[35]

In one sense, Baxandall may be seen as a latter-day Paracelsus, and the analysis of the works with which *Limewood Sculptors* is concerned as an exercise in chiromancy. The contemporary practice of chiromancy provides Baxandall with an appropriate interpretive strategy, as well as a useful metaphor for viewing and discussing sculpture and its materials.

The interrogative, analytical nature of chiromancy, as well as the term's metaphorical resonance, encourages an approach whereby the material of the

sculpture and the techniques appropriate to it are not simply described but analysed, their implications, associations and potential meanings explored. But by making use of it early in the book, Baxandall does more than simply indicate its usefulness for considering the issue of sculptural process. In citing Paracelsus, he also establishes a position in relation to other aspects of his subject. This interrogative stance, combined with the openness to the use of metaphor and analogy also registered in his adoption of Paracelsus, may be seen throughout the book. It is no coincidence, however, that the passage from Paracelsus that he cites first should be concerned with material; an alertness to the relevance of the material, like the chiromantic mode, may be discerned throughout the book. Baxandall's appropriation of Paracelsus means that material and process need not be contained and written about as a discrete subject but can be invoked, hinted at or used as an underlying assumption in discussion of issues that might in other books be considered quite separate matters.

The 'Functions' chapter, for example, makes little explicit reference to the processes of making, but observations such as that concerning Riemenschneider's reconciliation of piety and florid sculpture always take into account the qualities of limewood and the practicalities of workshop practice.[36] Baxandall's text is constantly inflected by his sensitivity to the significance of material and sculptural practice. At points this concern is not merely implicit but breaks the surface so as to be more obviously recognizable. Sometimes these explicit references to questions of material and technique are brief, taking the form of an illustration used to make another point. This is the case, for instance, in the quotation about the sculptor's storage of his wood from the contract between Michel Erhart and the Dominican convent in Ulm, where Baxandall sees raw material as a loaded issue and Erhart's demands as 'an important signal of independence'.[37] In cases such as this, the discussion is informed and underpinned by an assumption about the significance of material in the culture of South Germany around 1500 and the questions formulated with this in mind.

Baxandall's discussion of the 'Market' is similarly grounded in a familiarity with the processes of production. His interpretation of the way in which the sculpture trade registered a shift within the new economic Europe from the oligopoly of the guild system towards various forms of monopoly involves seeing sculptors' business practices in terms of businesses operating within the guild system being replaced by two types of monopoly. One was the classic integrating monopoly, such as Jörg Lederer's business covering all aspects of altarpiece production in Kaufbeuren; another was the imperfect monopoly, operated by sculptors such as the Master H.L., who were able to produce work in a distinctive style that constituted a marketable category of its own. An awareness of the way that the material is worked and the way in which its potential could be exploited by an individual carver – something Baxandall explores more fully in the next chapter on 'Identities' – is central to his notion of 'the practice of qualitative self-differentiation by superior craftsmen'.[38]

Elsewhere material and process are kept in play in a more extended and explicit way. Thus, in the chapter on 'The Period Eye', Baxandall's casting around for terms and modes of description in the wider visual culture of early sixteenth-century Germany prompts him to look at cognate activities, such as Mastersong.

and Modist calligraphy, in which technique was highly rated and eloquently characterized. By drawing our attention to the analogies between the exaggerated attention to line in Neudörffer's analysis of common, wound and broken ductus in handwriting styles of the 1530s, and the drapery edges of limewood figures, or between the 'flourishes' in Mastersong and the 'local passages of heightened elaboration and skill' in 'florid' sculpture, Baxandall is both alerting the reader/ viewer to the centrality of technique and linking the issues of material and process to wider concerns.[39]

This strategy is most apparent (as well as most successful) in the final section of the main discursive text. Titled 'Individuals', this chapter, in which works by four sculptors – Michel Erhart of Ulm, Tilman Riemenschneider of Würzburg, Veit Stoss of Nuremberg and Hans Leinberger of Landshut – are examined according to the interpretive strategies proposed in the previous chapters. It is at this point that both Baxandall's continuing concern with material and process and his boldness in integrating within a broader discussion what for him are central issues are most readily recognizable. His accounts of Erhart's *Virgin of Mercy* (plate 9) and Riemenschneider's *Holy Blood Altarpiece* (plate 10) refer directly to the former in terms of the 'radial wings of mantle and knee, and the head moved out of the heartwood, ... almost a paradigm of stable conversion'[40] and to the latter as 'a very beautiful compromise between what it is to represent and, on the other hand, a simple, swift, unstrained movement of blades on wood'.[41] Similarly, the discussion of Veit Stoss's *St Roche* (plate 11) (significantly described by Vasari in his chapter on carving in wood as a 'un miracolo di legno') foregrounds the sculptor's 'rhetoric of the edge', providing a parallel for this mode of carving in a calligraphic flourish and demonstrating how Stoss's figure 'makes a point of both its skill and its individuality.'[42]

In these essays – almost a set of meditations – about individual pieces Baxandall not only integrates remarks about technique and material into his consideration of all aspects of the sculpture he is addressing but – and this remains one of the most striking and original moves he makes – also takes account throughout of the way in which the material and its fashioning might have been perceived by contemporary viewers. Writing of Erhart's *Virgin*, for example, he goes on from characterizing the sculptor as 'an instinctive crystallographer, playing with axial directions' to stress 'a quality to be enjoyed in the carving'.[43] It is as if his continuing concern with technique and material here intersects with his similarly constant preoccupation with the conditions and circumstances of viewing, which in this particular case he discusses in terms of the sculpture's 'arc of address'. Addressing the sculpture is, then, a matter not only of the spectator approaching the work with a certain combination of devotional and secular expectations or assumptions about its social setting, but also one of that spectator bringing to it an awareness of the material and the skill with which this has been used. While this awareness will not, of course, correspond with that of the sculptor, it is nonetheless an active factor in how the work was viewed and responded to.

At this point we can return to Paracelsus and chiromancy. While Paracelsus refers specifically to people who work in wood, the way in which he writes about them is predicated on the possibility of others who are not joiners, carpenters or

9 (above) Michel Erhart, *Virgin of Mercy*, polychromed limewood, *c.*1480, Skulpturengalerie, Preußischer Kulturbesitz, Berlin.
10 (facing) Tilman Riemenschneider, *Holy Blood Altarpiece*, limewood, *c.*1501–5, St Jacobskirche, Rothenburg ob der Tauber. (Photo: Gundermann, Würzburg)
11 (right) Veit Stoss, *St Roche*, limewood, *c.*1520, Ss Annunziata, Florence. (Photo: Conway Library, Courtauld Institute of Art)

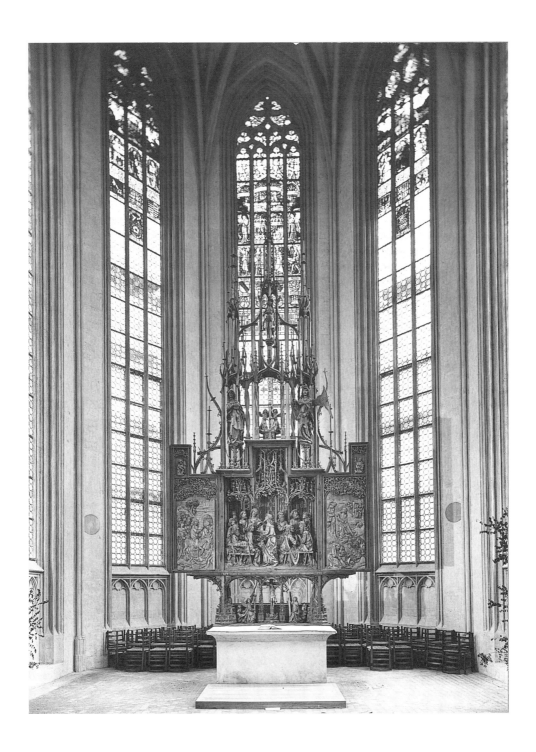

indeed sculptors perceiving some of these qualities. His sixteenth-century readers are invited to look at the material with the eyes of those who work it. In this way the working of the wood is not a matter that concerns only the sculptor but is also of interest to those who might buy, see or use his work. Although it is not explicitly stated, Baxandall's adoption of a chiromantic strategy brings with it the possibility of considering how the assessment of materials and processes might form an integral part of the viewing of limewood sculpture by contemporary spectators. The consideration of materials and process is thus not a matter to be confined to a discussion of a sculpture's production but needs also to have a place in any discussion of that sculpture's reception.[44]

But Baxandall's alertness to the centrality of material in the way he formulates other questions, and his reference to technique in his engagement with viewing practices are not the only distinctive features of his writing about sculptural process. His approach also opens up the possibility for others to write about the making of sculpture in a different way. The very act of citing Paracelsus on chiromancy involves looking for analogy, a strategy that is, as I have suggested, characteristic of Baxandall's writing. Such 'casting around' (to adopt one of his own expressions), for analogy goes with a constant trying out of possible terms, appropriate metaphors or telling allusions. Vivid though these often are, they are all introduced with a crisp tentativeness, signalling that an interpretation is being essayed, a line of approach suggested, rather than a narrative or series of events related. We are left in no doubt that Baxandall's text – both in the structures of its argument and its rhetorical devices – is an artifice, albeit one that prompts us to engage with the sculpture in new ways. The pleasure of reading the book lies in large part in sharing the author's engagement in the dynamic between the possible uses of word, analogy and metaphor, on the one hand, and the concrete materiality of the sculpture, on the other. But, as readers moving with the author between word and image, we are also kept constantly aware that these patterns of words and modes of viewing can be endlessly reformulated.

By taking on the role of chiromancer while at the same time making clear that this is but one strategy, Baxandall frees himself from presenting the processes of making sculpture in terms of a simple descriptive account. This is not overtly stated and its implications are not stressed within the text but they are very considerable for anyone thinking about processes of making and the way these might be discussed. One of the most significant qualities of Baxandall's strategy is the way in which it keeps open the possibility of collapsing the usual rigid sequence made up of one temporal stage involving sculptor, materials and making – what we might call production – and another separate stage involving setting and viewer – or what we might call reception. Although this is to translate something that Baxandall writes about subtly and elegantly into a crude oversimplification, the intermeshing of production and reception along these lines has considerable potential for the way we might write about technique and material, especially those relating to sculpture. What Baxandall provides us with in the *Limewood Sculptors* is an alternative, and far more open, model for writing about sculptural production than the familiar one based on a formulaic notion of sculptural process and articulated as a rigidly linear narrative relating different stages of design and making. Because the evidence about the use of preliminary

models at this date is slight, the book is not very much concerned with the relationship between drawing, model and finished work, which features so prominently in studies of sculptural practice such as those by Wittkower. But Baxandall's approach nonetheless has important implications for anyone writing about the making of sculpture in later periods when a tight sequence from design to finished work is assumed.[45]

Some further narratives of making

How might we use Baxandall's approach and mode of writing to fashion different ways of writing about sculptural process in periods and cultures beyond that of Renaissance Germany? How might a series of discussions loaded with such a density of cultural particulars be made use of, so as to address the making of works produced in very different circumstances and for quite different purposes? To apply the interpretive strategies so subtly formulated for investigating the material culture of early sixteenth-century Augsburg to that of mid-eighteenth-century London or Paris might seem at first sight to disregard the historical specificity so central to Baxandall's project. But his repositioning of the issues of material and technique within art-historical writing – for that is what is achieved in the *Limewood Sculptors* – allows us a purchase on sculptural process in a period when the status and business practice of sculptors was changing, genres and aesthetic categories were being reconfigured, conditions of viewing shifting and technological innovation was widespread.[46] In the mid-eighteenth century, as in the early sixteenth century, these factors together meant that responses to sculpture often involved a heightened awareness of the materials in which it was made and the processes of making.

No more vivid register of this is to be found than the remarkable folio volume published in Paris in 1768, giving a detailed account of the commissioning, designing and making of Bouchardon's equestrian statue of Louis XV. Although the production of this book was linked, of course, with the glorification of the monarch and the large scale and lavish format of the volume are commensurate with the status of the sculpture's subject, what is most remarkable about it is the fullness of the account of the casting of the bronze, accompanied by no less than 58 engravings. These include not only plates of the various stages of the process, paralleling – though on a somewhat grander scale – the plates of manufacturing processes in the *Encyclopédie*, but also a representation of the casting being viewed by an admiring audience (plate 12).[47] If the making of the sculpture is as much the subject of the book as the statue itself, it goes further than that in representing the way in which that process was viewed. While this volume has been used as evidence for Bouchardon's commission and the techniques of bronze casting, no attention has been given to it as a representation of sculptural process and its significance as an index of interest in that process in eighteenth-century France.[48] This same concern with process is registered in the many images of sculptors with their tools and models (plate 13), which were often used by engravers as subjects for their *morceaux de reception*, which employ a set of well-established conventions to represent the making of sculpture. One of the perhaps

12 The casting of Bouchardon's equestrian statue of Louis xv, engraving, from Pierre Jean Mariette, *Description des travaux ...*, Paris, 1765, National Art Library, Victoria and Albert Museum, London. (Photo: Victoria and Albert Museum)

more unexpected results of Baxandall's approach to technique is to prompt a reconsideration of this category of images, in which the linkage between the making and viewing of sculpture explored in the *Limewood Sculptors* is articulated visually.[49]

The interpretive possibilities suggested by the *Limewood Sculptors* may be taken up too in the field of eighteenth-century English sculpture and, having worked first on German wood sculpture and then moved into this area, I have found Baxandall's work has considerable resonance. Although the range of material, including the greater importance of drawings and models, might be different, and the sources for descriptive terms more directly related to the sculpture, many of the issues raised by Baxandall, as well as his way of writing about materials and processes, continue to be relevant.[50] Here Roubiliac's monument to the Duke of Argyll in Westminster Abbey (plate 14) might serve as an equivalent to the Riemenschneider Holy Blood retable at Rothenburg. A sculptural machine comparable in scale to the Rothenburg altarpiece and placed so that the viewer has to negotiate between the imagery, conventions and style of the sculptural representation and the architectural and social space in which it is placed, the Argyll monument had to serve public and secular functions, different from but in some ways equivalent to Riemenschneider's altarpiece, even if the devotional uses of the latter were lacking.[51]

Unlike the Rothenburg altarpiece, the Argyll monument attracted considerable contemporary comment. This includes George Vertue's fulsome praise of the monument as a work that 'outshines for nobleness & skill all those done before, by the best sculptors, this fifty years past', newspaper and periodical accounts (some probably paid for by the sculptor) recording the work's progress, the

different inscriptions proposed for it and its 'opening' in 1749, and the lengthy contract drawn up between the Duchess of Argyll and the Duke's executors and Roubiliac.[52] While some of these have been extensively used to document the erection of the monument and its reception, the texts have usually been interpreted uncritically with little regard for the conventions they employ or the uses for which they were intended. But before dealing with the interpretive issues this raises, we might first consider one of the most striking features of the work which Vertue (who much admired the monument) stressed and which continued to attract the attention and admiration of later viewers, among them Canova. This was the sculptor's virtuoso handling of the marble and, in particular, his carving of the figure of Eloquence (plate 15) so that 'the Draperys and foldings [are] truly natural and excells all others in skill and softness of plaits really

13 Nicolas de Lagillière, *Nicolas Coustou*, oil on canvas, *c*.1715, Gemäldegalerie, Preußischer Kulturbesitz, Berlin.

more like silk than marble.' While such comments in part draw on a familiar body of rhetoric about the minetic powers of sculpture in marble, they also signal an awareness on the part of contemporary viewers of the way in which the marble was carved and its surfaces finished. It would be crass and inappropriate to draw too close a parallel with the viewing of the surfaces or edges of limewood carving by Stoss or Riemenschneider but Baxandall's suggestive account of how contemporary viewers might have approached these offers a model for writing about contemporary responses to Roubiliac's handling of marble and of the importance that an awareness of the material and how it was worked had for the viewing of his work.

The subtle treatment of surface, playing on the tension between the verisimilitude of the representation and the virtuosity with which the marble was carved, was one of the qualities, along with the sculptor's powers of invention, that set him apart from his contemporaries. If we adopt the terms formulated by Baxandall to characterize one position taken in the market in which the limewood sculptors operated, Roubiliac could be said to have adopted a strategy of 'qualitative self-differentiation'. Making the most of his distinctive qualities meant drawing attention to those technical features of his work, on the assumption that these would be readily understood by his viewers and potential patrons. It also involved claiming a more elevated status than his rivals, such as Rysbrack and Scheemakers, through adopting a different series of design practices, particularly the use of models, that shifted the relationship between patron and sculptor, so that more trust was placed in the sculptor's inventive abilities and less

14 L.F. Roubiliac, *Monument to John, 2nd Duke of Argyll*, marble, 1749, Westminster Abbey, London. (Photo: Warburg Institute)

leeway given to the patron to choose from a range of proposed designs, as that patron might select a particular pattern for a piece of furniture or silver.[53] Using Baxandall's discussion as a starting point, we might write about Roubiliac's sculptural practice and the Argyll commission in particular in terms of the way it foregrounded virtuosity and asserted the exceptional skill of the sculptor in its execution as well as its design. As Vertue put it, the monument showed 'the greatness of his [Roubiliac's] Genius in his invention design and execution'.

While some aspects of Roubiliac's work may be addressed in ways already employed by Baxandall, the existence of a considerable amount of visual, as well as documentary, evidence about the design and commissioning of the Argyll monument might at first sight make the model Baxandall provides seem less relevant. Two drawings (plates 16 and 17), a terracotta model (plate 18) and the references in the sculptor's sale catalogue to a number of other models in clay and plaster indicate that we have here many more of the residues of the processes of design and making than we have for even a fairly well-documented South German wood sculpture such as the Rothenburg altarpiece. Here, we might think, the circumstances of production were quite different. Nonetheless, Baxandall's approach still seems to me to be helpful here too, if less directly.

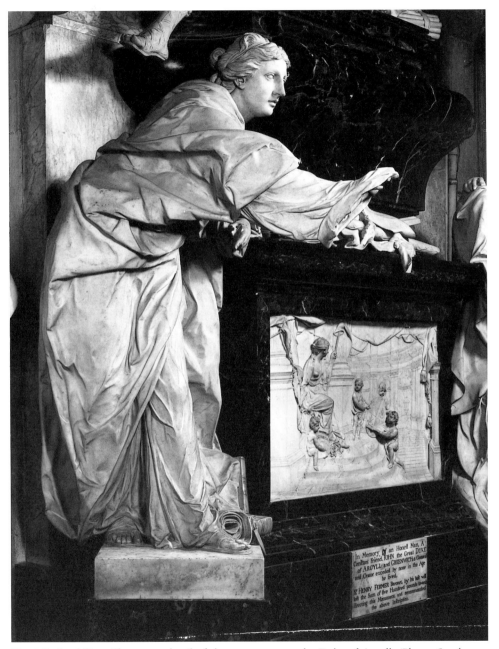

15 L.F. Roubiliac, *Eloquence*, detail of the monument to the Duke of Argyll. (Photo: Stanley Eost and the Paul Mellon Centre)

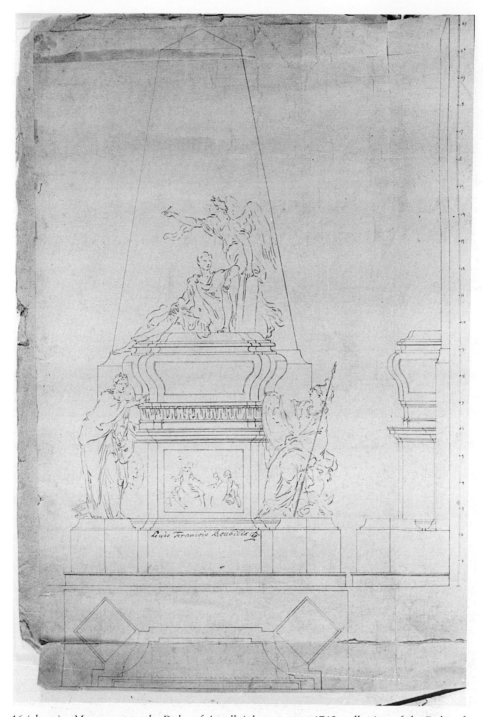

16 (above) *Monument to the Duke of Argyll*, ink on paper, 1745, collection of the Duke of Buccleuch and Queensbury. (Photo: National Gallery of Scotland)
17 (facing) H. Gravelot, *Monument to the Duke of Argyll*, pen and ink and black and white chalks, 1745, Victoria and Albert Museum, London.

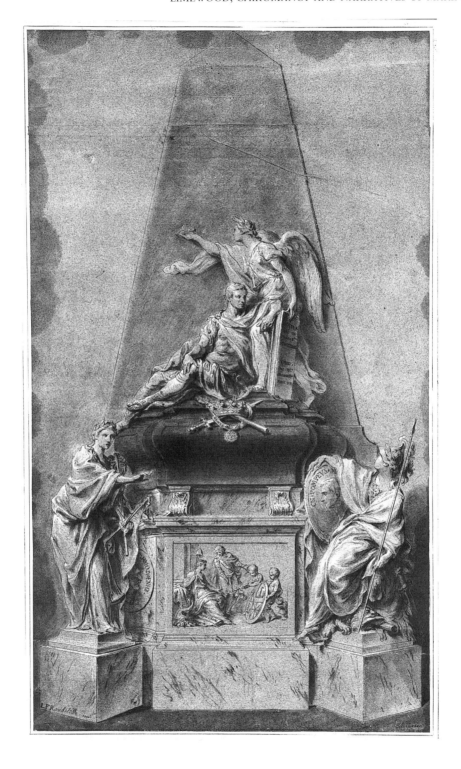

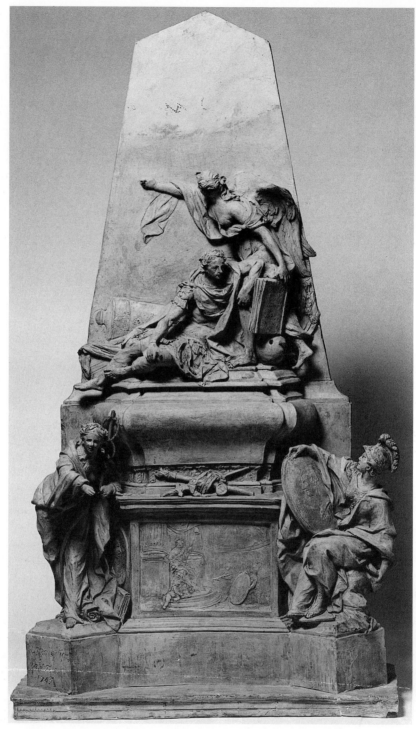

18 L.F. Roubiliac, *Monument to the Duke of Argyll*, terracotta, 1745, Victoria and Albert Museum, London. (Photo: Victoria and Albert Museum)

One way of reading the visual and documentary material relating to the Argyll monument is as a closed linear narrative. This might take the form of a narrative of the commission, constructed around a documentary chain with the drawings and models used as illustrations or confirmatory evidence. Or – and the two are not exclusive – it might take the form of a chronological account of the sculptor's formulation of the design and his progress towards the finished work, a narrative of creativity as it were. Used in this way, the material relating to the Argyll monument might be arranged so that the rough drawing attached to the contract lays out the overall scheme, the details are worked out in the larger, more finished drawing and then further refined on the terracotta model. This, however, largely ignores what does not survive in order to construct a seamless and apparently complete sequence. It also avoids any engagement with the awkward disjunctions between the different surviving 'designs', which do not indeed illustrate a steady and consistent development towards the finished work. Just as significantly, it fails to take account of the variety of functions that these drawings and models had and the complexities of their production.

By writing about sculptural processes in the way I discussed earlier, Baxandall opens up the possibility of approaching this material in a different way. By signalling, through the language used, the frequent recourse to analogy and the tentativeness of his approach how fictive any account of process must be, he provides us with a means of dealing with what must be a fractured and imperfect narrative. The possibilities are further enhanced when we introduce as an active element within the discussion the different conventions in which a contract or a contemporary newspaper account – themselves different modes of representation – might be written. Turning then to the crucial, but largely ignored, issue of the multiple and changing functions of drawings and models, we can then not only take advantage of the flexibility and openness of Baxandall's mode of addressing such works but also draw more directly on his writing by looking at cognate fields and activities within the culture.

In the case of the Argyll monument this would mean recognizing, for example, that the two drawings (which were originally both attached to the contract) served different functions and were, as it were, in different modes. While the more modest one was probably intended to complement the verbal description of the monument in the contract by giving the exact proportions of the architectural elements, the larger one was used to suggest the impression that the finished work might have through its imagery, the drama of its figures and the richness of the materials to be employed. Shortly after the monument's completion, this more highly finished drawing had been separated from the contract and was already framed, taking on another role, as it were, as a work in its own right, or perhaps as a private, small-scale memorial for viewing in a domestic, family setting. The terracotta could also have been used later in this way but its primary function was, like the larger drawing, to present to the patron some impression of the intended appearance of the monument at a certain stage in the financial transactions, which would have involved staged payments. But while the terracotta is likely to have been modelled by the sculptor himself, the drawings were drawn by two different hands, the presence of Roubiliac's name on one of them signifying not authorship but merely his confirmation that this was an adjunct to the contract, each page of which he had likewise signed.

Describing and relating the surviving drawings and models to each other in this way, I have not been writing about them as stages in a design process but rather as visual representations that stood at one remove from this process and were used primarily for other purposes. One way of regarding them is as residual fragments of a process of negotiation between patron and sculptor, or perhaps as purposely indistinct representations of design ideas to be employed as a focus for discussion between patron and sculptor.[54] But to approach them in this way – at the centre of a social encounter – means considering modes and conditions of viewing. Taking Baxandall's lead here, we might think of them in terms of a practice of viewing both two- and three-dimensional models in eighteenth-century England that ranged from the inspection of models for buildings or coaches to the exhibiting of models in demonstrations of experiments and public lectures about natural philosophy. This, in its turn, means addressing such registers of the making process in a wider context and exploring the possible associations and significances they had for contemporary viewers. At this point these issues of material and process are no longer of simply peripheral concern.

Familiar modes of writing about the materials and processes do not allow us to take account of the disjunctions and ambiguities I have mentioned or the multiple or changing uses of drawings and models. While Baxandall's *Limewood Sculptors* does not deal specifically with the possible relationships between these preliminary stages, the model he formulates for addressing questions of making and material has implications and applications far beyond the field of South German wood sculpture. The *Limewood Sculptors* allows us the possibility of writing discursively about the making of sculpture so that it no longer need be a marginal subject, tightly contained within a single separate chapter of a text. It also has implications for the way that catalogues – such as that which forms a significant part of *Limewood Sculptors* – are structured. While not setting out to be prescriptive or to establish an orthodoxy, it suggests that what has often been regarded as a narrow, curatorial concern can occupy a central position within art-historical writing.[55]

As elsewhere in his work, Baxandall's writing about the materials and processes of sculpture continually heightens our awareness of the elusive relationship between visual images and language. By adopting a self-reflexive position, he alerts us without fuss to the artificial, constructed nature of any narrative. Nowhere is this more salutary than when he comes to narratives of making which have so often been regarded as unproblematically descriptive. But as well as offering an alternative Baxandall at the same time demonstrates the importance of the issues of materials and making. By giving it such centrality throughout his text he prompts us to pay attention to the tangible and the material, though with a new self-awareness. Along with Baxandall's sensitivity to the slippages involved in the move between the visual and the verbal and the inappropriateness of language in dealing with visual experience, Baxandall's writing, above all in the *Limewood Sculptors*, where his curatorial past is most evident, keeps at the centre the stubborn materiality of his subject. But in doing so he challenges us to address this in new ways.

Malcolm Baker
Victoria and Albert Museum

Notes

Earlier drafts of this essay have been read by Anthony Burton, Norbert Jopek, Alex Potts and Michael Podro, as well as the editor, Adrian Rifkin, and I am grateful to all of them for their thoughtful responses. Others who have helped me in various ways include Ivan Gaskell, Hartmut Krohm, Andrew McClellan, Jennifer Montagu, Anthony Radcliffe, Katie Scott and Philip Ward-Jackson.

1 Michael Baxandall, *The Limewood Sculptors of Renaissance Germany*, New Haven and London, 1980, p. 136.

2 The figure has been variously attributed to a Netherlandish and (less convincingly) to the Master H.L. The most significant discussions are Theodor Müller, 'Zur südniederländisch Kleinplastik der Renaissance', in *Festschrift für Erich Meyer zum 60. Geburtstag*, Hamburg, 1957, pp. 195–6 and Jörg Rasmussen, 'Zum Meister H.L.', *Jahrbuch der Hamburger Kunstsammlungen*, 18 (1973), p. 64. For the questioning of the attribution to the Master H.L. of the related Adam and Eve group in Freiburg and the suggestion that this (and, by implication, the St George) might be a retrospective work of around 1600, see the summary given in 'Spätgotik am Oberrhein. Meisterwerke der Plastik und des Kunsthandwerks 1450–1530. Forschungsergebnisse und Nachträge', *Jahrbuch der Staatlichen Kunstsammlungen in Baden-Württemberg*, 9 (1972), p. 154. The interest in the earlier literature about the work's date and authorship, as well as its relationship with the drawings of Gossaert, have been more recently replaced by a concern with its possible use as a virtuoso carving for a *Kunstkammer* and its links with small-scale sculpture of a distinct genre favoured by a certain type of patron. For such sculpture, see J. Chipps Smith, *German sculpture of the later Renaissance*, Princeton, 1994, chap. 9.

3 This is already hinted at in the perceptive entry by Bernhard Decker in the exhibition catalogue, *Dürers Verwandlung in der Skulptur zwischen Renaissance und Barock*, Liebieghaus Museum alter Plastik, Frankfurt am Main, 1982, p. 179. This information about the appropriation of Dürer in sixteenth- and seventeenth-century sculpture is one of the boldest contributions to the study of German sculpture within the past twenty years. For a critique of the exhibition see the review by Jörg Rasmussen (*Kunstchronik* 35 (1982), pp. 240–8).

4 Baxandall, *Limewood Sculptors*, op. cit. (note 1), p. 135.

5 Michael Baxandall, *Patterns of Intention*, New Haven and London, 1985, p. 1.

6 As, for example, in 'The Language of Art History', *New Literary History*, 10 (1979), pp. 453–65; published in an abbreviated form as 'The language of art criticism' in Salim Kemal and Ivan Gaskell (eds), *The language of art history*, Cambridge, 1991.

7 The reception of *Limewood Sculptors* may be followed in the response of reviewers. The most important of these are: Richard Marks in *Burlington Magazine*, 124 (1982), pp. 451–3; Eberhard König, 'Gesellschaft, Material, Kunst. Neue Bücher zur deutschen Skulptur um 1500', *Zeitschrift für Kunstgeschichte*, 47 (1984), pp. 535–8; Thomas Puttfarken, 'Causes and Circumstances', *Art History*, vol. 4 (1981), pp. 479–83; Roland Recht in *Bulletin Monumental*, 142 (1984), pp. 474–5. Its significance has also be obliquely registered through its choice as one of sample examples of citation style in *Art History*'s 'Notes for Contributors'.

8 Willibald Sauërländer, 'Gothic Art Reconsidered: New Aspects and Open Questions', in Elizabeth C. Parker and Mary B. Shepard (eds), *The Cloisters, Studies in Honor of the Fiftieth Anniversary*, New York, 1992, p. 29.

9 ibid., p. 40, note 82. Rasmussen's paper appeared as '"Far stupire il mondo": Zur Verbrietung der Kunst des Veit Stoss' in Rainer Kahsnitz (ed.), *Veit Stoss. Die Vorträge des Nürnberger Symposions*, Munch, 1985. Significantly perhaps, the opening essay in the catalogue of Veit Stoss exhibition was contributed by Michael Baxandall ('Veit Stoss, ein Bildhauer in Nürnberg', in Rainer Kahsnitz (ed.), *Veit Stoss in Nürnberg*, exhib. cat., Germanisches Nationalmuseum, Nürnberg, Munich 1983, pp. 9–25.)

10 This paradigm shift may be seen most clearly in Larry Silver, 'The State of Research in Northern European Art of the Renaissance Era', *Art Bulletin*, 68 (1986), pp. 518–35.

11 Puttfarken, 'Causes and Circumstances', op. cit. (note 7), p. 482.

12 Interestingly, Baxandall has continued to address issues which seem to draw on his museum background and have implications for anyone concerned with the setting up of displays, as in his essay 'Exhibiting Intention: Some Preconditions of the Visual Display of Culturally Purposeful Objects', in Ivan Karp and Steven D. Lavine (eds), *Exhibiting Cultures. The Poetics and Politics of Museum Display*, Washington and London, 1991, pp. 33–41. His very interest in conditions of viewing and what might be described as the dynamics of spectatorship is closely allied with a concern with the way the physical presence of a work of art is perceived in a real space. Along with a fascination with the subtleties and ambiguities of descriptive terms – and how these might be played with – appears to go a tough practicality. This intertwining of, or movement between, the theoretical and the empirical, the rhetorical and the material, might

be seen as a sign of his familiarity with two modes of institutional discourse.

13 It is perhaps ironic that prominent among the concerns of many academic art historians over the past ten years have been modes of viewing, the problematics of display and the role of art institutions including museums – all issues with which curators are very much involved.

14 His publications of the Victoria and Albert Museum's sculpture of this type are *German wood statuettes 1500–1800*, London, 1967, and *South German Sculpture 1480–1530*, 1974.

15 Michael Baxandall, 'Hubert Gerhard and the Altar of Christoph Fugger: The Sculpture and its Making', *Münchner Jahrbuch der bildenden Kunst*, 17 (1966), pp. 127–44. A shorter article based on this research was published as 'A Masterpiece by Hubert Gerhard', *Victoria and Albert Museum Bulletin*, 1 (April 1965), pp. 1–17.

16 Baxandall, 'Fugger' op. cit. (note 15), p. 133.

17 H. Wilm, *Die gotische Holzfigur*, 3rd edn, Stuttgart, 1962. On Wilm see Ulrich Müller, *Hubert Wilm 1887–1953*, Kaufbeurer Geschichtshefte, Sonderheft 2, Kaufbeuren, 1987. (I am indebted to Norbert Jopek for this reference.)

18 Hans Huth, *Künstler und Werkstatt der Spätgotik*, Augsburg, 1925; reprint (with further texts), Darmstadt, 1967.

19 See, for example, the contributions of conservators such as Eike Oellermann and Erwin Mayer, working in collaboration with Hartmut Krohm, in *Tilman Riemenschneider, Frühe Werke*, exhib. cat., Mainfränkisches Museum, Würzburg, Berlin, 1981.

20 Examples of the former include Walter Melion, *Shaping the Netherlandish Canon: Karel van Mander's Schilder-Boeck*, Chicago, 1991; Patricia Rubin, *Giorgio Vasari: Art and History*, New Haven and London, 1995; Catherine M. Soussloff, *The Absolute Artist. The Historiography of a Concept*, Minneapolis, 1997. The latter forms the subject of the first chapter of Alex Potts, *Flesh and the Ideal. Winckelmann and the origins of art history*, New Haven and London, 1994.

21 Edouard Lanteri, *Modelling: a guide for teachers and students*, 3 vols, London, 1901–11; Félibien, *Des principes de l'architecture, de la sculpture, de la peinture …*, Paris, 1690.

22 Pliny does, however, introduce much other material into these chapters, most notably the biographical information about individual Greek sculptors in his account of marble in Book XXXVI

23 The fundamental article on the iconology of materials is Günter Bandmann, 'Bemerkungen zu einer Ikonologie des Materials', *Städel Jahrbuch* N.F. 2 (1969), pp. 75–100. Further contributions (many of them about bronze) include Wolfgang Kemp, 'Holz – figuren des Problems Material', in *Holz = Kunst-Stoff*, exhib. cat., Staatliche Kunsthalle, Baden-Baden, 1976, pp. 9–14;

Norberto Gramaccini, 'Zur Ikonologie der Bronze im Mittelater', *Städel Jahrbuch*, N.F. 11 (1987), pp. 147–70; Thomas Raff, *Die Sprache der Materialen*, Munich, 1994; Hermann Maué (ed.), 'Realität und Bedeutung der Dinge im zeitlichen Wandel' (with 20 further papers), *Anzieger des Germanischen Nationalmuseums*, 1995; Malcolm Baker, 'The production and viewing of bronze sculpture in eighteenth-century England', *Antologia di Belle Arte*, 1996, pp. 144–54; Elizabeth Dalucas, '"Ars erit archetypus naturae" Zur Ikonologie der Bronze in der Renaissance', in Voker Krahn (ed.), *Von allen Seiten schön. Bronzen der Renaissance und des Barock*, Berlin, 1996, pp. 70–81. The associations and meanings of material has received attention from historians of classical sculpture and some of these contributions have been usefully summarized in M.L. Anderson and L. Nista, *Radiance in Stone*, Rome, 1989.

24 Nicholas Penny, *The Materials of Sculpture*, London and New Haven, 1993; Suzanne B. Butters, *The Triumph of Vulcan. Sculptors' Tools, Porphyry, and the Prince in Ducal Florence*, Florence, 1996.

25 Jennifer Montagu, *Alessandro Algardi*, New Haven and London, 1985. For the sections of the text and catalogue discussed here see 1, pp. 51–64 and 2, pp. 369–76.

26 Jennifer Montagu, *Roman Baroque Sculpture. The Industry of Art*, New Haven and London, 1989. This study is complemented by the same author's *Gold, Silver & Bronze. Metal Sculpture of the Roman Baroque*, New Haven and London, 1989.

27 Even in John Pope-Hennessy and Ronald Lightbown, *Catalogue of the Italian Sculpture in the Victoria and Albert Museum*, London, 1964, which in its detail and scale remains the most exhaustive of any museum catalogue of sculpture, the documentary evidence is privileged over the physical. Despite the aim of cataloguers to describe the actual object, the material features of a work are often rather cursorily described and only comparatively recently have catalogues of sculpture included photographs of the backs of pieces.

28 Quoted from the translation in L.S. Maclehose, *Vasari on Technique*, New York, 1960, p. 148.

29 Rudolf Wittkower, *Sculpture. Processes and Principles*, London, 1977.

30 Useful discussions of sculptural models include: C. Avery, 'Giambologna's sketch-models and his sculptural technique', *Studies in European Sculpture*, 1981; C. Avery and A. Laing, *Fingerprints of the Artist. European Terra-Cotta Sculpture from the Arthur M. Sackler Collections*; M.G. Barberini, *Sculpture in terracotta del Barocco Romano*, Rome, 1991; I. Lavin, 'Bozzetti e Modelli. Notes on Sculptural Procedure from the Early Renaissance through Bernini', *Stil und Überlieferung in der Kunst des*

Abendlandes. Akten des 21. internationalen Kongressen für Kuntsgeschichte, 3, 1967, pp. 93–104; P. Volk, *Bayerische Rokokoplastik*, Munich, 1985. A good impression of recent work in this field is given by the papers from two symposia: P. Volk (ed.), *Entwurf und Ausführung in der europäischen Barockplastik*, Munich, 1986; K. Kalinowski (ed.), *Studien zur Werkstatt praxis der Barockskupture im 17. und 18. Jahrhundert*, Poznan, 1992. See also the entries for model in *Reallexikon zur deutschen Kunstgeschichte*, 2, Stuttgart-Waldsee, 1948, cols. 1081–98 (by H. Keller and A. Ress) and in J. Turner (ed.), *The Dictionary of Art*, vol. 21, London, 1996, pp. 767–71 (by Charles Avery). On the relationship between drawings and models, see C. Eisler, *Sculptors' Drawings Over Six Centuries*, New York, n.d.

31 Baxandall, *Limewood Sculptors*, op. cit. (note 1), p. 48.

32 Eberhard König, 'Gesellschaft, Material, Kunst', op. cit. (note 7).

33 Thomas Da Costa Kaufmann, *Court, Cloister and City. The Art and Culture of Central Europe 1450–1800*, London, 1995, p. 487. As Kauffmann suggests (pp. 485–6, n. 6), his chapter 3 may be read as a response to Baxandall.

34 Baxandall, *Limewood Sculptors*, op. cit. (note 1), p. 31.

35 ibid., p. 32.

36 ibid., p. 92.

37 ibid., p. 104.

38 ibid., p. 122.

39 ibid., p. 151.

40 ibid., p. 170.

41 ibid., p. 186.

42 ibid., pp. 192 and 195.

43 ibid., p. 172.

44 Baxandall's interest in this issue has more recently been echoed in various studies about other media that show a similar concern with contemporary perception of, and responses to, technique and facture. These include Phillip Sohm, *Pittoresco. Marco Boschini, his Critics, and their Critiques of painterly Brushwork in Seventeenth- and Eighteenth-Century Italy*, Cambridge, 1991, and Walter Melion, 'Hendrick Goltzius's project of reproductive engraving', *Art History*, 13 (1990), pp. 458–87.

45 For another approach to 'the process of [a work's] making' – a picture by Tiepolo – that does in this case involve drawing see Svetlana Alpers and Michael Baxandall, *Tiepolo and the Pictorial Intelligence*, New Haven and London, 1994, chap. 2. The remarks here about the 'oil sketch' and the reading of the confusing array of contemporary terms of 'an acknowledgement of the fluidity of type and purpose within the genre' might usefully be drawn upon in discussions of eighteenth-century sculptural models, such as those considered below.

46 For a discussion of this aesthetic shift, see Paul Mattick (ed.), *Eighteenth-century Aesthetics and the Reconstruction of Art*, Cambridge, 1993. The implications of the issues raised here for the viewing of sculpture are discussed in David Bindman and Malcolm Baker, *Roubiliac and the Eighteenth-century Monument. Sculpture as Theatre*, 1995, chap. 17, and Malcolm Baker, 'De l'église au musée: les monuments du XVIIIe siècle (fonctions, significations et histoire)', in J.-R. Gaborit (ed.), *Sculpture hors contexte*, Paris, (Louvre conférences et colloques], Paris, 1996, pp. 71–92.

47 Pierre Jean Mariette, *Description des travaux qui ont précédé, accompagné et suivi la fonte en bronze d'un seul jet de la statue equestre de Louis XV*, Paris, 1768. For the book and other images of Bouchardon's statue, see Lise Duclaux, *Le statue équestre de Louis XV*, LIIe exposition du cabinet des dessins, Musée du Louvre, Paris, 1973, pp. 31–4.

48 Current work by Andrew MacLellan and Christoph Franck will, however, address this aspect of the book.

49 This genre has yet to be discussed in any detail but a large number of examples are to be found in the entries for individual sculptors in François Souchal, *French Sculptors. The reign of Louis XIV*, I–IV, Oxford, 1982–91. Many of the engraved versions are gathered in W. McAllister Johnson, *The French Royal Academy of Painting and Sculpture engraved reception pieces, 1672–1789*, Kingston, 1982, and the implications for the way in which sculptors used such means to develop their practices is discussed by W. McAllister Johnson;, 'Visits to the salon and sculptors' ateliers during the Ancien regime' *Gazette des beaux arts*, vle pér., 120 (1992), pp. 17–35. For a possible way of reading the relationship between model and sitter suggested by a brief discussion of one such image – the portrait of Guillaume Coustou – in the wider context of Largillière's portraits by a former graduate student of Michael Baxandall see William MacGregor, 'Le Portrait de gentilhomme de Largillière', *Revue de l'art*, 100 (1993), pp. 29–43.

50 Although not explicitly stated, the approach taken by Baxandall in *Limewood Sculptors* underlies my contribution to Bindman and Baker, *Roubiliac and the Eighteenth-century Monument*, op. cit. (note 46).

51 For the monument and its functions see Bindman and Baker, *Roubiliac and the Eighteenth-century Monument*, op. cit. (note 46), pp. 147–57.

52 The following discussion draws on documentation published in Malcolm Baker, 'Roubiliac's Argyll monument and the interpretation of eighteenth-century sculptors' designs', *Burlington Magazine*, 134 (1992), pp. 785–97. Sources for unreferenced quotations in the present discussion are given there.

53 For this see Bindman and Baker, *Roubiliac and the Eighteenth-century Monument*, op. cit. (note

46), pp. 227–45 and Malcolm Baker, 'Roubiliac and Cheere in the 1730s and 40s: collaboration and sub-contracting in eighteenth-century English sculptors' workshops', *Church Monuments*, vol. 10 (1995), pp. 90–108.

54 On this see Bindman and Baker, *Roubiliac and the Eighteenth-century Monument*, op. cit. (note 46), pp. 266–7.

55 Baxandall's subtly pluralistic position in relation to both curatorial practice and art-historical theory is well illustrated by his remark that 'I do not at all like the tone of the debate, which seems oddly hortatory and peremptory: I dislike being admonished. On the other hand, what I do like is there being a manifold plurality of differing art histories, and when some art historians start telling other art historians what to do, and particularly what they are to be interested in, my instinct is to scuttle away and existentially measure a plinth or reattribute a statue.' The way in which this passage was quoted by Gerhard Schmidt in his essay, 'Probleme der Begriffsbildung' (*Gotische Bildwerke und ihre Meister*, Vienna, 1992, p. 000, citing Baxandall's 'The Language of Art History', *Gazette des Beaux-Arts*, vle pér., 95 (1980), La chronique des arts, pp. 1–2, which had been adapted from an article in *New Literary History* that was later to appear in another form in Kemal and Gaskell, *The Language of Art History*, op. cit. (note 6) is in itself an indicator of the diverse uses to which Baxandall's approach might be put. (I am grateful to Paul Williamson for these references.)

Michael Baxandall and the Shadows in Plato's Cave

Alex Potts

19 Donald Judd, *Untitled 1968*, Amber Plexiglass and stainless steel, 84 × 173 × 122 cm., Whitney Museum of Art, New York.

One reason I described the painting so carefully is because I don't think people look at art very carefully. My experience with art history at Columbia was that art historians never look at paintings.

You have to do it all at once. You have to look and understand, both. In looking you understand; it's more than you can describe. You look and think, and look and think, until it makes sense, becomes interesting.

I don't know what had happened to the pragmatic, empirical attitude of paying attention to what is here and how; it is basic to science. It should be basic to art too.[1]

Donald Judd

These quotations may seem a curious way of introducing my discussion of Michael Baxandall's engagement with Enlightenment conceptions of picturing and visual cognition in his book *Shadows and Enlightenment*. I have put them here not so much because they strongly informed my own reflections on shadowing in visual art as I was reading the book, but because I found them unexpectedly apposite to certain key aspects of Baxandall's analysis. I myself was surprised to discover how close some of Judd's and Baxandall's informing preoccupations appear from a present-day perspective. Obviously, a postwar American Minimalist artist would have thought about the visual logic of his own and his contemporaries' art in very different terms from a British art historian trying to reconstruct the role of shadow in Enlightenment understandings of visual perception and depiction. Yet Baxandall's project is informed by an underlying sense of purpose that has intriguing affinities with Judd's priorities as a writer and artist. The discussion that follows aims to show how and why this is the case.

This is by no means an attempt to cast Baxandall as a closet Minimalist. For a start, what is interesting about Judd is not the Minimalist imperative, but the commitment he had to looking intensively and thinking hard about the material specificity of a visual engagement with things. Moreover, I must admit that I entered Baxandall's world of Enlightenment shadows carrying a certain amount of baggage from my earlier readings in eighteenth-century conceptions of picturing, and that the latter in turn probably played a role in my being drawn to Judd's rigorous yet no-nonsense empiricism in the first place. Before saying any more about my own interests in Baxandall's shadow project, however, I must consider what might have impelled Baxandall to produce a book that in scope and tenor departs so radically from his earlier writing.

Shadows and Enlightenment is strikingly different in conception from the work that made his reputation, namely *Giotto and the Orators* (1971), *Painting and Experience in Fifteenth-Century Italy* (1972) and *The Limewood Sculptors of Renaissance Germany* (1980). Seen as an exercise in the cultural historical analysis of art, it might easily seem less rich, and less expansive, than these well-known studies on the Renaissance. But in present circumstances, it ends up being the more powerful and suggestive for risking a different set of priorities.[2] To clarify why this is so, I need to focus for a moment on a larger shift that has occurred in art-historical studies, away from the commitment to an out-and-out historicizing analysis of art informing so much of the more innovative art-historical scholarship of the 1960s and 1970s.

Shadows, published in 1995, follows on from *Patterns of Intention. On the Historical Explanation of Pictures*, which came out in 1986. In the latter, a book which a number of readers found a little baffling, a disjunction opens up between the elaborate accounts of the cultural circumstances that might have shaped the individual works or case studies which it analyses in detail, and the critical interpretation of these works' pictorial qualities. As if courting ironic reflection on

the book's subtitle, 'On the Historical Explanation of Pictures', Baxandall's painstaking presentation of a dense web of social and cultural detail relating to each work never quite fuses together, and never quite generates a convincing account of the inner workings of the picture concerned. While he seems to be offering more than enough contextual material to provide a thick description of the pictures he discusses, he effectively ends up turning back to the reader to say 'Look, this bundle of material can never of itself form a compelling interpretation.' It is as if his presentation is posited on the vague promise of a metaphoric fusion of cultural history and pictorial analysis, but constantly falters in the face of a stubborn tendency to metonymic dispersal. The effect is the more disconcerting because Baxandall does not allow a formal or aesthetic logic to take over either. The dense array of contextual material may keep failing to produce a cogent indication of the artist's intentions, but no compensatory solo performance by the artist ever quite takes off, so the contextual material can become background accompaniment. This may make the book seem a strangely perverse refusal of the larger ambitions of a social history of art, or else something of a failure. It is neither of these, for neither alternative does justice to the intractability of the difficulties it so curiously exposes and evades.

The repressed unease with 'historical explanation' in *Patterns of Intention* is symptomatic of something larger that was taking place at the time, both in Baxandall's project as an art historian and in the field of art and cultural history generally. By the early 1980s the imperative to historicize, which had played such an important role in the critical analysis of art and culture in the previous two decades, was faltering. The cardinal sin was now no longer being unhistorical but being untheoretical.

By the term historicize I do not mean a token insistence that past cultures should be understood in their own terms as distinct from present-day ones. At issue was a more ideologically loaded mind-set – an intensified awareness that important forms of knowledge and everyday social and economic practices of earlier cultures were lost, and that a convincing historical recuperation of these needed to recognize their radical difference from anything existing in the present. Such historicizing is evident in the work of Annales historians, such as Braudel, on pre-modern social and economic formations,[3] as well as in the new studies on the history of science by Kuhn and Foucault, with their insistence on the radical discontinuities in basic paradigms of scientific knowledge.[4] It was fuelled by curious mixture of attitudes – a thoroughgoing modernizing impulse on the one hand, combined with a deep-seated antipathy to dominant liberal or progressive models of modernization on the other, and fuelled both by radical and conservatively nostalgic impulses, sometimes simultaneously. Past cultures were imagined as valuable depositories of lost social and cultural forms, and the historian's imperative was to recuperate these in their integrity, undiluted by contemporary intellectual and ideological imperatives; only thus would be revealed what they had to offer of value to the present, as genuine alternatives to underlying contemporary attitudes and practices, as pointers to ways of thinking and acting radically otherwise. This was the case, whether, as in Frances Yates's cult text *The Art of Memory* (1966), it was a matter of recuperating a previously neglected occult tradition of thought that had flourished in the Renaissance, or

whether it was a case of bringing to light the vitality of archaic forms of labour in nineteenth-century industrial Britain, as in Raphael Samuel's seminal essay 'Workshop of the World: Steam Power and Hand Technology in mid-Victorian Britain' (1977).[5]

Such an historicizing bent confirmed, even overdetermined, a privileging of the historical in the study of the visual arts. It was no longer simply a matter of drawing out the historical particularity of past artistic forms or styles, but of understanding these forms as integral to the distinctive social and cultural fabric of the worlds from which they emerged. Such study raised urgent questions about mediation: how did non-artistic realities shaping the milieu inhabited by the artist and his/her audience enter into the art produced?[6]

Michael Baxandall has a particular and very exacting take on this issue of mediation. He has sought to identify everyday social practices that involved an attentiveness to visual form and demonstrably operated in the milieu inhabited by artist and patron. For him, it was not then a matter of seeking in art a reflection of the more significant historical realities of the culture concerned. Forms of expertise and ritual practices which might seem relatively marginal in a broader historical perspective were singled out by Baxandall because in them notions of visual ordering took a concrete form which could be seen to structure fundamental aspects of artistic depiction – the cultivation of a subtle inflection of line in penmanship in Renaissance Germany, the deployment of a formalized language of gesture familiar to preacher and congregation in Renaissance church services, or a pragmatic awareness of the structural qualities of different kinds of wood among craftsmen in fifteenth- and sixteenth-century Germany. *The Limewood Sculptors of Renaissance Germany*, published by Baxandall in 1980, is one of the classics of the social history of art. The book offers a comprehensive historical account of a major artistic tradition and provides a compelling analysis of the distinctive qualities of the art involved by grounding its production and reception in social and cultural practices of the time.

Baxandall's work made its initial impact at a time when a commitment to careful historical analysis of the social and cultural context of art was almost taken for granted. It was, for example, a guiding impulse of the ambitious new publishing initiatives launched by Penguin at the time under the editorship of Hugh Honour and John Fleming, the 'Style and Civilization' and 'Art in Context' series. 'Art in Context', in which each volume was designed to 'discuss a famous painting or sculpture in detail, as both image and idea, in its context whether stylistic, technical, literary, religious, social or political', gave rise to such classics as John Gage's *Turner: Rain Steam and Speed* (1972) and Bob Herbert's *David: Brutus* (1972). 'Style and Civilization', which included some influential and widely read texts like John Shearman's *Mannerism* (1967) and Linda Nochlin's *Realism* (1971), offered itself as an alternative to the traditional object-focused art history of the then dominant Pelican History of Art volumes: 'This series interprets the important styles of European art in the broadest context of the civilization and thought of their times. It aims, in this way, to achieve a deeper understanding of their character and motivation.' Where the work of art historians such as Michael Baxandall and Tim Clark stands out is in the albeit very different way each recognized the potential limits of such historical contextualizing and how it might

so easily become merely formulaic unless driven by a sense of ideological and intellectual purpose, by a fascination sparked off in the present without which past cultural forms would have little resonance or value.

Seen from a present-day perspective, a lot of this social and cultural history of art seems to be based on working assumptions about the possibility of an historical anchoring of the interpretation of art that is no longer entirely credible. There was an unspoken confidence that a clear and systematic differentiation could and should be made between modern attitudes and cultural paradigms, and pre-modern ones, and that a coherent picture of the unfamiliar cultural usages and normative values of past cultures could be reconstituted through a scrupulous examination of primary historical evidence. Not only was it believed that the art of a 'traditional' society, like Renaissance Italy or Germany, was to be understood by drawing out the particularities of its cultural milieu that made it categorically different from our own. It was also assumed that these differences provided the basis for an interpretation of the art grounded in concrete realities rather than tenuous subjective impressions.

In the particular case of Baxandall's analysis of Italian and German Renaissance art, the implication was that we would only develop a richer and more solid understanding of this art by finding out about specific visual discriminations of things practised in the artist's social milieu, but no longer current in our own culture. The grounding of our analysis would be all the firmer if these visual practices could be identified with linguistic distinctions articulated at the time. For example, an analysis of terms used to distinguish dance patterns, which were part of the everyday cultural equipment of anyone moving in the Florentine high society for which a painter like Botticelli worked, might help us to articulate the significance of the dance-like compositions of some of Botticelli's large mythological paintings.[7] It appeared that however important our own close engagement with a picture, historical reconstruction of unfamiliar aspects of the artist's milieu provided the most vivid moments of insight.

Patterns of Intention is symptomatic of a break-up of such assumptions. Its deeply ambivalent attitude to the prerogatives of an 'historical interpretation of pictures' is particularly evident in the chapter on Piero della Francesca's *Baptism of Christ*, which contrasts sharply with Baxandall's earlier treatment of Piero's work in *Painting and Experience in Renaissance Italy*. A wide range of cultural circumstance is invoked, including a rather perfunctory reference to Baxandall's own earlier argument that the visual logic of Piero's work could be related to the practice of gauging volume from container shape, which was part of a merchant's everyday expertise at the time. There is a sense that, in the end, none of the cultural historical detail seems to matter that much. The more intriguing aspects of the work's pictorial order, which Baxandall highlights at the end of his analysis, are emphatically – one might almost say defiantly – modern. Piero, no less than Picasso in Baxandall's chapter on the portrait of Kahnweiler, seems to be caught up in distinctively twentieth-century problems of picturing, the squaring up of suggested depth with the flatness of the picture plane. I suspect that this effect is partly unintentional and doubt that Baxandall was inviting us to engage in a Greenbergian reading of Piero. Rather, the apparent incongruity signals a disengagement from the larger ambitions of 'historical interpretation'. The

implication seems to be that, however carefully we uncover the cultural determinants which helped shape a work of art – in the case of Piero's *Baptism*, the formatting of the type of altarpiece he was commissioned to paint, and theological doctrines relating to the function of baptism – this will not necessarily provide a foundation for developing a convincing critical interpretation of the picture. When we engage closely with a work and ask why we find it compelling, we cannot count on historical props to reassure us about the significance of our inquiry. If we seek to escape this condition by imagining a lost community of values in Renaissance Italy, which once gave social substance to those aspects of Piero's work we find most intriguing, that may be more of a comforting illusion than anything else.

But equally, Baxandall did not want to offer a purely formal interpretation that had no anchoring in contextual detail, and the way he ended up giving such priority to his own critical engagement with the pictures made him feel a little uneasy. Those observations of his which seemed to offer the most telling insights, those involved in his parting note – 'Behind a superior picture one supposes a superior organization – perceptual, emotional, constructive' – are also ones he described rather wryly as 'intended to be provocative, or at least conspicuously disagree-able'.[8]

The section of the book which I found most illuminating, and least constrained by such ambiguities, was the section on Chardin and Enlightenment preoccupations with problems of visual perception and attention. Here, rather than the disparate array of cultural circumstances presented elsewhere in the book, which Baxandall appropriately called 'troc', something much more selective is being offered, that from the outset is structured by a critical assessment of the picture involved, Chardin's *Lady Taking Tea*. The possibility that a categorical difference might open up between the priorities we bring to bear making sense of the picture, and those informing the artist's fashioning of the work, is not an issue here. Certainly, Baxandall is careful to give his critical categories a basis in forms of understanding that we could assume to have been current in the Parisian art world inhabited by Chardin. But these are not categories that would necessarily seem alien to modern ways of attending to pictorial representation. He does not seek to make an issue of the problems of historicity summed up in the chapter heading to his discussion of Piero – 'Truth and Other Cultures'.

When he does identify a sense of strangeness or estrangement in Chardin's painting, this has not so much to do with its cultural specificity as with the unusual mode of engagement it invites from the viewer. His analysis underlines how a close examination of the picture draws the viewer into a curious interplay between a focused visual attentiveness and a sense of dispersal. And in this instance, quite exceptionally, he envisages the possibility of engaging with the picture in explicitly psychic terms. It might be, he suggests, 'a sort of Lockean Apollo and Daphne' – in other words, a version of the mythological tale about a god's desire thwarted by the metamorphosis of its object which is now being restaged as an empiricist drama of viewing, one in which the apprehension, and also perhaps possession, of the object which engages the viewer's attention is simultaneously intensified and frustrated. In Baxandall's own words, the picture presents the viewer – and here we should say above all a male viewer – with 'a

reenactment of bafflement by and the elusiveness and sheer separateness of the woman – who is, I can by now say without colouring your perception too much, probably Chardin's first wife a few weeks before her death'.[9] The critical interpretation in this instance achieves a kind of condensation which eludes him in his more dispassionate discussion of Piero. The evidently charged fascination exerted by the picture, a similarly charged fascination with visual sensation and perception registered in the eighteenth-century texts Baxandall discusses, and the fascination we might have with the distinctive inflection he gives to both, are inseparable from one another. At the same time, we are denied the epistemological certainty of making clear distinctions between that which is specific to the milieu in which Chardin produced the picture, and that which is specific to the ideological, cultural and psychic baggage we bring to bear viewing it. Such is the territory in which *Shadows and Enlightenment* operates.

In its very structure *Shadows and Enlightenment* defies a neat separation between eighteenth-century understandings of visual sense experience and modern ones. A good part of the book consists of a thoughtful and at times quite technical account of Enlightenment and of present-day speculation about the role played by shadow in visual perception and cognition. One has to grapple with nuts-and-bolts problems in optics and in the physiology of visual perception. For example, Baxandall takes us through eighteenth-century scientific studies explaining the blurring and colouring of shadows in terms of the diffraction and reflection of light, and also through some recent studies using computer simulation to explain how the eye and mind process clues offered by shadowing to build up a picture of three-dimensional shape. At the same time he makes us more fully aware that ambiguities and complexities of shadowing which normally escape our notice are integral to the fabric of visual experience and to the effects which constitute visual art.

Why then the historical focus on the Enlightenment? There is one very straightforward answer. The Lockean empiricism pervasive in eighteenth-century thought threw into particularly sharp relief the role played by visual perception in the operations of the mind. How we build up a coherent picture of the world from the flux of visual sensation that comes our way became a central issue once it was believed that our understanding of things ultimately derives from sense experience. And there is the further point that modern conceptions of Enlightenment are permeated by images of light and illumination – Enlightenment thinking is often thought of as motivated by an urge to dispel shadows and obscurities. Baxandall's analysis makes us realize that an empirically focused preoccupation with light inevitably produces a fascination with shadow, one that involves a heightened attentiveness to the way areas of relative deprivation of light in our field of vision both obscure and give greater definition to what we see.

But we still might want to ask what larger justification there is for Baxandall's rather technical focus on shadowing in visual art. A disquiet underlying the compulsion to ask this question, which rises to the surface on several occasions in Baxandall's analysis, in a sense defines the logic of his book. Shadowing and shading, as he himself admits, can seem a narrowly technical concern. Is not the exclusive preoccupation with shadow in danger of offering a rather aridly formal perspective on the eighteenth-century pictorial imagination? And is not shadow

also peripheral to even the more purely painterly obsessions of the modern art world? Baxandall's book made me aware of how shadowing plays a significant role in constituting key aspects of what a viewer sees when engaging closely, not only with pictorial representations, but also with sculpture. The apparent marginality of shadowing in conventional understandings of visual aesthetics is part of what makes the phenomenon so intriguing. Baxandall impels us ' to look and think' about shadows in art, 'to look and think, until it makes sense, becomes interesting' – as Judd put it. The value of thinking about shadow is that it makes us attend to an aspect of visual experience which affects our response to any work of art, but which we are rarely conscious of except as secondary adjunct or minor interference.

On the question of historicizing, we have seen how Baxandall's discussion of the scientific understanding of shadow pointedly refuses to offer any clear-cut distinction between Enlightenment and modern ways of thinking. What happens when the book moves to considering shadowing in art? A historicizing mind-set, and above all one sympathetic to notions of visual culture, would feel secure in assuming that Enlightenment thinking about the larger cognitive and perceptual issues raised by shadowing – particularly if it could be shown to have permeated to figures who played an active role in the art world – would tell us something significant about conceptions of shadowing prevalent in eighteenth-century art. But for Baxandall there is no such historical reassurance. The distinctive pre-occupation with shadow that interests him is both a compelling, yet at the same time, marginal feature of eighteenth-century painting. It is clear that Enlightenment shadow came to fascinate Baxandall because he had been captivated by the peculiar vividness, subtlety and complexity of shadowing in Chardin's painting. But he also makes it clear that, for the most part, shadowing for eighteenth-century artists was a technical resource dissociated from any real probing into the fabric of visual experience.

In thinking how Baxandall's study of shadow might prompt us to look closely at works of art in ways we might not have done before, the best point to start is the most obvious one, the art of the Enlightenment. Once our attention is drawn to shadows, we start noticing them everywhere, in almost any art that comes our way. This can easily become an idle and even irritating pastime, that may even start blocking our full awareness of the complex processes of picturing of which shadowing is part. Having started out on this path, cruising around in my memories of eighteenth-century painting and sculpture, however, it became clear to me that something quite elusive and also quite significant was at issue.

In the first place, there are the accepted shadowing conventions used in eighteenth-century painting to clarify form and to enliven visual effect. Baxandall discusses in some detail the standard shading devices utilized by painters of the period to enhance the sense of three-dimensional depth created by forms and marks on a flat surface. These devices roughly fell into two categories – shading single objects, such as the human figure, to give relief to the flat shape defined by the object's contours, and modulating the depiction of cast shadows in a larger environment.

But the more demanding eighteenth-century thinking about shadows involved much more than this. What in the end mattered for most painters was a

serviceable, if skilled, technical understanding of shadows and their pictorial depiction, which evaded their more ambiguous and puzzling aspects. An obsession with shadow effects, that would parallel the intensive speculation about shadow perception in the thought of the period, would have to go a stage further, to a fascination with less commonly observed phenomena, such as variations in the blurring of shadow edges and unexpected colouring and gradations of light and shade within shadows. By contrast with a conventional understanding of shadow, shadow in these cases is something that might produce momentary indeterminacies in the perception of local shape and colour. It is about shadowing as a material phenomenon in its own right that could not simply be made subservient to a clarification of shape and depth.

For Baxandall, Chardin is the artist most deeply involved with such subtleties, who made them the very object of his art, as Diderot recognized at the time in his famous accounts of Chardin's paintings exhibited at the Paris Salon in the 1760s.[10] He also cites Oudry, whose interest in subtleties of illumination and shadowing was dramatized in his famous white-on-white still-life. But does the shadow world that fascinates Baxandall extend much beyond the apparently modest still-life and genre of Oudry and Chardin? It both does and does not. There are plenty of eighteenth-century painters interested in complex and striking lighting effects – take Joseph Wright of Derby, for instance. But their use of shadowing is usually quite conventional. The strong contrasts of light and shade produced by candlelight, for example, often cover up for quite a crude rendering of shadow, that does not go much beyond standard academic techniques for using shading to produce a sense of relief. The light-and-shade contracts might be striking, but have nothing substantially to do with the ambiguities and subtleties of visual cognition – as viewers, we find ourselves looking into a world of clearly circumscribed, light-resistant and fairly hard surfaces. Baxandall shows how something more resonant is sometimes going on in the registering of shadow in the more painterly figure drawing of Venetian artists such as Piazetta and Tiepolo; indeed there are intriguing signs of an intensified awareness of shadow effects and their ambiguities in the presently rather neglected Venetian art of the earlier to mid-eighteenth century. In Britain, the only painter I could think of, off hand, who made special use of shadows was Stubbs, though his obsession was rather different from Chardin's, being most evident in his subtle use of low-level shadowing to create some quite remarkably animated modelling of smoothly rounded surfaces – horse's flanks, for example.

There is an interesting world of Neo-classical shadowing lying outside Baxandall's purview, concerned with creating a subtle play of light on things so the definition of their surfaces appears both precise and suggestively elusive. David's work is a good example. Pictures like *The Death of Marat* and *The Death of Bara* come alive through their shadowing. Particularly in these works, there is an almost unsettling interplay between shadowed areas, surface texture and the variegated substance of the paint. You only need to compare such paintings with similar works by his pupil Girodet, such as the latter's famous *Endymion*, to see what I mean. The subtle and complex play of light and shadow in David becomes all the more apparent when set beside the crudely dramatic light-and-shade contrasts of Girodet's work, which deploys a quite formulaic academic shading of

form to create a firm sense of solidity and depth. And something akin to David's interest in a play of light and shadow is evident in the more sophisticated Neo-classical sculpture of the period, though the medium makes the issues rather different. Any sculptural shadow has to take account of the way that even slightly different lighting conditions produce variations in shadowing, though this was at the time somewhat mitigated by the relatively uniform use of diffuse top lighting in sculpture galleries. Think how, if we look closely at one of Canova's marble sculptures, we end up having a more vivid awareness of the subtle effects of light playing on its gently variegated surfaces than of the underlying shape. The main forms of his nude figures are usually designed to face the viewer frontally and the direct light falling on their smooth surfaces tends to flatten them out. At the same time a sense of three-dimensionality is suggested by emphatic shadowing along certain edges of the bounding contour; while a closer viewing reveals the apparently flat expanse of white in the middle to be modulated by elusive hints of shading here and there.

While Baxandall is concerned with the direct depiction of variations of light intensity produced by shadow in painting, rather than their indirect and less controlled use in sculpture, his study is very suggestive for thinking about sculpture on a number of counts. For one thing, it is a reminder that the sense of three-dimensional shape that emerges from viewing a sculpture is created to a large extent from our perception of the variegated shadowing of its surface. The tactile effect of sculpture is inseparable from optical subtleties of shadowing and reflection. Baxandall also makes an intriguing reference to modern scientific studies on the invariant aspects of the shading of basic shapes under different lighting conditions that would be fascinating to pursue in relation to the manipulation of shadow effects in sculpture. For example, to what extent, if at all, might certain sculptors have been attentive to such invariants, even if unconsciously, so as to accommodate their work to variations in lighting?[11]

In the end, our priorities bring into focus those instances where shadows emerge from eighteenth-century art with particular intensity and subtlety. The examples I have chosen are rather different from Baxandall's, but they too are exceptions. One is not talking about a typical or underlying concern of eighteenth-century art. Which brings me to a further implication of Baxandall's analysis which I wish to address, but one on which he remains determinedly silent. Do shadows, in the rigorous and exacting sense he has in mind, matter for the contemporary visual imagination? One's initial response would probably be a categorical no. Is he then looking to the eighteenth century because there is a gap or blank in this respect in our own painterly world?

The depiction of shadow is almost precluded in the new large-scale out-and-out abstract or non-representational work which emerged in the 1940s and 1950s, particularly in America, and which has dominated the language of painting ever since. If shadows there are in recent art, shadows impinging on one's perception of shape and form, they are real shadows, shadows produced by actual objects – in other words sculptural shadows, or shadows cast by the edges of unframed canvases. A lot of obsessive formal talk about postwar abstract painting has focused on edges – and what we see of these edges depends on shadowing. Shadowing can also make itself felt as absence. A significant effect of the flat

expanses of colour in colour field painting, where there is no hint of internal shading of the kind that usually anchors a sense of depth, is the way that we are momentarily suspended in the open intangible spaces of a strangely shadowless world.

If there is no sensation, no perception, no cognitive awareness of pictorial or sculptural form without some shadow modulating, enhancing or confusing it, this certainly does not feature in the critical consciousness of the present-day art world. Even where shadow effects emerge most unavoidably, in three-dimensional art, art-critical discourse seems largely oblivious to them. This appears to be true of Judd whom I cited at the outset. The lighting of his work may have been a real issue for him. But when he complained that 'museum lighting is pretty bad' – 'All my pieces are meant to be seen in even or natural light' – he went on to explain that 'the shadows are unimportant, they are just a by-product.'[12] Here we seem to have the common-sense view that form and shape are primary, and shading something secondary, even irrelevant. But this makes absolutely no sense if we look at all closely at Judd's work, and also consider the lengths to which he went to guarantee that at least some of his work would be seen under appropriate illumination which did not spoil its more subtle optical effects.

Judd's disparagement of shadows in the passage quoted above was directed at the crude shadowing produced by the spotlighting of sculpture in modern artificially illuminated galleries. These spotlights create strongly defined and arbitrary shadows which can positively interrupt the viewing of a work. We live in an installation-conscious artistic world which can still be peculiarly blind to the effect of lighting on individual objects. Many curators' sense of sculptural display does not go much further than putting a spotlight on a work to create a dramatic light-and-shade effect and direct the viewer's attention to it. I remember once seeing the marble *Diskobolus* in the British Museum in a temporary exhibition with a few strong spots training on it creating crude sharp-edged shadows cutting across its surfaces which completely fragmented and flattened its forms. Curators often seem to be oblivious to the fact that relatively diffuse lighting is needed to allow the play of light and shadow to give shape and visual inflection to the surface of a sculpture.

It was being at the mercy of such curatorial negligence that Judd was objecting to, understandably, given his work's dependence on relatively diffuse and even light to achieve its effect. Optical subtleties – reflections, variegated shadows, and their changing effect as one moves around the work – form such an unavoidable component of what we are looking at with Judd because the forms are so simple. Similar effects are important, if less obviously so, in other work by contemporary artists. A play of shadow and surface illumination is integral to a lot of sculpture, indeed, in my view, to any interesting sculpture. It is only academic theory which has it that the distinctive thing about sculpture is plastic form entirely divested of 'painterly' effects.

To show more precisely what I mean by the significance of shadow effects for so-called Minimalist work, I take as an example a work by Judd that makes particularly intriguing use of shadows: an untitled box-shaped object set on the floor dating from 1968 (plate 19). Two sides and the top are of translucent pink Plexiglass and the ends of polished stainless steel. Running through the centre is a

rectangular tube of the same polished steel as the ends into which it is fixed. Looking into the rectangular opening of the tube from either end, you see a deepening darkness modulated by the outlines of cast shadows at the near edges. You can see through the Plexiglass top and sides into the interior to the reflecting surfaces of the tube suspended within, but your sense of the latter, and of the box's boundaries, become quite ambiguous because of the complex play of shadow and reflection, and the shifting patterns of coloured light penetrating the Plexiglass. The clearly bounded simple structure of the interlocking inner and outer boxes begins to dissolve, and the more one fixes one's attention on the reflecting, translucent, shadowed surfaces, the more elusive the form of the whole becomes. You need to relax your focus and let your look float freely over the work again to grasp it as a simple shape.

I started by speculating how Baxandall's close looking at shadows might in some way echo preoccupations evident in contemporary art. But Judd is not quite a contemporary. His insistence on a close and careful looking, and his attentiveness to visual sensation, comes out of a culture I associate with the 1950s and 1960s, a moment when a preoccupation with the fabric of visual experience and the materiality of things was a dominant concern of much interesting art and film. Greenberg's empirical formalism gave a systematic and latterly academic cast to these preoccupations.

The distinctive focus on shadow as an aspect of visual sensation in Judd's work is pretty unusual even when seen in relation to his closest so-called Minimalist contemporaries. While Carl Andre, for example, exploits to great effect the reflectivity and textures of materials – think of the varied play of light on the slightly uneven part-matt part-shiny surfaces of metals in his square floor pieces, for example – the radical flatness of most of his work seems designed to exclude or to render very marginal effects of cast shadow and shading. But Judd was not quite alone. Flavin and Hesse, for example, were also intrigued by the materiality of light and colour and the fixing and unfixing of form that occurs with the play of illumination – things made manifest in a world, if not just of shadows, then of light modulated by reflection, translucence and opacity.

I realize that I have been pushing the Baxandallian shadowplay in Judd's work to extremes which might run counter to either's understanding of his project. For all I know Baxandall cannot stand Judd's work, though I would like to think that Judd might have had some respect for the 'pragmatic empirical attitude' of Baxandall's investigation of shadow as 'real material fact, a physical hole in light' that 'has neither stable form nor continuity of existence' ... 'the outcome of a relation between light and dense solid'.[13]

But there is another dimension to Baxandall's understanding of shadows, another necessity to his obsession with 'shadows and Enlightenment' with which I want to finish, one that extends beyond the relatively narrow world of viewing and making works of art, even if that is where these obsessions need to start and return to gain any resonance and substance. Baxandall's final and most significant exemplification of what he calls 'Rococo-Empiricist' shadow is a tiny painting by Chardin: *The Young Draughtsman* (plate 20). At the most straightforward level the picture is about the depiction of shadows, for it shows a young man concentrating on trying to copy an academic drawing of a figure pinned to a wall

in front of him. This drawing within the picture offers a textbook exemplification of standard devices of modelling through a tripartite scheme of lights, half-tones and shades. It also makes a feature of the shadow cast by the depicted figure on its surroundings. Set in front of the drawing, which is placed so that it faces out to us directly, there is the real scene with the draughtsman seated on the floor, seen slightly diagonally from the back. Here, 'in reality', we again have highlights, shading, and strong-cast shadows, some clarifying the shape of objects and the enclosing room, others obscuring them. Much of the draughtsman's sharply foreshortened left leg is impossible to read because it is both obscured by a large shadow from an unseen object outside the picture frame and traversed by a

20 Jean-Baptiste Siméon Chardin, *The Young Draughtsman*, 1738, oil on panel, 19.5 × 17.5 cm, Nationalmuseum, Stockholm.

sharp edge of darker shadow cast by the portfolio he holds on his knees. He is completely absorbed in drawing, but in a slightly awkward pose that suggests that his laboured attentiveness to the complexities of form and shading might be slightly missing the point. And it is in that ambiguity that the most significant critical thrust of Baxandall's study lies. The young draughtsman stands in for everyone, however expert, for us as readers and viewers, and even for Baxandall as our guide.

As Baxandall puts it, 'the comedy is that as soon as we are addressing shadow we are liable to denature it ... It becomes something other than the shadow of usual experience simply by being addressed as itself.'[14] Baxandall, however, has not taken us through a complex argument about shadow perception simply to invite us to go off and experience shadow in a nice everyday way. He is here facing up to the idiocy latent in any too-focused and compulsive attentiveness, just the sort of thing that scholarly art historians are prone to once they have discovered a pet focus and are determined to make as much mileage out of it as possible. Baxandall has a nice point to make in this connection about how one might find one's awareness of things both clarified and led astray by getting caught up in observing the subtle changes in intensity of cast shadow with distance as identified by the eighteenth-century French artist and theorist Cochin: 'Once Cochin has led one to attend, one notices something like his scheme in operation in the visual world, continually: pensively gauging the penetrability of middle-ground shadows can become an enjoyable part of life ... On the other hand, that may be a morbid pleasure, a deformation.'[15]

Baxandall is looking for a way of thinking about visual perception which involves both a sharp focusing and a relaxing of attention. We might be inclined to call the latter inattentiveness, were it not that the free-floating openness of

awareness it allows provides the basis for any finely tuned conscious perception of things. To see this duality as an alternation between attention and inattention is misleading to the extent that inattention tends to come out as the negative of attention, whereas it is precisely in the moment of inattention that certain fundamental aspects of visual experience are processed and made sense of. We might be prompted to see here analogies with other forms of 'scientific' exploration of how the mind works – for example, the psychoanalytic insistence that conscious operations of the psyche can only be understood if we try to ground them in what cannot be made conscious, in the so-called unconscious. But this analogy-making threatens to broaden Baxandall's argument to the point where it can too easily be accommodated to contemporary obsessions with the limits and irresolvable conundrums of systematic scientific inquiry.

There are two aspects of Baxandall's analysis that guard against this broadening. One is that he is exploring the phenomenon of shadow perception at a level where it is both an object of specialist scientific inquiry and an aspect of everyday non-scientific experience. There is the further point that he is not claiming to be dealing with visual perception in general, but with some specific and historically localizable obsessions with the nature of visual perception and shadows. His insistence on exploring particular facets of looking in such an exhaustive and concrete way yields some important and surprising general insights into how we engage with and make sense of the physical world. Baxandall himself invites us to speculate on such larger questions when he concludes: 'For many purposes "attention" effectively disables itself as a concept by reducing the "in-attentive" to a negative or absence of something, rather than the active, determined and structured field in which consciousness plays . . . In this respect, at least, shadow is a quite provoking image of the makings of any actual experience at all.'

Any actual experience at all is the crucial phrase. Shadow works so powerfully because it is always there in what we see – it produces both clarity and obscurity in our apprehension of the world around us. It gives a vividness and variety to our perception of things, it brings the play of light on them alive, but it also deadens sight, and opens up holes in our visual field – in the deepest shadows, there is nothing to see. For someone looking intently, the play of shadow might appear a play of life and death – as Diderot suggested when he described Chardin's commitment to rendering the minutiae of visual sensation as that of a true philosopher.[16]

This is rather heavy a note on which to end, so I would like to switch track by citing Baxandall's wry reversal of Plato's philosophical parable about people imprisoned in a cave who can only see the shadows of objects passing behind them. Condensed in this parable are many conventional ideas about shadow as insubstantial appearance or illusion that has no bearing on the true form, the essence of things. But for the pragmatic, inquiring empiricist seeking to make sense of what there is to be seen, the play of optical effect in Plato's cave could still have a certain substance. The shadows might yield very little as images of objects, but there was something to attend to carefully in the way they fell on the surfaces of the cave. 'Even in Plato's cave', as Baxandall puts it, shadow 'must have offered some sort of information about a light source and a wall, if that was desired, but

ı are shut up in a cave, and it is not completely dark,
however modest a way, with whatever light is being
ıappens if you sustain a fascination with the flux of
ır way, if, in other words, you remain alive to the here

ɔn is a think apart,

rience..
r-ending meditation..

mise that reality
be a shade that traverses
ıat traverses a shade.
Wallace Stevens[18]

Alex Potts
University of Reading

Errata

On page 83

This should read: 'The eye's plain version is a thing apart'.

On page 77, in line 13 of the second paragraph the sentence beginning 'The light-and-shade . . .' should read: 'The light-and-shade contrasts might be striking,'.

The publisher regrets these errors.

[margin tilted text:] Section appears as 'The eye's plain version is a think apart' in the first line of the quotation from Wallace

Notes

1 *Donald Judd* (Kunstverein St Gallen, 1990), pp. 55, 54, 56. Judd is referring to his description of Barnett Newman's *Shining Forth (to George)* in an essay he published in 1970.
2 A discussion with Michael Podro was instrumental in clarifying my ideas on what made Baxandall's new book so intriguing and puzzling, though I alone must take responsibility for anything said here.
3 See for example, F. Braudel, *Capitalism and Material Life 1400–1800*, first published in French in 1967 and translated in 1973.
4 M. Foucault, *Les Mots et les choses* (1966; translated as *The Order of Things* in 1970) and T. Kuhn, *The Structure of Scientific Revolutions* (1962).
5 *History Workshop Journal* 3 Spring 1977, pp. 6–72. There is a nicely symptomatic comment (p. 58) in Samuel's study where he challenges the whig version of the history of the industrialization as a steady progress towards modern forms of mechanization by insisting that a close study of the fabric of economic life in mid-Victorian Britain revealed 'a less orderly canvas ... one bearing more resemblance to a Bruegel or even a Hieronymous Bosch than to the geometric regularities of a modern abstract'.
6 One of the more influential studies of this kind was Francis Haskell's rigorously empirical *Patrons and Painters: a study in the relations between Italian art and society in the age of the Baroque* (1963).
7 Baxandall, *Painting and Experience in Fifteenth-Century Italy* (1972), pp. 77–81.
8 *Patterns of Intention*, p. 135.
9 ibid., p. 103.
10 These intriguing critical interpretations of Chardin's work are gathered together in D. Diderot, *Oeuvres esthétiques* (Paris, 1965), pp. 481 ff.
11 *Shadows and Enlightenment*, pp. 56–9.
12 *Donald Judd* (Pasadena Art Museum, 1971), p. 41.
13 *Shadows*. p. 144.
14 ibid., p. 145.
15 ibid., p. 124.
16 From the 1765 Salon, quoted in D. Diderot, *Oeuvres esthétiques*, p. 486. See also *Diderot on Art* (1995), translated and edited by John Goodman, vol. I, pp. 60–1.
17 *Shadows*, p. 144.
18 From the poem 'An Ordinary Evening in New Haven'.

Last Words (Rilke, Wittgenstein) (Duchamp)

Molly Nesbit

> I want to do Roger Fry over again after nature.
> —Michael Baxandall[1]

> My chance is different from your chance.
> —Marcel Duchamp[2]

What shape does knowledge take? What words? What, unrecognized, falls and stays? Depth? How to *know* the tomb, the sea, the deaf rhythms in stones? *What* to know? One early spring day during World War I, a group sat outside in the Café-in-the-Park in New York, there for breakfast. Marcel Duchamp sat among them, his back planted squarely against all the forsythia, not seeing yellow, seen dead set against yellow, on purpose. That was his position. He looked long and hard at his hands. Then holding them up to his face, he looked at his friends. 'Drink fingers,' he said and stopped there.[3] Louise Norton knew enough not to do more than rather factually report this impossible assonance caught in the sun. Someone else might have seen green light for an instant, a language like leaves, good sense itself having left.

Separately, like shapes or tones, these two words held, if only as a joke. Fingers as solids might conceivably be eaten; fingers not being liquids could not be poured or spooned or sipped. Yellow flowers, nudes, the charms of reason had moved far away from them and him, well gone, and yet Marcel Duchamp had not rejected words. He was imagining a thick, insensible book of them (notes) to accompany his *Large Glass*. He had considered using *le monde en jaune* as its subtitle. But already Duchamp spoke and wrote in last words. He was writing their sentence. He had not yet turned thirty. He sat in the park. They had laughed.

He would often reflect upon all of this later, the words and the yellows, as his part of his own vast disinterest in retinal painting and sight. 'The retina', he would say at the end of his life, 'is only a door that you open to go further.'[4] He became known for his emphasis on grey matter, on brain.[5] But he would not privilege logic as the brain's best expression. Principles and laws too grew suspect.[6] Another note for the *Large Glass* gave the lie to generalities and systems in another way. Duchamp was here writing of willing his own mental failure, wanting memory simply to abandon its fingers and exist as lost grip:

To lose the *possibility of* recognizing *2 similar objects* – 2 colours, 2 laces, 2 hats, 2 forms whatsoever to reach the Impossibility of sufficient *visual* memory, to transfer from one like object to another the *memory* imprint. – Same possibility with sounds; with brain facts.[7]

In later life he would state the idea somewhat differently. Having put the *Glass* to rest and finished his two boxes, the one of notes and the suitcase of his *oeuvre complète* in miniature, he was meditating on the idea of a pseudo-geometric carcass pinned by a spider web, the figure envisioned as a set of opened legs. It seems to be an early 1940s version of his last master work, the *Etant donnés* (plate 21).[8] The spider web was his shorthand for a kind of iridescent pale grey fabric called pigeon-throat in French; the carcass he was calling *infra-mince*. He seems to have come up with that last word himself. His *infra-mince* was a kind of cut that he had been mulling since at least 1937, a cut pulling the idea of the mathematical cut out into the physical world, to the world of surface sensations and the five senses, but this is right away a world understood through cuts of separation, as physical separations, colour separations, textile separations, testicular separations. The first notes, done while on vacation in Denmark, speak of the matter as a separation between the sexes, something to be grasped in the sound made by velvet pants.[9] These would be the separations that produce difference, said another note written on the heels of this. He had returned to the problem of pairs.

> Two men are not an example of identicality and to the contrary move away from a determinable infra-thin difference – but there exists the crude conception of the *déjà vu* which leads from generic grouping (2 trees, 2 boats) to the most identical 'castings'. It would be better to try to go into the *infra-mince* interval which separates 2 identicals than to conveniently accept the verbal generalization which makes 2 twins look like 2 drops of water.[10]

Duchamp refused the pair any common standard. It was much like the assonance that lit into consonance. Consonance did not concern him. A world of similitudes did not interest him. He had long ago seen it to be an illusion and wished it away. He came to use the *infra-mince* to explore instead those immeasurable transitions *between* one thing and another. This between was not nothing. The gaps were physical, to be crossed but strangely, with echoes, no plank board. He crossed once on a bridge of smoke.

The bridge of smoke would be the first public definition of his *infra-mince*. It appeared on the back cover of the special Duchamp number of *View* in March 1945.

WHEN
THE TOBACCO SMOKE
ALSO SMELLS
OF THE MOUTH
WHICH EXHALES IT
THE TWO ODOURS
ARE MARRIED BY
INFRA-MINCE[11]

21 Marcel Duchamp, *Etant Donnes*, Philadelphia Museum of Art: Gift of the Cassandra Foundation. (Photo: Graydon Wood, 1995)

Words were not joined to the smell in this breath, which seemed loathe to explain itself and its marriage and did not. When Denis de Rougemont asked Duchamp to elaborate, he was told that this *infra-mince* could only be understood from examples, that 'it's something that still eludes scientific definition. I have intentionally taken the word *mince*[thin], a human word, affective, and not a precise laboratory measure. The noise or tune made by a corderoy pant leg, like this one, when one moves, comes from the *infra-mince*. The hollows in paper, between the front and back of a thin sheet … To be studied further!'[12]

The *infra-mince* did not, however, proceed to become a *problem* for Duchamp as he looked at his pants: that was the point of his much-quoted aphorism, which had it that there was no solution because there was no problem, problems being the nonsensical invention of man.[13] The *infra-mince* was found in the passage not of sense but of a something else between the senses themselves, there in the 'magnifying glass to reach' between touch and sight and smell and taste and sound.[14] It would be the warmth left by someone else in the seat of a chair.[15] There was an erotics passing through this and all material, an erotics that need not proceed straight from sight or the genital, an erotics that was endowing the carcass with a strange kind of life. His idea, like the erotics, was not being left to exist as an idea, not quoted or cited, but made to reveal itself as only material, in matter as matter, not to be spoken didactically in words, if mouthed, not drunk, only breathed. To breathe the world is not to know it.

Duchamp would periodically try looking for the *infra-mince* in the usual material of thought itself. Could an analogy be an example of *infra-mince*? Could allegory? The only trace of a development here would be the extension of the word allegory into *allégorie sur* 'l'oubli' [allegory on '*forgetting*'] and in a shorter, more trenchant form *allégorie d'oubli* [allegory of oblivion].[16] Words were not the best material for such a passage, better to show the word its weakness and vanity. Time would do the work of telling the word how to forget. He left words to their fate and now went his way without them.

In 1946 he started making the *Etant donnés* quietly, secretly, first with the help of Mary Reynolds, then Maria Martins and finally with that of his new wife Teeny. It would only be known to others after his death. Its givens came in the form of a cascade and a gas lamp. These were not the givens of a logic; they were not present as formal concepts of water and light. Those who knew his work well would recognize that they had been taken from the hypothetical givens in the Preface note for the *Large Glass*, but that they had now assumed another, quite unallegorical, concrete form. The *Etant donnés* did not proceed from notes or words, as the *Large Glass* had. Its waterfall was based on a photograph of a cascade in Puidoux (Switzerland), and its lamp was not a representation but there as itself, wired now to take an electric light. The givens had gone into things now. Language would leave them too.

To his interviewers, all of whom were ignorant of these givens solidly assuming shape, Duchamp would be accommodating but he would not privilege statements. If, in 1957, he had begun his short speech on the creative act with a citation from T. S. Eliot's 'Tradition and the Individual Talent', and had used Eliot's sense there of the mind as a medium, not a personality, he had used Eliot's statement in order to move the argument to the place where there was no longer

any permanent or binding textual control.[17] In his account the creative act would not be unified or known, not even by the artist. Duchamp believed in the existence of a gap between the intention of the artist that never was expressed and the unintentionally expressed elements in the final work. He called this gap the art coefficient and noted that the artist could never hope to surmount it. He would later tell Brian O'Doherty that in general you never *can* tell why you do things in life, for example, that he himself would simply not be *able* to give an answer to the question, 'why was your first child born without an eye?'[18] The art coefficient would be no answer either.

Eliot had also seen the poetic process as one of incomprehensible transformation. In his essay he had tried to explain this through an analogy to the physical world in which he made the mind out to be like a shred of platinum, catalytic, moving 'numberless feelings, phrases, images', 'particles which can unite to form a new compound', so to speak, producing out of all this a new art emotion. Duchamp did not pursue that analogy; he was not seeing a compound; he saw only a gap unfriendly to most glowing emotions and all platinum shreds. As for his view of the work's weight on the aesthetic scale, the amount could only be refined from the inert materials of the work itself by the spectator, much as sugar, he said, is derived from molasses. But none of this could be chalked up to the *infra-mince*. The conscious thought at the beginning and the end of the creative act belonged to different people, first to the artist and then to the spectator. This amounted to two different thoughts which were going to be participating as toothy words in the bite and chatter of the new modern art history. In practice it was largely a public chatter. With it, Duchamp concluded, the creative act would be completed, for it was the spectator who actually brought the work into the world.[19] But not on a bridge of smoke. Of the talk of modern art around him, Duchamp was extremely critical. It begged all the questions he had already asked himself about the relation of language to objects. In his own mind these questions had been settled and he did not enjoy having them raised again.

The very idea of knowing art or generalizing about all of modern art had come to seem to him, as it was and is, naive. This idea being as common as grass, he complained to his sister Suzanne and her husband in the summer of 1952 as he told them of the

> American museums [that] want at any price *to teach* modern art to young students who believe in a 'chemical formula'. All that produces only the vulgarization and complete disappearance of the *original fragrance*. This does not deny what I was saying above [in the letter], for I believe in the original fragrance, but like all fragrances, it evaporates very quickly (some weeks, some years at most); what remains is a dried nut, classified by historians in the chapter 'history of art'.[20]

Earlier that same year he complained in short form during an interview with Belle Krasne, 'I still have a decided antipathy for estheticians. I'm anti-artistic. I'm anti-nothing. I'm revolting against formulating.'[21] The public explanations of art were producing a set of simple givens (dried nuts) for art which he would criticize for the rest of his life; when he lumped them together, he called them 'exoteric'.

He championed the hygiene of the esoteric, a hygiene of unclarity and fume. He spoke of the artist of the future going underground. When Calvin Tomkins asked him if he had not himself gone underground already, Duchamp said, 'Maybe at the beginning.' And then, continuing, he turned the words around, 'But I'm not underground now, am I?'[22]

The interviewers who now came to him in increasing numbers expected to hear words taking their usual form; he tried to show them the difference between the tick-tock of organized knowledge and the untimed existence of wisdom. Wisdom often came deadpan, then laughing. The interview was a form Duchamp would accept and not try to dominate, but typically he would bend it at some point before the end. Authoritive voices, just like authoritive concepts would be shown something of their place. He would not be possessed by them or words. As he explained to Tomkins, his was a thought that preferred moving mute through the senses:

> I refused to accept anything, doubted everything. So, doubting everything, I had to find something that had not existed before – something I had not thought of before. What I did with any idea that came to me was to turn it around and try to see it with another set of senses. ... As soon as we start putting our thoughts into words and sentences, everything gets distorted. Language is just no damn good; I use it because I have to, but I don't put any trust in it. We never understand each other. Only the fact directly perceived by the senses has any meaning. The minute you get beyond that, into abstractions, you're lost.[23]

To William Seitz, he explained that painting for him had only ever been a tool: 'A bridge to take me somewhere else. Where, I don't know. I wouldn't know because it would be so revolutionary in essence that it couldn't be formulated.' In essence he had returned once more to the old problem of pairs and common standards, of *this is this* distinct from *this is that*. He was explaining that the bridge never moved him from *this* to *this*, or from *this* to *that*. *This* was itself already a nothing, purely open, too new. But then there was the problem of the verb. As Duchamp said, continuing to set the matter of an all-encompassing ignorance out for Seitz,

> ... in the end it comes to doubt 'to be'. Not doubt to say 'to be or not to be' – that has nothing to do with it. There won't be any difference between when I'm dead and now, because I won't know it. You see the famous 'to be' is consciousness and when you sleep you 'are' no more. That's what I mean – a state of sleepingness; because consciousness is a formulation, a very gratuitous formulation of something, but nothing else. And I go farther by saying that words such as truth, art, veracity, or anything are stupid in themselves. Of course it's difficult to formulate, so I insist *every word I am telling you now is stupid and wrong*.[24]

After his death, when the *Etant donnés* was unveiled in the Philadelphia Museum, Teeny summed all this up to the *Time* reporter, telling him that Duchamp 'wanted

to make a direct statement without words. Something you look at and just feel.'[25] Something that could not be called either life or death, either stupid or wrong. For it was something that could not be called.

And yet left to himself he read. Words would have an interest, but what? But which? When he liked a book, remembered Jackie Matisse Monnier, Teeny's daughter, 'he let you know. Roussel,' she listed, 'Wittgenstein, the little essay on landscape.'[26] She had given him the last of these to read, a French translation of three early essays by Rainer Maria Rilke. For Duchamp was partial to poetry. That was where, he told Tomkins, 'words get their real meaning and place.'[27] Poetic words do not produce organized knowledge. They travel from sight and through sound.

The Rilke essays date from the time when Rilke spoke to the young poet of art as an infinite loneliness 'and with nothing so little to be reached as with criticism'.[28] He would never claim to know art when he wrote of it. His own poetry would work to catch the drift of plenitude into loneliness and of loneliness into a plenitude, fixing on the matter of what he called things. It was a difficult process of elegy and indirect address:

> Never, not for a single day, do *we* have
> before us that pure space into which flowers
> endlessly open. Always there is World
> and never Nowhere without the No: that pure
> unseparated element which one breathes
> without desire and endlessly *knows*. A child
> may wander there for hours, through the timeless
> stillness, may get lost in it and be
> shaken back. Or someone dies and *is* it.
> For, nearing death, one doesn't see death; but stares
> beyond, perhaps with an animal's vast gaze.
> Lovers, if the beloved were not there
> blocking the view, are close to it, and marvel ...
> As if by some mistake, it opens for them
> behind each other ... But neither can move past
> the other, and it changes back to World.[29]

Words were the world and only had the world for reference. Yet Rilke felt it important to try to have them stretch somehow and vibrate *from* beyond. In 1924, near the end of his life, he would attempt to explain his efforts to a friend in a letter.

> By and large it is an inborn tendency of mine to deal with the secret as
> such, not as something to be unmasked but as the mystery which remains
> mystery right to its core, the secret which is all secret just as a lump of
> sugar is sugar through and through. Possibly, thought of like that, it solves
> itself in the circumstances of our life or of our love,when otherwise we
> should only achieve a mechanical diminution of the immensely secret
> without really transforming it into ourselves.[30]

22 Marcel Duchamp, *Why not sneeze. Rrose Selavy*, 1921. Philadelphia Museum of Art: The Louise and Walter Arensberg Collection.

This is not a view of sugar that can be tasted into sweetness, any more than one that can be drawn off from molasses. It is more like the sugar that Duchamp turned to marble in 1921 (plate 22), a sugar that might appear so to the eye but not (it is so heavy) to the hand. Sugar holds densities, in other words, and strangenesses in itself, in its lumps and in each grain. The No is physical, inherent in things. Separately, Rilke and Duchamp would see that. Separately, they would seek to express it. Rilke would seize the densities with words, words telling by means of their own internal echo of the space between the living and the dead, between light and the shades. Duchamp would lay out the *Etant donnés*.

In the early essays Rilke's version of separation used a slightly different ground. He wrote of the landscape of the *Mona Lisa* (plate 23) as one marking the start of a path:

One must look upon this landscape as a strange and distant thing, as a thing lost and without love accomplishing itself entirely inside, so that one day it might serve as the point of departure for an autonomous art. It needed to be far away and very different from us so as to become a liberating parabola for our fate. It was necessary that in its sublime indifference it show itself nearly hostile in order to offer our existence a new interpretation due to its objects. And it is in this spirit that the art of

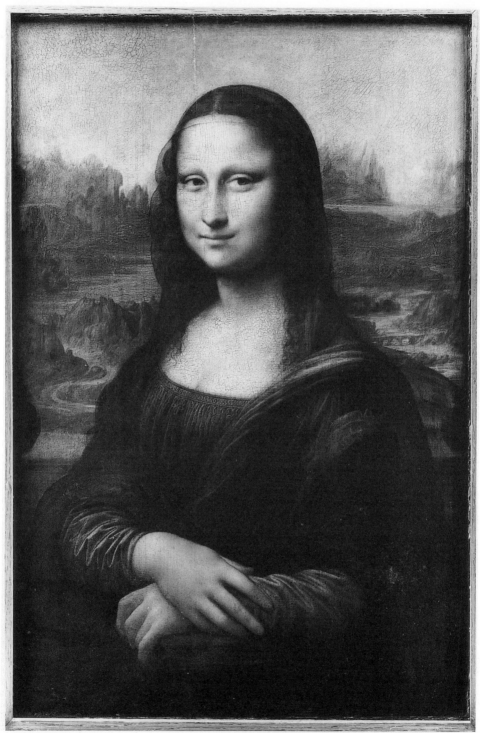

23 Leonardo da Vinci, *La Giaconda, Portrait of Mona Lisa*, The Louvre, Paris. (Photo: Réunion des musées nationaux, Paris)

landscape, of which Leonardo already had the premonition and the mastery, took form. It would develop slowly in the hands of solitaries from century to century. The route that it had to travel was long for it is difficult to disaccustom oneself more or less completely to the world, so as not to see it any longer with the forewarned eye of a native bringing everything back to himself and his needs when he looks. One knows how poorly one sees the things with which we live; it is often necessary that someone come from afar to tell us what encircles us. It is necessary to begin then by separating oneself from things in order to be capable afterwards of approaching them in ways more equitable and serene, with less familiarity and with a respectful distance. For one only begins to understand nature at the moment when one no longer understands it, when one feels that it is something else, that reality not taking part, which has no senses to perceive us – it's only then that one has left her, solitary, outside a deserted world. And this is needed so that one becomes through her an artist; it was no longer necessary to experience her as a subject, in the meaning she for us had, but as an object, as a great reality that was there.[31]

Rilke ended the essay by seeing the artist of his time set down among the things, like a thing, infinitely alone. In the second essay he addressed the fallibility of his own, even his most poetic words.[32] The third and last essay in the book took up the problem of the thing directly. It could not solve it. But the thing could appear, in the dearest of surfaces, for example, in the face of someone one loved.

Because all the happiness with which a heart has ever trembled; all the grandeur with which the lone thought nearly kills us; every one of these vast thoughts which come and go: there was an instant where they were but lips pursing, a brow's frown; or a shadow lengthening across a countenance: and this fold around the mouth, this line above the eyelids, this obscurity on a face – maybe they were already exactly thus: like pattern on an animal, like furrows in a rock, like hollows on a fruit ... There is but one surface, infinitely agitated and transformed. In that thought one can for an instant enclose the world and it is, simply and like a duty, set into the hands of the one who had this thought. For something cannot become a life thanks to the great ideas, but rather thanks to that from which one pulls a métier, an everyday thing, and which holds itself close to you til the end ...[33]

These are not words to be attached exactly to the *Etant donnés* any more than they reflect back to the readymades. Duchamp held them away from his own statements, held them in his mind, did not quote them. But he approved of these words of remove. In another context he would say to Francis Roberts, 'My landscapes begin where Da Vinci's end. The difficulty is to get away from logic.'[34]

His landscape, as one might expect, sat apart, the slow work of a solitary. It was not a work of art according to the definitions of his peers. It sought to belong to no tradition. His waterfall would *act* not even remotely logically. For one thing, by means of a motorized perforated disk rotating on but unattached to a rod in

front of a light, the waterfall was made to work like a primitive movie projector, turning by chance, most of the time flickering light from behind the scenes so that it showed up as the illusion of falling water in the landscape. The poor retina would see a deceitful sparkle there, a trick liquid now caught in trick sun. The retina could not know, it could not laugh, besides, eyes do not laugh by themselves.[35] It would not find firmer ground elsewhere. The body of the nude would not come forward logically either, though it would be cast, in part, from the bodies of women loved (it is known that the arm was cast from Teeny's; it is presumed that the torso carries Maria Martins' trace).[36] Bodies do not by themselves know in the formal, verbal way. But then, they do not have to.

This particular territory was being crossed as well by Ludwig Wittgenstein. He too had looked down at his hands and then turned for help to words, writing of the impossibility of ever knowing his own two hands with any certainty at all. To his mind, hands, like fingers, were not able to become concepts or objects exactly and therefore knowable according to the rules of philosophical knowledge unless, for the sake of argument, maybe savagely, one had them cut off. Even then, Wittgenstein drily remarked, the brain would be likely *not* to see them as gone.[37] Part of his philosophical investigations would settle on the problem of sensations and their expression in words, exposing the folly in grammar, for instance, the folly of seeing and feeling the same:

> Consider what makes it possible in the case of physical objects to speak of 'two exactly the same', for example, to say 'This chair is not the one you saw here yesterday, but is exactly the same as it.'
>
> In so far as it makes *sense* to say that my pain is the same as his, it is also possible for us both to have the same pain. (And it would also be imaginable for two people to feel pain in the same – not just the corresponding – place. That might be the case with Siamese twins, for instance.)
>
> I have seen a person in a discussion on this subject strike himself on the breast and say: 'But surely another person can't have THIS pain!' – The answer to this is that one does not define a criterion of identity by emphatic stressing of the word 'this'. Rather, what the emphasis does is to suggest the case in which we are conversant with such a criterion of identity, but have to be reminded of it.[38]

But a comparison between two hands or two men looking down at them, even if interrupted by an emphatically beaten breast, does not advance matters much. We do well to pause and turn away. For these two travellers never meet, their hands never touch. This will be only another tale of unpairing, of sugar. Wittgenstein would not call himself an artist. Duchamp would not consider himself to be a philosopher. When the French filmmaker Jean-Marie Drot tried to give him that compliment, he immediately demurred. 'The word philosopher is very flattering', he told Drot, 'but it is also a subject to be wary of. Questions of teaching, schools, of disciples have never interested me and still don't interest me. ... Much as he would like to, the artist cannot help another man. It's each one for himself, for I don't agree at all with the anthill that waits for us in a few hundred

years. I still believe in the individual and every man for himself, like in a shipwreck.' 'Is that the last word?' Drot asked. 'It's the last word,' Duchamp told him. Then, briefly, as he had in the yellow park, he smiled.[39]

His last words do not speak for solipsism. Those close to Duchamp at the end of his life remember his interest in all kinds of things, for example, in Wittgenstein. But, Teeny explained, although Marcel was interested, as was she, in Wittgenstein, 'he never worked with the ideas *per se*.'[40] But then, this was a man who for a long time had not worked with *any* others' ideas *per se*. Nonetheless there would be a difference between his interests and his disinterests. Duchamp would never, for instance, be at all interested in the possibilities suggested by psychoanalysis; he spoke of Freud-encrusted words as comparable to the mistake of retinal painting; he avoided Lacan when he could.[41] As he would say in an interview with Georges Charbonnier on French radio in 1960, words could not formulate the unconscious; that said, he went further and issued a reproach:

> ... I reproach our time for its need to use words be they old or new to translate the unconscious, if you like, that which happens in us. That formula I don't believe in at all: that language or words might in a precise or exact way translate all that which really happens in the world, i.e. that which passes under the individual and not outside the individual, you understand. ... The translation of these phenomena into words is very approximate, more than approximate and often false.[42]

He chose another tack at the end of the long interviews with Cabanne, these destined from the start to become a book, the last of them done in Paris just after Duchamp had returned from the opening of his exhibition at the Tate in June 1966. Cabanne was asking him to speak of his current life, most of the interview having been devoted to recollections of the past. And so Duchamp spoke of having seen *Masculin Féminin*, the latest Godard. He spoke admiringly of Genet's play *The Screens*. He claimed not to read very much, only what he had always liked, for this occasion naming Mallarmé, whom he had named to others before. By way of conclusion Cabanne asked him if he believed in God (not the best of questions since Duchamp had already told him that he did not subscribe to the word belief). Duchamp told him that God was another of man's inventions, that for him the question did not exist, and then he turned the table and asked Cabanne a question that most Frenchmen could not have answered.[43] 'Do you know', he asked, 'the story of the Viennese logicians?'

The latest Wittgenstein book to be posthumously published, *Lectures & Conversations on Aesthetics, Psychology and Religious Belief*, had treated these matters of knowing God and death in the last of its essays, in particular, in its second section, where Wittgenstein dismantled the phrase 'belief in God' and its peculiar use of the word belief, a use which seemed not, he felt, in this case to require any evidence. Yet even a belief based on evidence posed problems. Wittgenstein imagined himself saying, 'The mere fact that someone says they believe on evidence doesn't tell me enough for me to be able to say now whether I can say of a sentence "God exists" that your evidence is unsatisfactory or insufficient.'[44] But Cabanne had not read this and had to say no.

'The Viennese logicians', Duchamp explained, 'worked out a system wherein everything is, as far as I understood it, a tautology, that is, a repetition of premises.' He went on,

> In mathematics, it goes from a very simple theorem to a very complicated one, but it's all in the first theorem. So, metaphysics: tautology; religion: tautology: everything is tautology, except black coffee because the senses are in control! The eyes see the black coffee, the senses are in control, it's a truth; but the rest is always tautology.

He was letting Wittgenstein have the last word although he neither named him nor quoted him at all exactly. Except for the remark about black coffee, he had explained much the same thing to Denis de Rougemont some twenty years earlier except that he had not used either religion or metaphysics as the example, but had used the favourite Surrealist concept, myth, and attached it to science, specifically physics and mathematics.[45] Black coffee had not appeared in Wittgenstein's reflections on religious belief, but it had slipped into the first essay in this new Wittgenstein book. That one was an essay on aesthetics and it would take up matters dear to Duchamp. In Wittgenstein's words, art produced language problems, what he had come to call language games. He was speaking to a few of his students.

> 2. You might think Aesthetics is a science telling us what's beautiful – almost too ridiculous for words. I suppose it ought to include what sort of coffee tastes well.

> 3. I see roughly this – there is a realm of utterance of delight, when you taste pleasant food or smell a pleasant smell, etc., then there is the realm of Art which is quite different, though often you may make the same face when you hear a piece of music as when you taste good food. (Though you may cry at something you like very much.)

> 4. Supposing you meet someone in the street and he tells you he has lost his greatest friend, in a voice extremely expressive of his emotion. You might say: 'It was extraordinarily beautiful, the way he expressed himself.' Supposing you then asked: 'What similarity has my admiring this person with my eating vanilla ice and liking it?' To compare them seems almost disgusting. (But you can connect them by intermediate cases.) Suppose someone said: 'But this is a quite different kind of delight.' But did you learn two meanings of 'delight'? You use the same word on both occasions. There is some connection between these delights. Although in the first case the emotion of delight would in our judgement hardly count.

> 5. It is like saying: 'I classify works of Art in this way: at some I look up and at some I look down.' This way of classifying might be interesting. We might discover all sorts of connections between looking up or down at works of Art and looking up or down at other things. If we found,

perhaps, that eating vanilla ice made us look up, we might not attach great importance to looking up. There may be a realm, a small realm of experiences which may make me look up or down where I can infer a lot from the fact that I looked up or down; another realm of experiences where nothing can be inferred from my looking up or down. Cf. wearing blue or green trousers may in a certain society mean a lot, but in another society it may not mean anything.[46]

That your eye or mine looks at these words and reads them tells us nothing about the way in which Marcel Duchamp's eyes fell on these words and read them. We know that in general he read Wittgenstein, but we can only circumstantially infer that he read this particular book when he did. But he did not use Wittgenstein's words, if he did read these, in a way that appears to us as a genuine use. Wittgenstein's words, like Rilke's, exist here as examples, not models, only more words of remove. They say nothing about the *Etant donnés*, nor do they speak for the *Etant donnés*. Words, theirs or his, did not in any case cause it. Aesthetic cause and effect, Wittgenstein had remarked, do not find their parallel in physics, or in the taking of pills. Or, one might add, in the taking of words.

And yet Wittgenstein's critique of motives in the lecture on aesthetics casts its light across Duchamp's landscape, even if it does not exactly illuminate it. Wittgenstein had introduced the causal explanations of Freud into his mix and proceeded to dismantle them, in the process shattering the language game of 'beautiful':

> Freud does something which seems to me immensely wrong. He gives what he calls an interpretation of dreams. In his book *The Interpretation of Dreams* he describes one dream which he calls a 'beautiful dream'. A patient, after saying that she had had a beautiful dream, described a dream in which she descended from a height, saw flowers and shrubs, broke off the branch of a tree, etc. Freud shows what he calls the 'meaning' of the dream. The coarsest sexual stuff, bawdy of the worst kind – if you wish to call it that – bawdy from A to Z. We know what we mean by bawdy. A remark sounds to the uninitiated harmless, but the initiated, say, chuckle when they hear it. Freud says the dream is bawdy. *Is* it bawdy? He shows relations between dream images and certain objects of a sexual nature. The relation he establishes is roughly this. By a chain of associations which comes naturally under certain circumstances, this leads to that, etc. Does this prove that the dream is what is called bawdy? Obviously not. If a person talks bawdy he does not say something which seems to him harmless, and is then psychoanalysed. Freud calls this dream 'beautiful', putting 'beautiful' in inverted commas. But *wasn't* the dream beautiful? I would say to the patient: 'Do these associations make the dream not beautiful? It was beautiful. Why shouldn't it be?' I would say Freud had cheated the patient. Cf. scents made of things having intolerable smells. Could we therefore say: 'The "best" scent is really all sulphuric acid?' Why did Freud give this explanation at all? Two things people might say:

(1) He wishes to explain everything nice in a nasty way, meaning almost that he is fond of bawdy. This is obviously not the case.
(2) The connections he makes interest people immensely. They have a charm. It is charming to destroy prejudice.
(21) Cf. 'If we boil Redpath [one of the students in the room] at 200° C, all that is left when the water vapour is gone is some ashes, etc. This is all Redpath really is.' Saying this might have a certain charm, but would be misleading to say the least.
(22) The attraction of certain kinds of explanation is overwhelming. At a given time the attraction of a certain kind of explanation is greater than you can conceive. In particular, explanation of the kind 'This is really only this.'[47]

What can be known from such examples that exist only alongside one another, neither cause nor effect, neither explanation nor solution? Duchamp might let the shadow of someone else's thought fall now and then into his own, but none of these ideas would actually appear as itself, left in the form of itself. To speak of these ideas, their relation, and their status, one must leave the regulated spaces of texts and disciplines, the groves of academe. Paradoxically, they are best spoken in the absence of language.

Wittgenstein knew better than anyone how to tap on the word until it sounded like nothing. Rilke would use his strike to find inaudible frequencies. Duchamp preferred silence. Theirs were all words formed and moved to keep their thought close to things. Each was most interested to return the world to the word, losing lines of neat argument, at decisive points stopping, leaving thought to stand lamely, a vibration opaque. Together their words can only exist as discontinuities, soliloquies, unlaced, unchained coincidence. Separately each of their words carries a touch of the world. And because of this, an unmappable landscape looms up in the darkness between them, edges of different worlds hovering close, the world now a presence like the smells in the smoke. The lay of this world makes for a massive incoherence, no order, no this becoming this, no boiling down. Is it too obvious to say that thought is forever being touched like this by things physical? That thought, because of this, can never go flat out, completely abstract? Thought, like deep breath, still comes towards us. But when it does, it comes and goes with use.

Molly Nesbit

Notes

No one works alone but in this case mine would not have been possible without the grace and friendship of Teeny Duchamp, Jacqueline Matisse Monnier and Paul Matisse. And it has been made still richer in the details by the learned suggestions and generosity of Ecke Bonk, Richard Hamilton, Francis Naumann, Naomi Sawelson-Gorse and Michael Taylor. It is respectfully dedicated to Michael Baxandall who, quite without meaning to, once showed me what could be gained from an open return to practical vision.

1 In conversation at a party after the Uma lectures in Berkeley, Spring 1983.

2 To Lawrence D. Steefel, Jr. during an interview in 1956 while Steefel was preparing his

dissertation. Quoted in Steefel's essay, 'Marcel Duchamp and the Machine', in *Marcel Duchamp*, eds Anne D'Harnoncourt and Kynaston McShine (New York and Philadelphia: Museum of Modern Art and Philadelphia Museum of Art, 1973), p. 73. Duchamp would say much the same to Calvin Tomkins in 1965: 'Your chance is not the same as my chance, just as your throw of the dice will rarely be the same as mine.' Quoted by Tomkins in his profile of Marcel Duchamp, 'Not Seen And/Or Less Seen', *New Yorker*, v 41 (6 February 1965), p. 57.

3 Louise Norton Varèse, 'Marcel Duchamp at Play', in *Marcel Duchamp*, op. cit (note 1), p. 225. See also in the same catalogue David Antin's essay, 'duchamp and language', pp. 99–115 for its many perceptions, among them: 'language is a system of great coherence and elegance which he violates for its potential energy he "rips it off" tapping the energy of one system and feeding it into another it is not the only system he could use but it is his favorite system and it is the most profoundly human system he could have found.' The notes for the *Large Glass* are to be found in *Duchamp du signe*, eds Michel Sanouillet et Elmer Petersen (2ᵉ éd.; Paris: Flammarion, 1975) and *Marcel Duchamp, Notes*, ed. and trans. by Paul Matisse (Paris: Centre national d'art et de culture Georges Pompidou, 1980). *Duchamp du signe* exists in an English edition, initially known as *Salt Seller*, and now as *The Writings of Marcel Duchamp*, eds Michel Sanouillet and Elmer Petersen (Oxford: Oxford University Press, 1973). Unless otherwise specified, I have retained these two translations of the notes. Beginning in 1920, Duchamp would let Rrose Sélavy do most of the work of word management for him. In general, he spoke and she wrote until the work on the *Etant donnés* began, at which point she faded from sight. I have written elsewhere on Rrose Sélavy and her relation to language: see 'The Language of Industry', in *The Definitively Unfinished Marcel Duchamp*, ed. Thierry de Duve (Cambridge: MIT Press, 1991), pp. 351–384 and 'Concept of Nothing: New Notes by Marcel Duchamp and Walter Arensberg', in *The Duchamp Effect*, eds Mignon Nixon and Martha Buskirk (Cambridge: MIT, 1996), pp. 130–175, the latter written in tandem with Naomi Sawelson-Gorse.

4 Dore Ashton, 'An Interview with Marcel Duchamp', *Studio International*, v 171 (June 1966), p. 246.

5 The retina-grey matter distinction comes up frequently in his interviews. For one of the earliest, see his contribution to the *Western Round Table on Modern Art*, ed. Douglas MacAgy (San Francisco Art Association, 8–10 April 1949).

6 See, for instance, his 1914 note on a Principle of Contradiction, reconsidered and fatefully dismissed, *Notes* (1980), note 186. He would

however keep the idea of a nominalism where the word pushed away from musical value, communication, and interpretation. On the logic question, see especially Paul Matisse, 'Some More Nonsense About Duchamp', *Art in America*, v. 68 (April 1980), pp. 76–83. For Duchamp's critique of law, see: Denis de Rougemont, *Journal d'un époque (1926–1946)* (Paris: Gallimard, 1968), p. 563ff., entry dated 3 August 1945. See also Francis Roberts's interview with Duchamp done in 1963 and published as 'I Propose to Strain the Laws of Physics', *Art News*, v 67 (December 1968), p. 63: 'If I do propose to strain a little bit the laws of physics and chemistry and so forth, it is because I would like you to think them unstable to a degree.' And Tomkins, op. cit., p. 60: 'The word "law" is against my principles.'

7 *Salt Seller*, p. 31. *Duchamp du signe*, p. 47: 'Perdre la possibilité de reconnaître 2 choses semblables – 2 couleurs, 2 dentelles, 2 chapeaux, 2 formes quelconques. Arriver à l'impossibilité de mémoire visuelle suffisante pour transporter d'un semblable à l'autre l'empreinte en mémoire. – Même possibilité avec des sons; des cervellités.'

8 *Notes* (1980), note 24.

9 *Notes* (1980), note 9. Craig Adcock has pointed out that the term may well have been derived from the mathematician Esprit Pascal Jouffret's sense that the point of view from the fourth dimension onto the third dimension passed through '*un couche infiniment mince*'. See his book for this and its extended mathematical discussion of the *infra-mince*, *Marcel Duchamp's Notes from the Large Glass: an N-dimensional Analysis* (Ann Arbor: UMI, 1983), p. 37. See also the section devoted to Duchamp in Georges Didi-Huberman's catalogue, *L'Empreinte* (Paris: Centre Georges Pompidou, 1997).

10 *Notes*(1980), note 35, dated 'Copenhague 29 juillet 37'. 'Deux hommes ne sont pas un example d'identiticité et s'éloignent au contraire d'une différence évaluable infra mince – mais il existe la conception grossière du déja vu qui mène du groupment générique (2 arbres, 2 bateaux) aux plus identiques "emboutis" Il vaudrait mieux chercher à passer dans l'intervalle infra mince qui sépare 2 "identiques" qu' accepter commodément la généralization verbale qui fait ressembler 2 jumelles à 2 gouttes d'eau.' Here and elsewhere I have retained the French term. It is variously translated as infra-slim or infra-thin.

11 *Writings of Marcel Duchamp*, p. 194. First published in *View*, v 5 (March 1945), back cover of the special number on Marcel Duchamp in French, each letter in a different font: 'QUAND/ LA FUMEE DE TABAC/SENT AUSSI/DE LA BOUCHE/QUI L'EXHALE,/LES DEUX ODEURS/S'EPOUSENT PAR/INFRA-MINCE.' *Les Quatre vents*, no. 8 (1947), p. 7, would publish it with a different array of typefaces.

12 Denis de Rougemont, *Journal d'un époque*, pp. 567ff., in an entry dated 7 August 1945: 'C'est quelque chose qui échappe encore à nos définitions scientifiques. J'ai pris à dessein le mot mince qui est un mot humain, affectif, et non pas une mesure précise de laboratoire. Le bruit ou la musique que fait un pantalon de velours à côtes, comme celui-ci, quand on bouge, relève de l'infra-mince. Le creux dans le papier, entre le recto et le verso d'une feuille mince ... A étudier!' Ellipse in original text.

13 Quoted by Harriet and Sidney Janis, 'Marcel Duchamp: Anti-Artist', which first appeared in the March 1945 Duchamp number of *View* and has been reprinted in *The Dada Painters and Poets: an Anthology*, ed. Robert Motherwell (2nd ed.; Boston: G. K. Hall, 1981), p. 313. See also Rudi Blesh, *Modern Art USA: Men, Rebellion, Conquest, 1900–1956* (New York: Knopf, 1956), quoting Duchamp on p. 76: 'Problems? There are no problems; problems are inventions of the mind.'

14 *Notes*(1980), notes 11 and 32: Duchamp's phrase was '*loupe pour toucher*'.

15 ibid., note 4.

16 ibid., notes 1, 2, 5, 6 and 16.

17 T.S. Eliot, 'Tradition and the Individual Talent', from his collection, *The Sacred Wood: Essays on Poetry and Criticism* (London: Methuen, 1920), pp. 47–59.

18 Brian O'Doherty interviewed Duchamp in 1963 as part of his WNBC-TV programme 'Dialogues – The Armory Show Revisited'.

19 'The Creative Act' was first given at a session of the Convention of the American Federation of Arts, in Houston, April 1957. Reprinted in *Writings of Marcel Duchamp*, pp. 138–40.

20 'Affectueusement, Marcel: Ten Letters from Marcel Duchamp to Suzanne Duchamp and Jean Crotti', *Archives of American Art Journal*, v 22 (no. 4 (1982), letter dated 17 August 1952, pp. 16–17.

21 Belle Krasne, 'A Marcel Duchamp Profile', *Art Digest*, v 26 (15 January 1952), p. 24.

22 op. cit., p. 93. The esoteric-exoteric distinction appears in several of his interviews. See, for example: that with Dorothy Norman in 1953, excerpted in *Art in America*, v 57 (July 1969), p. 38. In 'Where do we go from here?', his March 1961 speech at the Philadelphia Museum College of Art, he ended with the line, 'The great artist of tomorrow will go underground.' Published in *Studio International*, v 189 (January 1975), p. 28.

23 op. cit., pp. 40 and 56. There were similar diatribes against language in many of his longer interviews in the early 1960s. See especially those with: Georges Charbonnier, *Entretiens avec Marcel Duchamp* (Marseille: André Dimanche, 1994), pp. 29, 51, 55, 62, and 73, a four-part interview for French radio done in December 1960 and January 1961; Mike Wallace 1960; Alain Jouffroy, *Marcel Duchamp* (Paris: Centre

Georges Pompidou, 1997), p. 62, recorded in 1961; William Seitz, 'What's Happened to Art? An Interview with Marcel Duchamp on Present Consequences of New York's 1913 Armory Show', *Vogue*, v 141 (15 February 1963), p. 113; Jean-Marie Drot, *Jeu d'échecs avec Marcel Duchamp* (1963), a film with interviews taken in New York and Pasadena on the occasion of Duchamp's retrospective there.

24 Seitz, op. cit., p. 113.

25 'Peep Show', *Time* (11 July 1969), p. 58. He would say something similar to to Colette Roberts in April 1968, 'Interview by Colette Roberts', *Art in America*, v 57 (July 1969), p. 39: [the things made by the artist] 'are produced underneath, outside of any explanation, of any words to explain them. And the man who is supposed to be an artist becomes an artist only later on, so to speak – when, after he has done the work, the public takes him on and accepts him. He has a feeling, and then there is an exchange of feelings that cannot be produced by simple willing on the part of the artist.' Paul Matisse, Teeny's son, would translate the last, posthumous group of Duchamp's notes and it would be on that occasion that he would share his sense of Duchamp's relation to language: 'Marcel used to say that explanations explained nothing. In fact, he thought so little of them that when others explained his work he usually agreed, even when they were wrong. He knew that even when we are right we only lose the world by explaining it, and that nothing, finally, is better than taking reality just as it comes.' From his 'Introduction', *Notes* (1980), p. xv.

26 In conversation with the author, October 1996. Rainer Maria Rilke, *Sur le paysage*, trans. Maurice Betz (Paris: Emile-Paul frères, 1942). The essays included were 'Sur le paysage' (n.d.), 'Worpswede' (1902) and 'Choses' (1907).

27 See, for examples: Charbonnier, op. cit., p. 55; Katharine Kuh, *The Artist's Voice: Talks with Seventeen Artists* (New York: Harper & Row, 1962, p. 88, interview in 1961; Tomkins, op. cit., p. 57; Marcel Duchamp, *Entretiens avec Pierre Cabanne* (2ᵉ éd.; Paris: Somogy, 1995), pp. 110–111 and 129, interviews done during the months of April, May and June, 1966.

28 Rilke, *Letters to a Young Poet*, trans. M. D. Herter Norton (revised ed.; New York: Norton, 1954), p. 29.

29 Rilke, 'The Eighth Elegy', of the Duino elegies, translated by Stephen Mitchell in his edition *Ahead of All Parting: The Selected Poetry and Prose of Rainer Maria Rilke* (New York: Modern Library, 1995), p. 377.

30 J. R. von Salis, *Rainer Maria Rilke: The Years in Switzerland*, trans. N. K. Cruikshank (Berkeley: University of California Press, 1964), p. 180.

31 Rilke, *Sur le paysage*, pp. 19–21: 'Et il fallait regarder le paysage comme une chose lointaine et étrangère, comme une chose perdue et sans

amour, qui s'accomplit tout entière en elle-même, afin qu'il pût servir un jour de moyen et de point de départ à un art autonome. Il fallait qu'il fût loin et très différent de nous afin de pouvoir devenir une parabole libératrice pour notre destin. Il fallait que dans son indifférence sublime il se montrât presque hostile pour pouvoir offrir à notre existence une nouvelle interprétation grâce à ses objets. Et c'est dans dans cet esprit qu'a pris forme cet art du paysage dont Léonard de Vinci avait déjà le pressentiment et la maîtrise. Il se développa lentement, entre les mains de solitaires, de siècle en siècle. Longue était la route qu'il fallait suivre, car il était difficile de se désaccoutumer du monde assez complètement pour ne plus le voir avec l'oeil prévenu de l'indigène qui rapporte tout à lui-même et à ses besoins lorsqu'il regarde. On sait combien nous voyons mal les choses au milieu desquelles nous vivons; il faut souvent que quelqu'un vienne de loin pour nous dire ce qui nous entoure; il fallut donc commencer par écarter de soi les choses pour devenir capable par la suite de s'approcher d'elles de façon plus équitable et plus sereine, avec moins de familiarité et avec un recul respectueux. Car on ne commençait à comprendre la nature qu'à l'instant où l'on ne la comprenait plus; lorsqu'on sentait quelle était autre chose, cette réalité qui ne prend pas part, qui n'a point de sens pour nous percevoir, ce n'est qu'alors que l'on était sorti d'elle, solitaire, hors d'un monde désert. Et il fallait cela pour qu'on devînt artiste par elle; il ne fallait plus l'éprouver en tant que sujet, dans la signification qu'elle avait pour nous, mais comme un objet, comme une grande réalité qui était là.' See also p. 23: '. . . un avenir a commencé au coeur de notre temps; que l'homme n'est plus l'être sociable qui se meut en équilibre parmi ses semblables, ni celui autour duquel gravitent le soir et le matin, le proche et le lointain. Qu'il est posé parmi les choses, comme une chose, infiniment seul, et que toute communauté s'est retirée des choses et des hommes, dans la profondeur commune où puisent les racines de tout ce qui croît.'

32 ibid., pp. 32–3: 'Nous jouons avec les forces obscures que nous ne pouvons pas appréhender avec nos mots, de même que les enfants jouent avec le feu, et il semble que toute énergie ait reposé, jusqu'à présent inemployée, dans les choses, jusqu'au jour où nous sommes venus pour l'appliquer à notre vie éphémère et à ses besoins. Mais, à travers les millénaires, les forces ne cessent de secouer et de faire tomber leurs noms et elles dressent comme un Etat opprimé contre ses petits maîtres, ou, sans même se soucier d'eux, elles se lèvent tout simplement, et les cultures tombent des épaules de la terre, qui est de nouveau grande et vaste et déserte, avec ses mers, ses arbres et ses étoiles.' See also pp. 71–3: 'Il appartient à l'artiste d'aimer l'énigme.

Là est tout son art: l'amour qui s'est répandu sur des énigmes, – c'est là ce que sont les oeuvres d'art: des énigmes enveloppées, parées, recouvertes d'amour. . . . il faut toujours sous entendre lorsque l'on essaye d'augurer de la vie d'un homme: < < Nous devrons souvent nous arrêter devant l'inconnu. > >'

33 ibid., pp. 86–7 (ellipse in original text): 'Car tout le bonheur dont un coeur a jamais tremblé; toute la grandeur dont la seule pensée nous détruit presque; chacune de ces vastes pensées qui vont et viennent; – il y eut un instant où elles ne furent qu'un troussement de lèvres, un froncement de sourcils; ou une ombre qui s'étend sur un front: et ce pli autour de la bouche, cette ligne au-dessus des paupières, cette obscurité sur un visage, – peut-être étaient-ils déjà exactement ainsi: comme dessin sur un animal, comme sillon dans un rocher, comme creux sur un fruit . . . Il n'y a qu'une seule surface, infiniment agitée et transformée. Dans cette pensée on pouvait durant un instant enfermer le monde, et elle était, simplement et comme un devoir, posée dans les mains de celui qui avait cette pensée. Car quelque chose ne peut pas devenir une vie grâce aux grandes idées, mais grâce à ceci que l'on s'en dégage un métier, une chose quotidienne, et qui se tienne auprès de vous jusqu'à la fin . . .'

34 Quoted by F. Roberts, op. cit., p. 64.

35 Paul Matisse, who was charged with reassembling the *Etant donnés* when it was moved to the Philadelphia Museum, has described the peculiarities of the waterfall mechanism in his article, 'The Opening Doors of *Etant donnés*', SITES, no. 19 (1987), p. 6.

36 On the identity of the models for the nude in the *Etant donnés*, see Arturo Schwarz, *The Complete Works of Marcel Duchamp* (3rd ed.; New York: Delano Greenidge, 1997), v 2, p. 790; Caumont and Gough-Cooper's entry, op. cit., for March 31, 1968; Calvin Tomkins, *Duchamp: A Biography* (New York: Henry Holt, 1996), pp. 353ff; Francis Naumann, *Maria: the Surrealist Sculpture of Maria Martins* (New York: André Emmerich, 1998), p. 24ff.

37 Ludwig Wittgenstein, *On Certainty*, ed. G. E. M. Anscombe and G. H. von Wright, trans. Denis Paul and G. E. M. Anscombe (New York: Harper & Row, l972) , *passim*. Wittgenstein is taking the example of the hand from G. E. Moore in order to revise it. See also *The Blue and Brown Books* (Oxford: Blackwell, 1958), p. 52 ff.

38 Ludwig Wittgenstein, *Philosophical Investigations*, trans. G. E. M. Anscombe (Oxford: Blackwell, 1953), p. 91.

39 Drot, *Jeu d'échecs avec Marcel Duchamp* (1963). I have used the translation given in the dubbed 1987 English soundtrack.

40 In conversation with the author, March 1994. It is not clear exactly when Duchamp began to read Wittgenstein. When Anthony Hill asked him

whether he knew the *Tractatus* at the time he was working on the *Large Glass*, Duchamp replied that he did not but, Hill explains, 'He did admit to having tried to read Ogden and Richards's *The Meaning of Meaning*.' See Hill's article, 'The Spectacle of Duchamp', *Studio International*, v 189 (January 1975), p. 21. It is worth noting that Wittgenstein was being widely read by artists and others in New York in the early 1960s.

41 In an unpublished interview with Richard Hamilton and others in London, June 1966. Teeny told me of Duchamp's avoidance of Lacan during one of our conversations in March 1994.

42 Charbonnier, op. cit., pp. 50–1: 'Tous les cinquante ans ou tous les trente ans, il y a besoin de renouvellement, surtout dans la langue. Le fait, en effet, que c'est un peu plus flagrant ... c'est plus net à notre époque, c'est plus flagrant, en effet, et c'est dû, justement, au caractère de notre époque qui demande beaucoup plus au langage que les autres époques. Et moi, c'est un reproche – c'est complètement personnel – que je lui fais: ce besoin de se servir de mots, qu'ils soient nouveaux ou anciens, pour traduire l'inconscient, si vous voulez, ce qui se passe en nous. C'est une formule à laquelle je ne crois pas du tout: que la langue ou les mots puissent traduire de façon exacte ou précise tout ce qui, vraiment, se passe dans le monde, c'est-à-dire ce qui se passe sous l'individu et non pas en dehors de l'individu, vous comprenez ... La traduction par les mots de ces phénomènes est très approximative, plus qu'approximative et souvent fausse ...' See also pp. 29–30 [apropos the word *intelligence*]: 'Qu'est-ce que ça veut dire? Et c'est difficile à définir nous-mêmes, puisque nous ne pouvons pas employer de mots, il nous faut accepter une certaine élasticité dans ce que nous désirons. Mais, enfin, il y a une chose certainement qui existe: c'est laisser, pour ainsi dire, laisser ouvrir la porte au lieu ce contrôler tout ce qu'on fait par des mots en expliquant ce qu'on va faire ou qu'on voudrait faire. N'expliquer rien. Laisser, laisser faire.

Charbonnier: "Vous souhaitez, me semble-t-il, l'intervention de l'esprit pas l'inconscient, par les voies inconscientes ..."

Duchamp: "Exactement. C'est ce qui existe toujours."

Charbonnier: "Mais par une voie consciente?"

Duchamp: "Non. Essayer de le canaliser dans une conscience, dans une forme consciente, qu'on puisse au moins en jouir un peu, n'est-ce pas, savoir ce qui se passe. Mais d'une façon très respecteuse, si vous voulez, et non pas en imposant les mots pour définir ce qui sort de cet inconscient. Dès l'instant que vous y mettez des mots, vous gâchez tout. J'ai une horreur du mot, vous savez."' All ellipses appear in original. In this case I have transcribed the interview from

the soundtrack, which is slightly different.

43 *Entretiens avec Cabanne*, pp. 129–31: 'Vous connaissez l'histoire des logisticiens de Vienne? Les logisticiens de Vienne ont élaboré un système selon lequel tout est, autant que j'ai compris, tautologie, c'est-à-dire une répétition des prémisses. Dans les maths, cela va du théorème très simple au très compliqué, mais tout est dans le premier théorème. Alors, la métaphysique: tautologie; la religion: tautologie, tout est tautologie sauf le café noir parce qu'il y a un contrôle des sens! Les yeux voient le café noir, il y a un contrôle des sens, c'st une vérité; mais le reste, c'est toujours tautologie.' Duchamp attacks the idea of belief on p. 111. I have taken the translation from the English edition, *Dialogues with Marcel Duchamp by Pierre Cabanne*, trans. Ron Padgett (New York: Viking, 1971), p. 107.

44 Wittgenstein, *Lectures & Conversations on Aesthetics, Psychology and Religious Belief*, ed. Cyril Barrett (Oxford: Blackwell, 1966), p. 60. The book appeared by April 1966 when it was advertised along with the *Zettel* on the back cover of that issue of *Philosophy. The Journal of the Royal Institute of Philosophy*, v 41. The American edition was brought out by the University of California Press in June. The Duchamps were in London from 15 June to 21 June 1966 according to the chronology compiled by Jacques Caumont and Jennifer Gough-Cooper in *Marcel Duchamp Work and Life*, ed. Pontus Hulten (Cambridge: MIT, 1993). My thanks to Stephanie Fay of the University of California Press for her help in pursuing these publication details.

45 Denis de Rougemont, *Journal d'une époque*, pp. 563–4, entry dated 3 August 1945 and p. 569, entry dated 9 August 1945. Wittgenstein treated of tautology in the *Tractus Logico-Philosophicus*, trans. C. K. Ogden (London: Routledge, 1922), p. 165, '6.124 The logical propositions describe the scaffolding of the world, or rather they present it. They "treat" of nothing. They presuppose that names have meaning, and that elementary propositions have sense. And this is their connexion with the world. And it is clear that it must show something about the world that certain combinations of symbols – which essentially have a definite character – are tautologies. Herein lies the decisive point. We said that in the symbols which we use something is arbitrary, something not. In logic only this expresses : but this means that in logic it is not *we* who express, by means of signs, what we want, but in logic the nature of the essentially necessary signs itself asserts. That is to say, if we know the logical syntax of any sign language, then all propositions of logic are already given.'

46 *Lectures*, pp. 11–12.

47 *Lectures*, pp. 23–4.

Women under the Gaze: a Renaissance genealogy

Paolo Berdini

Preliminary Excursus

The physical expression of mental conditions was one of Alberti's preoccupations with regard to the legibility of images. Leonardo shared this concern, which fuelled his project to represent systematically the gestures corresponding to basic human sentiments such as pain, anger, fear, etc. Although there is, in the end, no dictionary of the Renaissance language of gestures, their legibility has traditionally proved useful for the reading of images. Unlike the practitioners of iconography, Michael Baxandall does not consider the language of gestures as yet another instance of a concordance between the visual and the verbal, to be classified under the general heading of motifs. His search for sources that may 'offer suggestions about a gesture's meaning' is part of a less constrictive and hermeneutically more ambitious project of equipping the beholder with 'categories authentic' to an image's time and culture and thereby capable of facilitating an 'excursion into alien sensibilities'. If appreciation of an art object depends on the beholder's familiarity with other cultures' visual dispositions and responses, the language of gestures has to be seen as porous to circumstances of context ('a gesture takes its meaning from context') and to be associated with other 'visual skills' in order to contribute to the formulation of broader categories, such as what Baxandall termed 'the period eye'. The interpretive value of 'the period eye' lies in the critical framework it provides for a closer and more rewarding valuation of past phenomena and behaviours. It seems to partake of an aesthetic of reception, for it brings into contemporary focus past modes of attention and in so doing situates the image in relation to the horizons, both of the past and of the present. Historiographically, however, it advertises the past's priority and superiority, and credits itself with avoiding contamination with the present, in relation to which it shows impatience if not hostility. The present is present only as a set of constraints to be removed if proximity with the past is to be achieved. Nonetheless, it must be the present which determines whether past voice is authentic or significant. In the process of assimilating past forms of visual attention, behaviour and skill, 'the period eye' raises questions concerning the mechanisms of inclusion and exclusion which determine what sources and attitudes are relevant and why. One instance, in particular, is of interest to me. Since the agent of 'the period eye' is a collective beholder who enacts – is the sum

of – historically certified modes of attention, its construction must at one point have undergone what may be called gender neutralization. The distinction between 'the period eye' and what I will describe as 'a regime of vision', depends on acknowledging – and amending – such neutralizations, and in what follows I offer a few remarks on the matter. But before I go further in subjecting Baxandall's art-historical category to hermeneutical scrutiny, it is necessary to note that to strive for conceptualizations that an author himself found it unnecessary to offer risks to convey the possibly displeasing tone of the unauthorized biography. And while an author cannot be blamed for not addressing what a reader would like to see addressed (expectations cannot be fulfilled but only modified), by the same token the reader should not recoil from subjecting the text to his/her own preferred mode of reading.

To return to 'the period eye'. Its agent is constructed by providing an optical abstraction, perspective's station point, with a set of social attributes, and by subsequently conjugating visual skills of a technical sort which derive from optics, geometry and mathematics, with visual skills of a more cultural sort, such as those necessary to detect and read allegory, for example, when it is embedded in a naturalistic mode of representation. The beholder is gradually equipped with a critical apparatus that follows closely humanistic painting's agenda as it emerges from Book I to Book II of *De pictura*: perspective's objectifying mode of representation, painting's form of activity (narration), its content (commendable human action or *historia*), purpose (moral edification), and mode of expression (movements of human figure in space). Ultimately, the legibility of an image depends on the beholder's ability to process the movements of human figures in space, and the language of gestures in particular, into a form of discourse which reflects familiarity with humanistic painting's characteristics. Unlike iconography, however, which detects a gesture's meaning without specifying how meaning itself should be located within the critical discourse that its search has initiated, 'the period eye's' concern with meaning goes beyond its disclosure and offers specifications on its role and discursive status. Having observed a structural affinity between the mode of organization of the pictorial field and that of narration, 'the period eye' locates its agency in perspective's point of view, which seems to guarantee a gender neutralization of both the mechanism of vision and that of discourse. A closer look at such an affinity betrays the effects of gender neutralization.

In Masaccio's *Expulsion* I will point to a discrepancy between the text and its visualization. Such a discrepancy might have alarmed iconography, though 'the period eye', which does not postulate concordance, overlooks its significance. In my account this discrepancy is interpreted as instrumental to the visualization of a gender distinction in relation to the subject of vision. As man is the subject of the look, woman is the object of the gaze, two complementary positions that constitute identity in the field of vision. The same distinction is at play in relation to the rhetorical function of the word, man being the agent of its emission and woman that of its reception. As women are not agents of the word, their role in narrative painting is limited and their gestures embody a different physiognomics, a distinctively feminine one, partial and thereby sufficient to preclude the universality of 'the period eye'.

To question the gender neutralization of 'the period eye' involves rectifying the model of correspondence between rhetoric and images with regard to both agencies of discourse and of vision. What emerges with the partiality of any point of view is an awareness that it can only be theorized by virtue of that other, whose dislodged presence is functional and essential in establishing its identity. That a partial identity could claim the voice of the universal was one of the great constructions of Renaissance thought and its regime of vision; the project of disclosing is relevant only if directed at constructing more incisive critical tools into its mechanism. Far from blaming 'the period eye' for what it did not deem necessary or worthy of inclusion in its agenda, this critique is offered as a complement; for that is what I take the discourse on difference to be – the possibility, not the necessity, of the complementary.

1. Downcast Eyes

In the experience and judgement of art objects both the characteristics of the object and the prerogatives of the viewer operate as critical factors. Their interplay is what we call a regime of vision. Humanism's was a regime of vision committed to constructing narratives in visual terms, to narrating by images. Such narrative painting – most programmatically theorized as Alberti's *historia* – depended on the agent of significant human action being represented in a space that is systematic and continuous with the viewer's, a perspectival space. In that space human actions become legible for the movements of the body are intended to express the sentiments of the soul, a transliteration that operates through physiognomics and rhetoric. Physiognomics was central to the project of conveying emotions pictorially, and by exploring the potential of linear contour, humanism's regime of vision developed an ever expandable vocabulary of expressive features for rendering human emotions via corporeal and, specifically, facial expressions.

As for the prerogatives of the viewer, humanism's regime of vision promises to adhere to the mechanics of viewing and therefore conceives of its 'subject' as one that surveys the external, objectified world from an assumed point of view. The gender neutralization of such a 'subject' rests on the assumption that what is represented following the regime's instructions does not correspond to an individual's particular vision, but rather coincides with what is seen from a specific point.[1] Following the rules of perspective, an image is constructed such that is supposed to stand against the real, and replace it, producing the effect of a window open onto the world.

These are the conditions of looking which make the *historia* legible and which ultimately enable narration by images.

There is, however, a noticeable exception to these conditions, a crucial figure of difference. As Leonardo commented in the margin of one of his several studies of female heads (plate 24): 'Women should be represented with demure actions, their legs tightly closed together, their arms held together, their heads lowered and inclined to one side.'[2] Nor are Leonardo's comments unique; they are echoed in a variety of texts addressing the proper posture of women. Sebastian Brant, for

24 Leonardo da Vinci, *Head of a Girl*, Collection of HM The Queen. Photo: Art Resource, New York

example, wrote: 'A wife who would be modest found/Should cast her eyes upon the ground/and not coquet whene'er she can/And not make eyes at every man.' Juan Luis Vives, in his widely read treatise on the education of a Christian woman, refers to the same posture, where he wrote: '... it is befitting that she be retiring and silent with her eyes cast down.'[3] Moreover, Leonardo's drawings belong to a large repertoire of analogous images from all the Renaissance schools of painting, including works by Raphael, Parmigianino and Sebastiano, among others.

Such statements and drawings suggest that women should not be represented as agents of significant human action and that their role in the visualization of the *historia* is limited, different. Women are precluded from enacting the range of physiognomic postures available to the male body, to the point that their bodily actions are restricted and locked in a formula typified by *downcast eyes and tilted head*. Within humanism's regime of vision women are assigned a role other than that of enacting a plot; they are intended to be looked at and, consequently, assume a posture that acknowledges their visibility. They are, that is, to be represented as under the gaze.

The prevalence of woman under the gaze within this regime of vision raises questions, above all about the coexistence of the visual formula *downcast eyes and tilted head* with a mode of representation that claims to be strictly mimetic and thereby scarcely open to *a priori* configurations. Moreover, there is the issue of the reasons for adopting the formula in the first place, and the corollary question of its visual and textual sources. Ultimately, these questions converge on the problem of how humanism's regime of vision conceives of and represents difference in the field of vision.

The analysis of two images from the Brancacci Chapel that follows will set the terms for an inquiry that focuses on the making and working of the visual formula within humanism's regime of vision, on how it conditioned the representation of the female body, and on how its critique eventually forced the regime of vision itself into a crisis.

2. The Fall and the discovery of sexuality in the field of vision

In the Brancacci Chapel of the Florentine Church of the Carmine, Masaccio and Masolino painted in fresco scenes from the life of St Peter honouring Pietro

Brancacci, a prominent citizen in the service of the Republic. Executed in the mid 1420s the frescoes set the terms for a new artistic form: the visual narrative with moral overtones. Two portions of the fresco at the far ends of the upper register, however, display biblical events that are not directly related to the Petrine narrative of the rest of the frescoes (plates 25 and 26). These scenes, representing respectively *The Temptation* and *The Expulsion of Adam and Eve* (plates 27 and 28), act as a visual and thematic overture to the cycle; together they represent *The Fall of Man*, the event that necessitated the work of redemption carried out by Christ and later by the vicars of his Church – first among them, Peter. In both images Adam and Eve are rendered full-length and in proximity to one another. Executed by Masolino and Masaccio, the two images epitomize a stylistic contrast between the slender elegance of Gothic figures and the new pathos of Renaissance bodies. The contrast is all the more significant when one considers that the two images are not discrete portions of a larger narrative of Genesis, but form a two-part visualization of the Fall as a dramatic change in the human condition. The two images are pendants both visually and thematically, and constitute the two terms of a contrast.

Biblical studies have emphasized how the structure of Genesis follows a mirror-like form, whereby the first scene matches the last, the second the penultimate and so on. The ABCDCBA sequence makes clear how the order of sin inverts that of creation.[4] Subdivided into seven scenes, the narrative finds its climax in scene four, the act of disobedience, where the human actors are alone, standing before the tree of knowledge. It is then that woman decides to accept the snake's advice and ignore God's warning, and that likewise man accepts the fruit offered by his wife in defiance of God's command. The originality of humanistic exegesis of the Fall – a term foreign to Biblical language – lies in its equating of the Adamic condition with that of humanity at large. Anthropological in character, Renaissance interpretations of Genesis placed at their centre man and his choices, and aimed at establishing a link between the *origin* of evil and the *primordial* condition of goodness. There is no definition or description of that primordial condition apart from its radical cancellation brought in by the eruption of evil. Its main quality is that of having been lost. Paradise is both: the place from which man is expelled, and the condition humanity has been deprived of as a consequence of Adam's sin. To interpret Genesis 3 as Fall, that is as a contrast between a before and an after, is already to see it in terms of representation, for the before can only be imagined by considering the consequences of its loss. So conceived, the Fall's structure recalls more a myth than an historical narrative. It also echoes, and should be assimilated into, a Greek tragedy, with the important distinction of the different degrees of God's identification with good, partial and conditioned, in Greek deities, total and omnipotent in Yahweh. The myth of the first man or, to be precise, of the first pair driven out of a wonderful kingdom for disobeying a taboo is, also, an old one. It provides a multiplicity of explanations for the introduction of evil and the end of the time of innocence. Moreover, it offers a model for the exiled man, and the paradigm of the tragic beginning.[5] In Christianity, just as in Plato, man is the agent of a strange discrepancy: a being destined for the good he is, nevertheless, inclined towards evil. The origin of such contradiction lies in the Fall and its explanation requires a complex 'hermeneutics

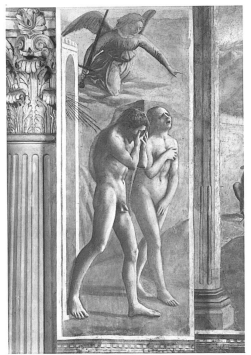
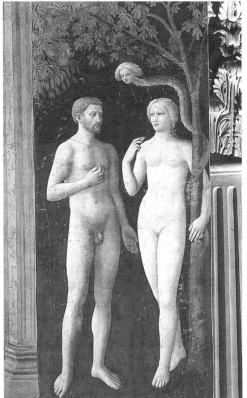

25 (facing, above) West wall of Brancacci Chapel in S. Maria del Carmine, Florence. (Photo: author).
26 (facing, below) East wall of Brancacci Chapel in S. Maria del Carmine, Florence. (Photo: author).
27 (above left) Masaccio, *Expulsion from Paradise*, Brancacci Chapel, S. Maria del Carmine, Florence. (Photo: Alinari/Art Resource, New York)
28 (above right) Masolino da Panicale, *Temptation of Adam and Eve*, Brancacci Chapel, S. Maria del Carmine, Florence. (Photo: Scala/Art Resource, New York)

of responsibilities' capable of ascertaining its nature, its theological and moral implications, and, above all, its gender distribution.

The events of the Fall are described in Genesis 3. Having disobeyed God's directive to avoid the tree of knowledge, Adam and Eve try to hide from God. When the human-like voice of God demands to know 'Where are you?' Adam replies: 'I heard you in the garden and I was afraid because I was naked: so I hid.' The guilt following transgression takes the form of a sudden awareness of the body's nakedness, a condition that Adam and Eve, in their prelapsarian innocence, neither knew nor suspected. Consciousness of the naked body becomes a sign that Adam and Eve's initially harmonious relation to God and to each other has been disturbed. Whereas prior to transgression a lack of awareness of nudity was indicative of the transparency and purity of their thought, now guilt requires that their bodies should be covered. Moral shame is located in sexuality.[6] Guilt makes Adam and Eve think of their bodies as uncovered and in need of protection from the outside gaze, whether God's or each other's. In sum, sexuality finds its initial definition in the field of vision as

109

awareness of the body's exposure to sight, though 'Emphasis on sexuality and fertility in the whole story is felt more than it is explicitly realized.'[7]

In the words of Paul Ricoeur, 'The nakedness of the innocent pair and the shame that follows fault express the human mutation of all communication, marked henceforth by dissimulation.'[8] The need to conceal inaugurates the discourse on sexuality and before finding leaves to provide primitive clothing, Adam and Eve employ their arms and hands for that purpose. Neither the portions of the body to be covered nor the mechanics of their concealment are accorded any textual specification and, more importantly, within the text, the impulse to screen the body is not differentiated along gender lines. Consequently, artists tended to visualize the Fall in such a way that Adam and Eve share one and the same gesture: the right hand covers the groin while the left arm hides the breast. This gesture has acquired a long and distinguished iconography. Ultimately, it derives from Praxiteles's *Aphrodite*, a life-size sculpture that survives in several Roman versions. Among them is the *Venus pudica* Capitolina (plate 29), which adds to a torso engaged in the manner just described a mild *contrapposto* enacted by the left leg, which has been moved forward to balance the downward tilting of the head. It is present in Pisano's pulpit at Pisa and is employed by, among others, the Limbourg Brothers (plate 30) and Hieronymous Bosch in the left panel of the *Haywain* triptych where both Adam and Eve enact the familiar gesture (plate 31). In a much dramatized version it provides a model for Masaccio.[9] Masaccio's Eve echoes the *Venus pudica* in the activity of the torso but the pathetic upward gaze and the contracted motion of a body withdrawing at the pace of expulsion are original features. In the case of Adam, Masaccio alters the model entirely. As he advances parallel to Eve, Adam employs his hands to cover his eyes and screen his sight, not to cover his genitalia. Michael Baxandall has pointed out that Adam and Eve's gestures find individual explanation in contemporary physiognomics: Eve's pressing her breast with the palm of her hand is a sign of grief, Adam's covering his eyes with his fingers is a sign of shame.[10] The two sentiments visualized by Masaccio, grief and shame, only partially coincide with the sentiments mentioned in the text, shame and fear. Lack of concordance between image and text was a deliberate choice on Masaccio's part, for a further scrutiny reveals that Adam and Eve's gestures are not only different, but in one important respect complementary. Adam screens his eyes – that is, he prevents himself from seeing, from being the agent of vision. Eve, conversely, covers her pubic area; hers is a concern with being seen, as she feels herself to be the object of vision. Man prevents himself from seeing, woman prevents herself from being seen. Masaccio sacrifices the literal visualization of the text in favour of a form of exegesis in which the complementary opposition between man's and woman's gestures posits sexuality as difference to be registered in the field of vision.

The complementary contrast between seeing and being seen has now to be checked at the preceding stage, that is before transgression, at the time of innocence. Turning to Masolino's visualization of the Temptation we discover that while Adam is gazing at Eve, she feels no need either to reciprocate or to obstruct man's gaze. Before the Fall Adam gazes uninhibited at Eve and the focus, as well as the quality, of his attention is such that Eve can, in fact, sustain his gaze

without discomfort. It is only with the Fall that woman becomes conscious of being the object of the gaze, and her anxiety at being an object of vision is accompanied by Adam's reluctance to be its agent, and to exercise a prerogative that has lost its innocence.

Adam and Eve's visual behaviour in the state of innocence makes clear how, as a consequence of the Fall, awareness of sexuality in the field of vision manifests itself in a difference located in agency and split along gender lines. Just as man is the subject of seeing, of the look, woman is the object of being seen, the object of the gaze, and the two stances taken together represent the full working of vision as an activity carried out by agencies that are necessarily partial to and conscious of the other. The questions raised by Masaccio's image are thus both visual and exegetical. On the one hand, there is the problem of a regime of vision that constructs its agency in terms of a complementary difference determined by position and gender, and on the other there is a textual reading that invests that difference with ethical value and translates it into different roles assigned to the male and female subject. These two sets of issues – the visual and exegetical – would seem to be of wholly different orders, unless we are able to think about Masaccio's image as grounded in both, and itself a form of exegesis, a visual exegesis.

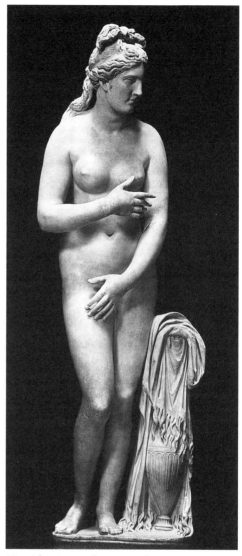

29 After Praxiteles, *Capitoline Venus*, Museo Capitolini, Rome. (Photo: Alinari/Art Resource: New York)

3. To see and to be seen: prerogatives of a regime of vision split along gender lines

Returning to the first set of questions, we can now address the ways in which humanism's regime of vision posits the complementary status of seeing and being seen. We may recall the paradigm of the window open onto the world and the status of the subject of seeing as one that surveys the outside world following the rules of perspective. We may call that agency of viewing the subject as look. As we acknowledge the subject as look we also recognize that symmetrically opposed to

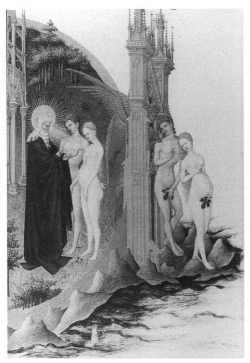

30 (above) Detail from Limbourg Brothers, *Terrestrial Paradise*, from the *Tres Riches Heures du Duc de Berry*, fol.25v, Musée Conde, Chantilly. (Photo: Giraudon/Art Resource, New York)

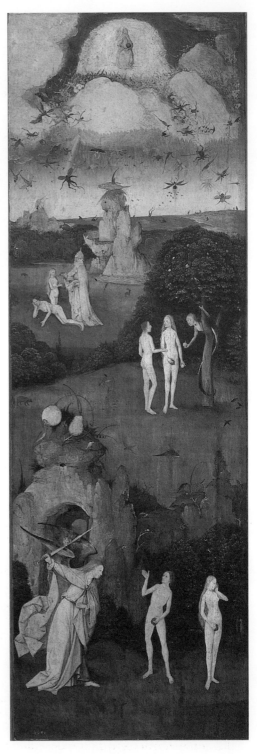

31 (right) Detail from Hieronymous Bosch, *The Haywain*, Prado Museum, Madrid. (Photo: Scala/Art Resource, New York)

112

the look, and also complementary, is the status of the subject as spectacle located in the field of vision and determined by its visibility – that is, the subject as being looked at. In the first condition, generally associated with the triangle of vision and familiar from perspectival constructions (plate 32, fig. 1), a subject is shown looking at an object from a marked position. The second condition not surprisingly reverses the terms of construction of the first, and locates the subject where before was the object, so that the subject of the look becomes now the object of the gaze (plate 32, fig. 2).[11] The two diagrams can be superimposed in order to suggest that the subject of vision is also in the picture, is being looked at (plate 32, fig. 3). Such is Jacques Lacan's diagrammatic representation, which helps in explaining why the simultaneous manifestations of the subject of vision, as look and gaze, should manifest a split, as in Masaccio's image, along gender lines, where the gaze is identified with the woman as spectacle.[12] Lacan's argument and diagrams are helpful for understanding how, in perspective, representation is offered with its complement, the working of the gaze: that is, masculine seeing, the look, is opposed to, and complemented by, the feminine

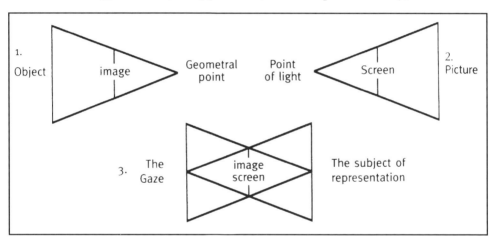

32 Diagrams of perspective and inverse perspective, from. J. Lacan, *The Four Fundamental Concepts of Psycho-Analysis* (1973), New York 1978.

being seen, the gaze. The fact that in humanistic discourse on vision, the agency of seeing can only be theorized in light of its complement, the inverse condition of being seen, and that look and gaze, seeing and being seen, enjoy a residual status indicate that what we are witnessing is the construction of identity as determined by the complementary opposition of two terms, with the subject emerging as inseparable from the limits imposed by the other. If identity emerges only within recognition of a drive, which is at the mercy of the other, whose privations are the testimony of the other, its definition – as with any definition of identity – cannot do without the acknowledgement of that which the other is capable of depriving the subject of. In the field of vision, the point of view and possibility of the complementary other translates into the notion of the gaze: the gaze is the agent of the complementary other. Consequently, a definition of the subject as agent of seeing imposes on the other a form of limitation that translates into being seen.[13]

Masaccio's avoidance of a literal visualization of the text in favour of a representation of identity as made of a complementary opposition between seing and being seen, indicates also that in the field of vision the construction of identity consists of assigning alternative positions within the dichotomy seeing/being seen.

Feminine identity takes the position of or, to use the Lacanian term, the 'ordering' of to-be-seen, a role residual, and opposed to, the masculine to-see. But if to see and to be seen are just 'orderings' that reflect the complementary construction of identity, one obvious question arises. Why is woman assigned the 'ordering' to be seen? Why is she the one under the gaze? To be under the gaze is for woman the consequence of the Fall, a form of punishment for that act of transgression.[14] The humanistic notion of woman under the gaze appears, then, as the conclusion of a trajectory that originates in the exegesis of Genesis.

I want now to turn to Genesis' exegesis and to analyse the ways in which Eve's presumed responsibility was ascertained, how her shortcomings were extended to all women, and how conclusions were drawn from that exegesis concerning the necessity of control over women and their representation.

4. Augustine's exegesis of Genesis and its consequences: woman under the gaze and disciplined

Though Genesis 3 makes no reference to sexuality, punishment for the act of transgression takes the body as its target: fatiguing labour for men, giving birth in pain for women. How the new status of the body determines in both Adam and Eve to rethink their identity is not explicit. The discourse on individual responsibilities in the Fall involves in patristic literature and later on, in humanistic commentaries, a focus on the status of female body as a consequence of Eve's act, and for what it presumably reveals on feminine psychology in general.[15] Considerations on female character involve, beginning with Augustine, the elaboration of a series of corrective measures to which the female soul should be subjected, a discipline of the soul which should reveal itself through a discipline of the body. If physiognomics is the *ars* or practice of detecting the sentiments of the soul via the movements of the body, discipline constitutes the restricted field of feminine physiognomics. It is the Fall, its dynamics and Eve's presumed responsibility in it, which makes it necessary to subject women to corrective discipline.[16]

According to Augustine's standard exegesis, Adam and Eve were punished in kind for their disobedience to God. 'The punishment for disobedience was nothing other than disobedience. For human misery consists in nothing other than our own disobedience to ourselves.'[17] The consequence of Adam and Eve's rebellion was a rebellion in the flesh, to be identified with all that we experience against our will: pain, suffering, fear, ageing and death. What the Fall epitomizes is the initial and everlasting emergence of what Augustine terms the 'disobedient members'. Sexual desire is equated with an act of disobedience, driven by the indecent movement, *impudens motus*, of members that resist the rule of will and which, therefore, have to be covered as shameful members.[18] In one of his letters (245), Augustine justifies the necessity, and practice, of women's veiling of their

bodies with the assertion that 'the sex of their bodies is lacking the image of God.' Veiling becomes the partial remedy to to-be-seen.[19]

For Augustine, woman as agent of Scientia – as opposed to Sapientia, whose agent is man – is equipped with limited inner strength, which limits her apparatus of self-control and thereby her power to resist temptation. Because of her deficiency Eve, incapable of resisting temptation, induced Adam to disobey. Now this deficiency, which is not Eve's own limitation but a feminine prerogative, is initially connected by Augustine to sexual desire, which he variously terms *libido*, *cupiditas* and *concupiscience*. Feminine disposition to sin, grounded on insufficient control over her sexual drives, is not merely a deficiency, however, for it exerts a corrupting role on man in his own attempt to overcome temptation. According to Augustine, the emergence of male sexual desire involves a tension and a conflict between the internal image of good and the external image of woman. Augustinian exegesis locates the feminine in a system in which she is innately in conflict with man's call for Christian emancipation, and the conflict plays itself out in the field of vision. The discipline to which woman has to be subjected is then a function of preventing man's distraction from his inner vision and suggests a notion of vision that is both real and metaphorical.[20] At its initial stage vision is a potentially libidinous activity that calls for sublimation in men and correction in women. The gender distinction here is grounded on two assumptions: first, that women do not possess the resources necessary to transcend the real in favour of higher visions, and second, that woman herself is the material vision that man has to transcend.

Augustine is radical in his conviction that the struggle against the internal domination of sin is a desperate one. In his view, only an institutional discipline imposed on the individual from the outside can overcome 'disobedient members'. Such is the power of corruption exerted by libido, that in fact only Christ, being born without the intervention of semen, is exempt from its sinful consequences. Augustine calls for a cooperation between church and society in order to exert control over the female body, and concludes his exegesis by stating that the necessity of redemption for woman should translate into a discipline of the body. Interestingly for my purposes, this discipline takes as its point of departure the notion that she is the object of vision, that she is under the gaze. If straight-looking eyes are the index of a calm man of friendly attitude, a woman should be typified by downcast eyes and tilted head, the signifiers of a body under the gaze and disciplined, and, since Aristotle, of feminine inferiority.[21]

In terms of physiognomics and the theory of expression in general the formula 'downcast eyes and tilted head' was justified by referring to two different sets of sentiments that find bodily representation. The body can give expression to sentiments which are innate and presumably universal or acquired and culturally determined.[22] In this latter instance a posture or a facial expression informs us not of the character of the figure but of the rules, the *regulae* of a discipline imposed on the subject by coercion and characterized by a specific bearing and appearance. Here is where the feminine physiognomics of 'downcast eyes and tilted head' originates and resides. A female character does not reveal her emotions via the movements of her body; her body is denied that male prerogative as it is locked into a posture that speaks for an overall behaviour deprived of individual specifications.[23] The only

correspondence that the female body enacts is that between *disciplina animae* and *disciplina corporis* – that is, a specific *discipline* of the soul which reveals itself through a *discipline* of the body. If the basic principle of Christian discipline is to act impeccably 'as if one were at any time under God's gaze',[24] 'downcast eyes and tilted head' are indicative of such awareness; they are an index of feminine visibility, of prudence, modesty and reverence before an external gaze, and of what it means to subject oneself to rules, 'que veut dire avoir l'esprit d'une règle'.[25]

Discipline crosses the representation of women at its very foundation: as a consequence of the Fall woman is under the gaze, she knows that she is constantly watched, and her behaviour and posture should reflect that awareness.[26]

5. From discipline to contemplation

Although Christian in its origin, the notion that woman is under the gaze was not limited to religious discourse. With humanism, and Petrarch in particular, the notion and the posture acquired a new set of verbal and visual qualifications that affect representation. Humanists first dismantled the allegorical barrier of courtly culture that surrounded and protected the image of woman and, starting with Petrarch's Laura, began to imagine or represent woman in isolation and under the internalized gaze characteristic of discipline: tilted head, downcast eyes, tightly closed legs, the catalogue is familiar and meticulous. When Petrarch speaks of *aura* as the manifestation of a sentiment that is a complex mixture of recollection and fantasy, he refers to his vision of Laura as portrayed in 'downcast eyes'. 'Downcast eyes' becomes the guarantee for a non-reciprocity which is an essential and reassuring factor in Petrarch's mode of gazing.[27] 'Io temo sì de' begli occhi l'assalto' (RVF, 39) [I fear the encounter with her beautiful eyes] reads one of his verses. The poet sees a danger in being seen, as the possibility of the female gaze turning on him evokes the myth of Diana and Acteon. The image of Acteon's dismembered body as a punishment inflicted for unwarranted gazing at Diana's body and enacted by Diana's own returned gaze obsessed Petrarch, who resorted to 'Downcast eyes' as the only safe female posture.[28] Protected by Laura's reliability not to return his gaze, the poet dismembers the beloved's female body, employing his own verses as dissecting tools. Shielded by his optic fear, the poet selects parts, assigns values, and establishes hierarchies of truth and discourse. The discipline of the female body gradually translates into a localization of feminine virtues within the feminine body, and Petrarch's feminine nomenclature becomes essential in complementing the image of the disciplined woman. The selection and hierarchy of anatomical parts, expressions, colours and gestures are poetically typified in order to offer a repertoire of metaphorized sensibilities which canonize the female body's form of expression. And the canon emerges as a set of visual norms that cross artistic theory and criticism, expanding its vocabulary and its area of interest. The survival and expansion of Petrarchan forms of attention and nomenclature throughout the fifteenth and sixteenth centuries effectively contributed to the transformation of woman under the gaze from the punitive 'to be seen' of Augustinian origins to being an object of contemplation. In both the Christian discipline and Petrarchan poetry, downcast

eyes and tilted head are symptomatic of modesty and repentance – that is, of acceptance of rules, of complying with a project that requires and imposes, above all, silence.[29] Silence – as a consequence of the Fall women do not preach or speak the word – translates into a condition of receptivity but not transmission which is essential to the Petrarchan one-sided engagement with the female body.

6. The female body and mimesis: the dialogue and the discourse on feminine beauty

Any critique of the model of discipline which assigns to women the 'ordering' to be seen had to provide a setting for women to speak, which is what the humanistic dialogue supplied. It is important now to consider how the humanist dialogue worked to subvert that model and to provide feminine visibility with a positive connotation.

It was the humanist Sperone Speroni who came to recognize that only the dialogue could give voice to women, for only the dialogue could offer the terms and circumstances of private discourse, indispensable ingredients for any reflection on women and their status.[30] His apologia for the dialogue is based on the efficacy of its dialectics, in so far as it relies on a contrast of characters to offer a rich image of reality. By giving voice to men and women of different age, class and opinions, the dialogue captures reality's multiple appearances without being compelled to advocate a single moral example. It is only in such a plurality and dialectical 'a piu' voci', that a female voice can find a potential audience for its arguments.

Speroni did not mean by dialogue merely interplay among fictional characters, but instead the real exchange of personal correspondence, which he published and valued highly as a literary form. In this respect it is important to recall that the first humanistic critique of Augustine's exegesis of Genesis is contained in an exchange of letters between Isotta Nagarola and her interlocutor Lodovico.[31] Claiming that inordinate appetite rather than innate fragility was the cause of Eve's capitulation to the devil's challenge, Isotta sees the original sin as a manifestation of ignorant pride, rather than congenital weakness. Lodovico, quoting Augustine, reminds his interlocutor that ignorance of the law is not a conciliatory factor but quite the opposite, an aggravating one. However, the pride is not related by Lodovico to the discovery of sexuality in its exposure to vision, except where he makes a cryptic reference to vision: 'The eyes which guilt makes blind, punishment opens.' And here the different responsibilities in the episode assigned to Adam and Eve offer us a further clue into Masaccio's representation of their differential response. It is Eve's eyes that, according to Lodovico, had to open, not Adam's. His eyes were open and knew, but he proceeded nonetheless. Eve had yet to open her eyes, but for Adam the consequences of the act were somehow reversed; he had to cover his, which were already open. Lodovico quotes Ecclesiasticus, where it states that 'in a state of innocence flesh was obedient to him', a notion on which, as we have seen, Augustine elaborated, in order to reaffirm that it was she who altered that state and liberated those impulses of which she was to become the first target. Uncontrolled impulses of the

flesh became the punishment for woman's claim to knowledge. But Isotta's powerful defence of women had recourse to humanistic precepts when she claims that Eve cannot stand for all women, since responsibility can only be individual. Moreover, since Adam is not taken as representative of all men, there is no reason for considering Eve representative of all women.[32]

The defence of women made possible by the form of the dialogue also occasioned a reconsideration of the negativity that Augustine, and later Christianity at large had attached to the beholding of the female body. Citing Neo-platonic notions of beauty and equipped with a Petrarchan vocabulary of taxonomic contemplation, the dialogue offered a new context for discussing the nature and relative value of beholding the female body. According to Firenzuola, 'a beautiful woman is the most beautiful object one can admire, and beauty is the greatest gift God bestowed on his human creature. And so, through her virtue we direct our souls to contemplation, and through contemplation to the desire for heavenly things. For this reason beautiful women have been sent among us as a sample and a foretaste of heavenly things …'[33] Beauty when contemplated could become a virtue that elevates the beholder to heavenly things. The anagogic potential of feminine beauty – the opportunity it offers its beholder to transcend it in favour of divinity itself – presupposes that the beholder, that is the male beholder, transcends what he sees and thereby gains access to higher visions. If Augustine female beauty possessed negative connotations – so that its only value rested in the activity of overcoming the temptation of it – in Neo-Platonism female beauty found partial rehabilitation. But female beauty could become an object of contemplation only if distanced from the real, that is, only if addressed as ideal beauty. It is at this junction that one of the most popular myths concerning Apelles becomes crucial; ideal beauty was thought to consist of a synthesis of different parts of the female body belonging to different women. The working assumption is here that no actual woman can possess all the qualities of the ideal, and consequently there can be no absolute beauty in real women. The ideal poses the problem and the necessity of a selection of different qualities from different sources to be recomposed later in representation. Once beauty is distanced from any individual woman, it can be accepted as an object of contemplation, as one of the intermediary steps towards the immaterial beauty of the divine. Petrarch's feminine taxonomy and nomenclature offered the items and standards of that selection, and the activity itself, a male prerogative once more, constituted a distancing factor, a step away from the real.

Even when they attribute a sacred value to beauty, Renaissance dialogues on feminine beauty nonetheless confirm the terms of a regime of vision which assigns to woman the 'ordering' of being seen, of being under the gaze. What they also confirm is that the liberating experience that feminine beauty may offer is entirely directed to men. Women are not allowed to engage with corporeal beauty, whether feminine or masculine, in analogous terms. The power of the gaze to transcend the seen in favour of higher visions is an exclusive prerogative of the male gaze, of a gaze that exerts its power as it addresses the object of vision in an unconditioned, unrestricted, unmitigated way. And women's access to the gaze is only conceivable in terms of a straight inversion – enacting the male gaze so as to

be able to see, and see women in particular. 'I would like to see … I would like to see …' writes Lucretia Misippa in her Homeric fantasy published in 1549 in Ortensio Landi's collection of early feminist writing.[34] And what Misippa was eager to see were those feminine qualities advertised by the male beholder. Things like the clean and finely pressed clothing of Dutch girls.

7. Disrupting the male gaze: from Titian to Rembrandt

It is now time to address the phenomenology of male beholding within the regime of vision that had assigned to women the 'ordering' to be seen. As we have seen, the notion that woman should be represented as under the gaze precluded her from enacting the range of physiognomic postures available to the male body and confined her to the 'downcast eyes and tilted head' formula. Given these restrictions in the Renaissance as before it in antiquity – that is within mimesis' mode of representation – the female body is envisioned as entertaining an unclear relation to language. Not an agent of the plot, the female body is said to elude discourse, to resist interpretation, to make script ineffectual. There is a certain tension between 'downcast eyes and tilted head' and mimesis, in the sense that the representation of the female body in accordance with that formula may be conflictual with the terms of reception typical of narrative painting.[35] In particular, the female nude may disrupt the time of the narrative, for its time runs the risk of being replaced by the time of the beholder's subjective projection, the timetable of the male gaze engaged in inspection and arousal.

The reclining female nude, a type elaborated and brought to fame by the Venetian School in the sixteenth century, embodies those non-discursive qualities that reveal the complex relationship between mimesis and feminine representation. Even when acting in a narrative, the female body can induce a different form of attention, whereby it radicalizes the condition of being seen to the point of disrupting the narrative. It is a danger inherent in mimesis as Aristotle was already aware. The question of whether Titian's female nudes offer the beholder the material for positive contemplation that evolves towards higher forms of vision or whether the beholder of these images has bypassed mimetic identification, has rid himself of narrative constrictions and is now engaging the image on his own terms, is still an argument of contention. In Titian's series of reclining nudes accompanied by a spectator, a musician equipped with his instrument, the intrinsic ambiguity of the image reaches enigmatic proportions multiplying the questions raised by the representation of the female nude alone. In the *Reclining Nude with Organist* (plate 33) the woman is under the male gaze, which she acknowledges by casting her eyes downwards and tilting her head. Her discomfort is manifest. The musician too seems quite anxious about the capacity of music to elevate his attention to higher forms of beauty – at the moment his gaze is all too focused on the female genitalia. His choice of a different instrument may well speed up the process and break his temporary arrest in the transcendental venture (plate 34).[36]

A crucial observation concerns the disruption that female beauty as spectacle can bring to mimetic representation and narrative construction. The posture of

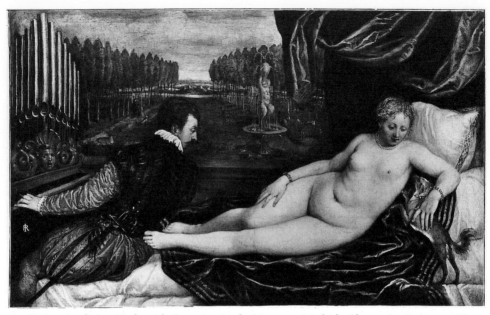

33 Titian, *Reclining Nude with Organist*, Prado Museum, Madrid. (Photo: Art Resource, New York)

the beholder in the *Reclining Nude with Organist* offers the male beholder outside the picture a plausible model to follow, an exemplum. The reclining nude is, however, still under the gaze of the outside beholder, who is also guaranteed access to the scene represented without mediation. The proximity of the body to the foreground and the setting's limited plausibility in spatial and logic terms – a bed in a garden with partial screen and elements of an interior juxtaposed to the natural openness – are pictorial devices intended to facilitate the dual accessibility to the female nude by the male gaze: addressed directly to the beholder or mediated by the purposeful gaze of the musician. Laura Mulvey has brilliantly scrutinized this dual condition of the male beholder in reference to cinema, though the contradiction to which she refers in her *Visual and Other Pleasures* may well be not only a prerogative of cinema but of mimesis in general.[37] In cinema, with the complicity of a darkened auditorium, the beholder can engage in voyeurism by identifying with the character on the screen, or he can engage in fetishistic scopophilia, where what is shown is perceived as outside the space and time of representation, outside plot and narrative, and existing only for the satisfaction of his erotic instinct. A different time is thus introduced which threatens to disrupt and dismantle the fictitious mimetic construction for the benefit of an imaginary and precariously alternative one. The fragmentation and partial incoherence of the close-up conspires in Titian's painting to obtain this dual quality of attention to the image: fetishism and voyeurism coexist, and there is no reason to believe that they are in opposition to each other. Voyeurism is a visual pleasure mediated by the character, its time and structure are those offered by the image or the film. Fetishistic scopophilia operates outside that structure, its time being that of the beholder alone.

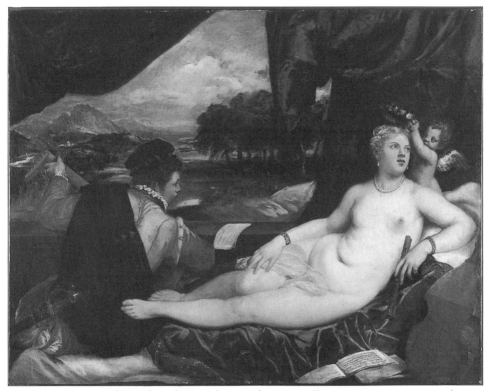

34 Titian, *Venus and Cupid, with man playing a lute*, Fitzwilliam Museum, University of Cambridge. (Photo: Fitzwilliam Museum)

The alternative so often posed in reference to Titian's representations of female nudes – where they must be either pin-ups or agents of mythological sublimation – might after all be versions of the alternative proposed by Mulvey for film. Whether the beholder plays the game proposed by the musician, or prefers his own, has to do with whether he engages the female nude in the narrative or whether he has decided that female beauty and the erotic drive that it activates in the male gaze are external to narrative. A corollary to the second option concludes that female beauty resists context, discourse and whatever verbal form we invoke for our experience of it, and that it is in its nature to disrupt mimetic constructions/constrictions and to stand outside on its own. There is nothing hermeneutically questionable with this attitude; it may just be a little embarrassing. As for the interpreter, the choice between voyeurism or fetishism is, after all, not too edifying, and it could well be characterized as an opposition between humanists and lookers.

Nonetheless all this makes little difference to the woman one way or the other, for she is firmly after all the passive object of this experience of transcendence. It could never be the other way around, for female beauty is at the service of the male gaze and woman can never engage with physical beauty for reaching a higher vision. That is the case in so far as she is trapped in a regime of vision in which her role, her 'ordering', is that of being seen, of being under the gaze.

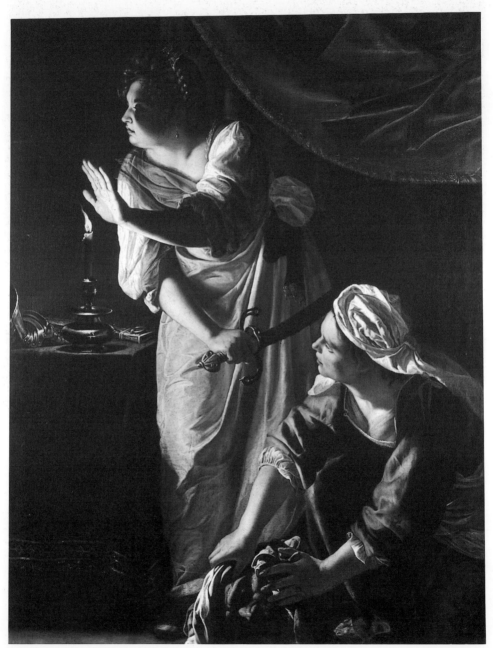

35 Artemisia Gentileschi, *Judith and her Maidservant with the Head of Holofernes*, 1625, The Detroit Institute of the Arts: Gift of Mr Leslie H. Green. (Photo: © The Detroit Institute of the Arts, 1994)

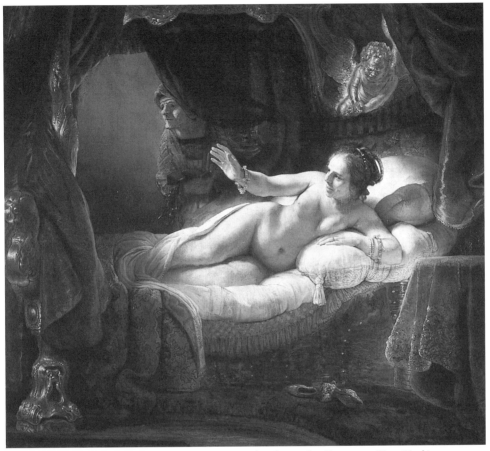

36 Rembrandt, *Danae*, The Hermitage, Leningrad. (Photo: Art Resource, New York)

Short of Manet's *Olympia*, is there a regime of vision that supersedes that alternative, culturally and historically? By way of conclusion, let me consider a picture by Artemisia Gentileschi representing *Judith and her Maid* of *c*. 1625 (plate 35). Having just killed Holophernes, the two women are possibly still in the enemy's camp. They are naturally circumspect and, in the darkness, point, gaze at somewhere, we do not know how close, where danger may lie.[38] The reference to an indeterminate presence shocks the beholder. It places him in a condition that is opposite to that of suspense, to use an analogy with film. In a typical Hitchcock suspense narrative, the spectator knows what the character in the film does not, and of course he or she cannot but follow the character's movements with great anxiety. In Artemisia's paintings the situation is reversed: it is the beholder who is left in the dark, unable to find orientation. By making crucial what is not in the visual field and excluded by the picture's frame (though clearly in its scope), Artemisia introduces a powerful disturbance in the beholder's form of attention, raising a question which the beholder cannot answer. Beholding is crossed by an anxiety that transcends the picture's subject matter, as it strikes beholding at its very centre: making sense of the seen. It

123

constitutes a powerful way of disrupting the beholder's tempo, his unconstricted attendance, his unconditioned gaze.

In Rembrandt's *Danae* (plate 36) we encounter a strategy of disturbance similar to Artemisia's, with the difference that now the disturbance affects a beholder engaged with the female nude. Danae's gesture of screening something outside the pictorial field effectively disturbs the male gaze engaged with the body of Danae, regardless of the iconography of that gesture which, as we learn from Panofsky, is a considerable one.[39] The female body is still under the male gaze, though the dynamics of that gaze have been altered drastically. No longer undisturbed, no longer free to move and scan, advance and withdraw, the male gaze is deprived of its leisurely cadenza. Inspection has been disturbed, its timing altered, its circumstances corrupted; the visual pleasure has been, to some degree, spoiled. The beholder operates now within a regime of vision that imposes on him some restrictions, and that is capable of responding to his gaze, of contaminating it. The space and time of the beholder are no longer unconditioned by what occurs in the pictorial field. The image is no longer the window open onto the world, but rather a stage in which the character can turn unexpectedly towards the audience. The light can turn towards us, we have to be alert, the game is over or, better, another game has begun. I still like to call it the Baroque.

Conclusions

It all started with Genesis and its exegesis. What I wanted to discuss here is how sexuality in the field of vision finds representation in opposite agencies, seeing and being seen, the look and the gaze. I tried to explain how this dual condition is rooted in humanism's regime of vision, and why, following Augustine's exegesis of Genesis, woman comes to be assigned the 'ordering' to be seen. I explained how the 'ordering' to be seen imposes a specific visual formula 'downcast eyes and tilted head', which represents a discipline imposed on the female subject. I have also discussed how the female body locked into this visual formula carries specific consequences for mimetic representation. I have discussed the case of the reclining nude as inducing a dual form of male beholding, one resulting in transcendental vision, and the other anchored in voyeurism. I have concluded that the female body is a passive agent of male beholding and that woman is under the gaze as long as we remain within the regime of vision that has assigned her the ordering of being seen. Finally, I have alluded to another regime of vision, one that, if it does not liberate woman from the constraints of being seen, at least begins to question its mechanisms.

Paolo Berdini
University of Stanford

Notes

1 As Clark Hulse points out, in his *The Rules of Art. Literature and Painting in the Renaissance*, Chicago and London 1990, 58: 'The Latin, as we shall see, gives more exactly what he [Alberti] means, not only for the phrase *sub luce*, literally "under the light," but meaning "visible reality," but also because of the passive form of the verb, *videantur*. The great maneuver of the treatise is Alberti's persistent equation of painting with what is seen – not with what I see or you see, but with vision itself.'

2 Leonardo, *On Painting*, M. Kemp (ed.), New Haven and London 1990, 147.

3 S. Brant, *The Ship of Fools* (1525), New York 1944, 135; J.L. Vives, *The Institution of a Christian Woman* (1523), Leiden, New York and Cologne 1996, 41. On Vives see G. Kaufman, 'Juan Luis Vives on the Education of Woman', *Signs* 3 (1978): 891–7, and E. Garin (ed.), *Il pensiero pedagogico dell'umanesimo italiano*, Florence 1958. Francesco Barbaro too, in his *De re uxoria* (Ms., *c.*1410), identifies feminine demeanour with 'evenness and restraint in the movements of the eyes, in their [women's] walking, and in the movement of their bodies'. (English translation as *On Wifely Duties*, in B.G. Kol and R.G. Witt (eds), *The Earthly Republic. Italian Humanists on Government and Society*, Philadelphia 1978, 189–228, 202).

4 See, in particular, J. Zaclad, 'Création, péché originel et formalisme', *RHPR* 51 (1971): 1-30; J.T. Walsh, 'Gen 2:ab-3:24: A Synchronic Approach', *JBL* 96 (1977): 161–77; T.E. Boomershine, 'The Structure of Narrative Rhetoric in Gen 2-3', *Semeia* 18 (1980): 113–29; D. Patte and J.F. Parker, 'A Structural Exegesis of Gen. 2-3', *Semeia* 18 (1980): 141–59; O. Davidsen, 'The Mythical Foundation of History: A Religio-Semiotic Analysis of the Story of the Fall', *LingBib* 51 (1982): 23–36, and G.J. Wenham, *Genesis 1-15* (World Biblical Commentary vol.1), Waco, Texas 1987, 49–55.

5 R. Gordis, 'The Significance of the Paradise Myth', *AJSL* 52 (1936): 86–94; W.H. Shea, 'Adam in Ancient Mesopotamian Traditions', *AUSS* 15 (1977): 27–41; J. Ellington, 'Man and Adam in Gen 1-5', *BT* 30 (1979): 201–205; G. Gerleman, 'Adam und die alttestamentliche Anthropologie', in J. Jeremias and L. Perlitt (eds), *Die Botschaft und die Boten*, Festschrift für H.W. Wolff, Neukirchen 1981, 319–33.

6 It should be stressed that awareness of nudity through sin does not indicate that the naked state of the couple is at the origin of their sin. Though the symbolism of the serpent – a cunning and exceedingly long-lived creature custumarily associated with fertility – and the unspecified nature of the knowledge provided by the tree's fruit may refer not to a general and moral knowledge but to a sexual one, and to the fulfilment of sexual desire in particular. The partial anthropomorphization of the serpent also attests to the dual nature of the misdeed: human and other, internal and external. In the knowledge resulting from the opening of the eyes, exegeses have variously emphasized sexual, moral or cognitive instances, though what the dual character of the narrative above all indicates is an awareness of duality itself – that is a general recognition of a gap between 'so-being' and the oppositional nature of 'shall-be'. Moreover, the meaning of the phrase 'the knowledge of good and evil' lies more in its function than in its content. It symbolizes obedience and disobedience. As Martin Buber has observed, the knowledge of good and evil that transgression promised is 'an adequate awareness of the opposites inherent in all being with the world.' See M. Buber, 'The Tree of Knowledge: Genesis 3,' in H. Bloom ed., *Genesis*, New York, New Haven and Philadelphia 1986, 43–48. Buber concludes his reading by stating that: 'In themselves, naturally, neither the concept of clothed and unclothedness, nor that of man and woman before one another, has anything whatsoever to do with good and evil; human 'recognition' of opposites always brings with it the fact of their relatedness to good and evil.' (47) One may add that awareness of the opposites latent in creation begins with an acknowledgment of the gender difference brought about by the play of subjectivity in the field of vision.

7 H. Wallace, *The Eden Narrative*, (HSM 32), Atlanta 1985, 146, chap. 5, 'Fertility and sexual motifs in Gen 2-3', 143–72. See also J. Coppens, *The connaissance du bien et du mal et le péché du paradis. Contribution à l'interprétation de Gen II–III*, Gembleaux 1948; E.H. Pagels, *Adam, Eve, and the Serpent*, New York 1988; P. Trible, *God and the Rhetoric of Sexuality*, Philadelphia 1978; A.H. Brenner, *A Feminist Companion to Genesis*, Sheffield 1983.

8 P. Ricoeur, *The Symbolism of Evil*, Boston 1967, 247.

9 See N. Salomon, 'The *Venus pudica*: Uncovering Art History's Hidden Agendas and Pernicious Pedigrees', in G. Pollock (ed.), *Generations and Geographies in the Visual Arts: Feminist Readings*, London and New York 1996, 69–87; V. Allen, 'The Naked Lady: A Look at Venus in the Renaissance', *Feminist Art Journal* 6 (1977): 27–9; L. Bonfante, 'Nudity as a Costume in Classical Art', *American Journal of Archaeology* 93 (1989): 543–70.

10 M. Baxandall, *Painting and Experience in Fifteenth Century Italy*, Oxford 1972, 61, refers to a Benedictine reading of physiognomics.

11 The notion of reversed, or inverted perspective, has received a number of critiques, most of

which claiming that it constitutes a notion rather than a form of representation, and that it lacks precise and consistent terminology, both technical and conceptual. In his discussion of anamorphosis and reversed perspective Lacan points out the difficulties of visualizing the gaze, for it refers to a dimension of the visual that cannot be reduced to (and therefore is not representable according to the rules of) geometrical space. It is precisely this quality of the visual which exceeds spatial coordinates that, according to Lacan, pertains to the gaze. Strictly speaking, reverse perspective, as the gaze, cannot be represented, for if I can see myself being seen, I can never see myself from the point from which I am seen. For a critique of the Lacanian notion of the gaze from the point of view of *a* theory of perspective, see J. Elkins, *The Poetics of Perspective*, Ithaca and London, 1994, esp. 247–55.

12 J. Lacan, *The Four Fundamental Concepts of Psycho-Analysis* (1973), New York 1978, 75: 'At the very level of the phenomenal experience of contemplation, this all-seeing aspect is to be found in the satisfaction of a woman who knows that she is being looked at, on condition that one does not show her that one knows that she knows.'

13 K. Silverman, *Male Subjectivity at the Margins*, London and New York, 1992, chap. 3.; J. Lacan, *Feminine Sexuality*, J. Mitchell and J. Rose (eds), New York, 1985, Rose's important introductiory essay is reprinted in idem, *Sexuality in the Field of Vision*, London, 1986. Also relevant to this discussion are chap. 7, 'The Imaginary', and chap. 10, 'Sexuality in the Field of Vision', of Rose's book.

14 According to P. Trible, *God and the Rhetoric of Sexuality*, Philadelphia, 1978, 97: 'The creation of Eve alters Adam's creatural nature and institutes the sexual distinction. Before "intrinsic division" there is no sexual identity proper. The institution of sexual differentiation, of Eros, establishes the possibility of discontinuity of discourse of which the Fall will be soon the consequence.'

15 On humanistic commentaries on the status of the female body as a consequence of Eve's act and for what it presumably reveals of feminine behavior in general, see M. Bal, 'Sexuality, Sin, and the Emergence of Female Character', in S. Rubin Suleiman (ed.), *The Female Body in Western Culture*, Cambridge, 1985, 317–38.

16 On the theory and practice of corrective discipline for women in the Renaissance, see, G. Zarri (ed.), *Donna, disciplina, creanza cristiana dal XV al XVII secolo*, Rome, 1996, and P. Prodi (ed.), *Disciplina dell'anima, disciplina del corpo e disciplina della società tra Medioevo e età moderna*, Bologna, 1994.

17 Quotations refer to the edition by Roland J. Teske, Augustine, *On Genesis: Two Books on Genesis against the Manichees; and On the Literal Interpretation of Genesis, an Unfinished book*, Washington, DC, 1991.

18 On Augustine's exegesis, see in particular Elaine H. Pagels, 'The Politics of Paradise, Augustine's Exegesis of Genesis 1-3, versus that of Chrysostom', *Harvard Theological Review*, 78 (1985): 67–99; idem, *Adam, Eve, and the Serpent*, New York, 1988; and K. Power, *Veiled Desire. Augustine on Women*, New York, 1996.

19 To the Christianization of a practice that was customary among the Greco-Roman and Jewish world, see H. Tavard, *Women in Christian Tradition*, Notre Dame, 1973, and A.J. Schmidt, *Veiled and Silenced. How Culture Shaped Sexist Theology*, Macon, Georgia, 1989.

20 The metaphorical notion of vision does not divert its agents from their working phenomenology, it is rather intended to expand their area of responsibility. While it retains its attributes of optical experience, to see signifies to discern between good and evil. The process is exegetical in nature; the opening of eyes which already see postulates the presence of an activity of moral judgment that subsumes and supersedes the real in ways analogous to the trajectory of the exegetical reading which retains at the level of allegory the text's literal content and progressively expands its experience and value as it ascends towards the anagogical.

21 Aristotle, *De generatione anamalium*, 731b16–732a12, asserted '. . . all female births come from a deficiency of natural heat.' On the notion of women's inferiority and its Aristotelian source, see M.C. Horowitz, 'Aristotle and Woman', *Journal of History of Biology* 9 (1976): 183–213; R. De Maio, *Donna e Rinascimento*, Milan, 1987; G. Servadio, *La donna nel Rinascimento*, Milan, 1986; and the important study by I. McLeon, *The Renaissance Notion of Woman*, Cambridge, 1980.

22 The difference between innate and acquired is indirectly acknowledged by Aristotle who, in *De Anima*, postulates a relationship between posture of the body and emotion of the soul as pertaining to the human condition in general, whereas in *On Rhetoric* he defines gestures as complementary to forms of speech which are culturally determined and specifically conditioned by subject matter, scope of persuasion and quality of audience. It should be noted that it is this artificial quality of rhetoric, its neutrality and malleability that offended Plato, who blamed rhetoric for acting in the service of an argument rather than the truth. As we shall see, the humanistic and feminist critique of physiognomics was platonic in inspiration.

23 On feminine physiognomics, see P. Magli, 'The Face and the Soul', in M. Femer (ed.), *Fragments for a History of the Human Body*, 3 vols., New York, 1989, vol. 2, 87–127.

24 Bonaventura Gonzaga da Reggio, *Alcuni avvertimenti nella vita monacale, utili et necessari*

a ciascheduna Vergine di Cristo, Venice, 1576.

25 Francis of Sales, *Recueil des entretiens spirituels*, in A. Revier and R. Devos (eds), *Oeuvres*, Paris, 1969, 1089. Although discipline originates as a punishment for Eve's responsibility in the Fall, it soon becomes emancipated from that initial circumstance and comes to be considered a condition of good female upbringing and a positive feminine value. A good summary of the literature on the subject is offered by R. Kelso, *Doctrine for the Lady of the Renaissance*, Urbana, 1956; useful anthologies of texts were curated by G. Zonta, *Trattati d'amore del Rinascimento*, Bari, 1916, and idem, *Trattati sulla donna del Rinascimento*, Bari, 1916; J. Murrey and K. Eisenbichler (eds), *Desire and Discipline. Sex and Sexuality in the Premodern World*, Toronto, 1996; see also M.K. Blade, *The Education of Italian Renaissance Women*, Mesquite, Texas, 1983.

26 On the phenomenology and genealogy of 'downcast eyes and tilted head' see G. Pozzi, 'Occhi bassi', in E. Marsch and G. Pozzi (eds), *Thematologie des kleinen-Petits thèmes littéraires*, Fribourg, 1986, 152–86. Cfr. A.C. Meisel and M.L. del Mastro (eds), *The Rules of Benedict*, New York, 1975, chap. 7, 'Humility'.

27 On this crucial partiality of vision for the construction of the image-myth of Laura, see J. Freccero, 'The Fig Tree and the Laurel: Petrarch's Politics', *Diacritics* 5 (1975): 34–40, who characterizes it as 'the idolatrus and unrequired passion for a beautiful and sometimes cruel lady'. See also W. Haller, 'The Petrarchan Sonneters and Neo Platonic Love', *Studies in Philology* 42 (1945): 164–82.

28 'The profile form, already a fragmentary statement fixing one side of the upper body but absenting the rest', also accomplishes the preclusion of reciprocity in a strictly technical sense. Patricia Simons, 'Women in Profile: The Gaze, the Eye, the Profile in Renaissance Portraiture', *History Workshop* 25 (1988): 4–30, offers interesting observations on the profile's defusion of the gaze.

29 Francesco Barbaro's *apologia* of feminine silence is notable. In his *De re uxoria* (Ms, *c.*1410), he collects Greek and Roman sources on the gender value of silence, and concludes chap. 4, 'On Speech and Silence', by stating that: 'Therefore women should believe they have achieved glory of eloquence if they will honour themselves with the outstanding ornament of silence.' (206). Ref. to English edition in note 3.

30 S. Speroni, 'Della dignità della donna', in idem, *I dialoghi di Sperone Speroni*, Venice, 1542. On Speroni and the humanistic dialogue, see J.R. Snyder, 'La teoria del dialogo', *Filologia veneta* 2 (1981): 113–38.

31 Isotta Nagarola, 'Of the Equal or Unequal Sin of Adam and Eve', in M.L. King and A. Rabil jr. (eds), *Her Immaculate Hand. Selected Works by and about the Women Humanists of Quattrocento Italy*, Binghamton and New York, 1983, 57–69; see also M. King, 'The Religious Retreat of Isotta Nogarola (1418–1466): Sexism and its Consequences in the Fifteenth Century', *Signs* 3 (1978): 807–22, and idem, *Women of the Renaissance*, Chicago and London, 1991, and O. Niccoli (ed.), *Rinascimento al femminile*, Bari and Rome, 1991.

32 The argument was taken up later by Luigi Dardano (L. Dardano, *Bella e dotta difesa delle donne in verso e prosa*, Venice, 1554, G5.) who added to the reply against the typological argument the Christian right to repent. Not only is legally sin, like crime, individual but when confessed and repented it cannot be held against the sinner for 'blessed are those whose sins are forgiven', nor can it be passed down to others 'for the son does not bear the sin of the father'. In conclusions, Adam and Eve have paid and suffered long and bitterly, and no concept of 'kind' has moral validity. The disparity in attitude of Adam and Eve established the so-called double standard; see K. Thomas, 'The Double Standard', *Journal of the History of Ideas* 20 (1959): 195–216.

33 A. Firenzuola, *On the Beauty of Women* (1523), Philadelphia 1992, 11, also in A. Firenzuola, *Opere*, 2 vols, Florence, 1950; on Firenzuola and his theory of beauty, see, among others, J. Murray, 'Agnolo Firenzuola on Female Sexuality and Women's Equality', *Sixteenth-century Journal* 22 (1991); 199–213; E. Cropper, 'On Beautiful Women, Parmigianino, *petrarchismo*, and the Vernacular Style', *Art Bulletin* 56 (1976): 374–94; idem, 'The Beauty of Women: Problems in Rhetoric of Renaissance Portraiture', in M. Ferguson, M. Quilligan and N. Vickers (eds), *Rewriting the Renaissance: The Discourses of Sexual Difference in Early Modern Europe*, Chicago, 1986, 175–90' M. Rogers, 'The Decorum of Women's Beauty: Trissino, Firenzuola, Luigini and the Representation of Women in Sixteenth-Century Painting', *Renaissance Studies* 2 (1988): 57–86; idem 'Sonnets on Female Portraits from Renaissance North Italy', *Word & Image* 2 (1986): 291–305; idem, 'Reading the Female Beauty in Venetian Renaissance Art', in F. Ames-Lewis (ed.), *New Interpretations of Venetian Renaisance Painting*, London, 1994, 77–90; P. Emison, 'Grazia', *Renaissance Studies* 5 (1991): 427–60; G. Matthews, 'The Body, Appearance and Sexuality', in N. Zeman Davis and A. Farge (eds), *A History of Women in the West III: Renaissance and Enlightenment Paradoxes*, Cambridge, Mass., 1993, 46–84; E. Saccone, 'Grazia, Sprezzatura, Affettazione in the Courtier', in R. Hanning and D. Rosand (eds), *Castiglione: The Real and the Ideal in Renaissance Culture*, New Haven, 1983, 45–56; V. Baradel, 'Figure d'amore. Aspetti della

figurazione femminile nel Rinascimento', *dwf: donnawomanfemme* 25–26 (1985), 57–77.

34 Ortensio Landi, *Lettere di molte valorose donne, nelle quali chiaramente appare non essere ne di eloquenza ne di dottrina alli huomini inferiori*, Venice, 1549, M2, r-v: 'I would like first to see the beauty of the ladies of the Thomas More family. I would like to see the good manners of the women of Holland, and to learn from them how to make such beautiful cloth' Translation and commentary in C. Jordan, *Renaissance Feminism. Literary Texts and Political Models*, Ithaca, N.Y., and London, 1990, 140.

35 Thanks to the work of Svetlana Alpers, we no longer identify mimesis with narrative, acknowledging in particular the presence of a mode of representation other than narration within mimesis, the *descriptive*. Having said this, it should be clear, however, that the problems under discussion do not fall within Alpers's notion of the *descriptive*.

36 It was Otto Brendel who first pointed out the role of music in activating and guiding an involvement with beauty which, initially physical, gradually becomes metaphysical, see O. Brendel, 'The Interpretation of the Holkham *Venus*', *Art Bulletin* 28 (1946): 65–75, and U. Middeldorf's objection, ibidem, 29 (1947): 65–7. E. Panofsky, *Problems in Titian. Mostly Iconographic*, New York, 1969, followed Brendel's allegorical reading, while C. Hope, 'Problems in Interpretation in Titian's Erotic Paintings', in R. Pallucchini (ed.), *Tiziano e Venezia* (Atti del Convegno Internazionale di Studi, Venezia, 1976), Vicenza, 1980, 111–124, has elaborated Middeldorf's argument.

37 L. Mulvey, 'Visual Pleasure and Narrative Cinema', *Screen* 16 (1975): 6–18 ; reprinted in idem, *Visual and Other Pleasures*, Bloomington and Indianapolis, 1989, 14–26, she concludes that, '. . . the structure of looking in narrative fiction film contains a contradiction in its own premises: the female image as a castration threat constantly endangers the unity of the diegesis and bursts through the world of illusion as an intrusive, static, one-dimensional fetish. Thus the two looks materially present in time and space are obsessively subordinated to the neurotic needs of the male ego. The camera becomes the mechanism for producing an illusion of Renaissance space, flowing movements compatible with the human eye, an ideology of representation that revolves around the perception of the subject; the camera's look is disavowed in order to create a convincing world in which the spectator's surrogate can perform with verisimilitude. Simultaneously, the look of the audience is denied an intrinsic force: as soon as fetishistic representation of the female image threatens to break the spell of illusion, and the erotic image on the screen appears directly (without mediation) to the spectator, the fact of fetishization, concealing as it does castration fear, freezes the look, fixates the spectator and prevents him from achieving any distance from the image in front of him.' (26)

38 It should be noted that Artemisia disobeys Alberti's basic rules of narrative painting, namely that the painter should be concerned only with things seen and in light.

39 E. Panofsky, 'Der gefesselde Eros (zur Genealogie von Rembrandts Danae', *Oud Holland* 50, (1933): 193–217.

APPENDIX

Bibliography – Books by Michael Baxandall

Titles arranged chronologically.

Baxandall, Michael. *Piero della Francesca: 1410/20–1492*. Paulton, England: Purnell Press, 1966.

Baxandall, Michael. *German Wood Statuettes 1500–1800*. London: Her Majesty's Stationery Office, 1967. [series title: Victoria and Albert Museum, South Kensington Illustrated Booklet no. 14]

Baxandall, Michael. *Giotto and the Orators: Humanist Observers of Painting in Italy and the Discovery of Pictorial Composition 1350–1450*. Oxford: The Clarendon Press, 1971.

Baxandall, Michael. *Painting and Experience in Fifteenth Century Italy: A Primer in the Social History of Pictorial Style*. Oxford & New York: Oxford University Press, 1972.

Baxandall, Michael. *South German Sculpture 1480–1520*. London: Her Majesty's Stationery Office, 1974 [series title: Victoria and Albert Museum Monograph no. 26]

Baxandall, Michael. *The Limewood Sculptors of Renaissance Germany*. New Haven: Yale University Press, 1980.

Baxandall, Michael, A. Schadler, *et al*. *Veit Stoss in Nurnberg: werke des meisters und seine schule in Nurnberg und umgebung*. Nurnberg: Germanisches Nationalmuseum, 1983.

Baxandall, Michael. *Patterns of Intention: On the Historical Explanation of Pictures*. New Haven & London: Yale University Press, 1985.

Alpers, Svetlana and Baxandall, Michael. *Tiepolo and the Pictorial Intelligence*. New Haven: Yale University Press, 1994.

Baxandall, Michael. *Shadows and Enlightenment*. New Haven: Yale University Press, 1995.

Articles by Michael Baxandall

Baxandall, Michael and E. H. Gombrich. 'Beroaldus on Francia'. *Journal of the Warburg and Courtauld Institutes* 25 (Jan. 1962): 113–15.

Baxandall, Michael. 'A Dialogue on art from the Court of Leonello D'Este: Angelo Decembrio's *De Politia Litteraria Pars* LXVIII'. *Journal of the Warburg and Courtauld Institutes* 26 (1963): 304–26.

Baxandall, Michael. 'Bartholomaeus Facius on Painting'. *Journal of the Warburg and Courtauld Institutes* 27 (1964): 90–107.

Baxandall, Michael. 'Guarino, Pisanello and Manuel Chrysoloras'. *Journal of the Warburg and Courtauld Institutes* 28 (1965): 183–204.

Baxandall, Michael. 'A Masterpiece by Hubert Gerhard'. *Victoria and Albert Museum Bulletin* 1, n. 2 (1965): 1–17.

Baxandall, Michael. 'Hubert Gerhard and the Altar of Christoph Fugger: The Sculpture and its Making'. *Münchner Jahrbuch der Bildenden Kunst* 17 (1966): 127–44.

Baxandall, Michael. 'Rudolf Agricola and the Visual Arts'. In *Intuition und Kunstwissenschaft. Festschrift fur Hanns Swarzenski*, edited by Peter Bloch, Tilman Buddensieg, A. Hentzen, T. Muller. Berlin: Gebr. Mann Verlag (1973): 409–18.

Baxandall, Michael. 'Alberti and Cristoforo Landino: The Practical Criticism of Painting'. In *Problemi attuali di scienza e di cultura*, quaderno n. 209 (Rome: Accademia nazionale dei Lincei, 1974): 143–54.

Baxandall, Michael. 'The Language of Art History'. *New Literary History* 10, n. 3 (Spring 1979): 453–65. Also published in *Gazette des Beaux-Arts* 95, ser. 6, suppl. 1–2 (May/June 1980).

Baxandall, Michael. 'Rudolph Agricola on patrons efficient and patrons final: a final discrimination'. *Burlington Magazine* 124 (July 1982): 424–5.

Baxandall, Michael. 'Veit Stoss, ein Bildhauer in Nurnberg'. In *Veit Stoss in Nurnberg: Werke des Meisters und seiner Schule in Nurnberg und Umgebung*, exhibition catalogue Germanisches Nationalmuseum Nurnberg (Munchen: Deutscher Kunstverlag, 1983): 9–25.

Baxandall, Michael. 'Art, Society, and the Bouguer Principle'. *Representations* 12 (Fall 1985): 32–43.

Baxandall, Michael. 'The Bearing of the Scientific Study of Vision on Painting in the Eighteenth Century: Pieter Camper's *De Visu* (1746)'. In *The Natural Sciences and the Arts*. Edited by Allan Ellenius (*Acta Universitatis Upsaliensis, Figura*, New Series 21), Uppsala, 1985: 125–32.

Baxandall, Michael. 'Exhibiting Intention: Some Preconditions of the Visual Display of Culturally Purposeful Objects'. In *Exhibiting Cultures: The poetics and politics of museum display*. Edited by Ivan Karp and Steven Lavine. Washington/London: Smithsonian Institute Press (1991): 33–41.

Baxandall, Michael. 'Exposer L'Intention. Les conditions préalables à l'exposition visuelle des objets à fonction culturelle'. In *Les Cahiers du Musee national d'art moderne* 43 (Spring 1993): 35–43.

Book Reviews by Baxandall:
Reviews arranged chronologically

Baxandall, Michael. 'Pisanello', *Art Bulletin* 57 (March 1975): 130–1. [Review of Giovanni Paccagnini, *Pisanello*, trans. Jane Carroll, New York: Phaidon Press, 1973].

Baxandall, Michael. *Burlington Magazine* 116 (Nov. 1974): 679–80. [Review of Justus Bier, *Tilman Riemenschneider: die spaten werke in stein*, Vienna: Verlag Anton Schroll].

Baxandall, Michael. *Burlington Magazine* 122, n. 925 (1980): 260–1.[Review of *Farbige Skulpturen: Bedeutung, Fassung, Restaurierung*, Munich: Georg Callwey, 1980].

Baxandall, Michael. *The Times Literary Supplement* n. 4010 (1 Feb. 1980): 111. [Review of *Giorgio Vasari: The Man and the Book*, Princeton: Princeton University Press].

Baxandall, Michael. *History: the Journal of the Historical Association* 66, n. 216 (Feb. 1981): 127. [Review of Carl C. Christensen, *Art and the Reformation in Germany*, Athens, Ohio and Detroit: Ohio and Wayne State University Press, 1979].

Baxandall, Michael. 'On Michelangelo's Mind'. *New York Review of Books* 28, n. 15 (8 Oct. 1981): 42–3. [Review of David Summers, *Michaelangelo and the Language of Art*].

Baxandall, Michael. *Art History* 4, n. 4 (Dec. 1981): 484. [Review of Reinhild Janzen, *Albrecht Altdorfer: Four Centuries of Criticism*, Ann Arbor: UMI Research Press].

Baxandall, Michael. *The Times Literary Supplement* n. 4133 (18 June 1982): 675. [Review of *Tilman Riemenschneider: his life and work*, Lexington: University Press of Kentucky].

Baxandall, Michael. *English Historical Review* 99 (Jan. 1984): 602. [Review of Salvatore *Tramontana, Antonello e la sua citta*, Palermo: Sellerio Editore, 1981].

Baxandall, Michael. *English Historical Review* 105 (April 1990): 455–6. [Review of *Art and Society in Renaissance Italy*. Edited by F. W. Kent and Patricia Simons, Canberra/Oxford: Humanities Research Centre & The Clarendon Press, 1987].

Baxandall, Michael. *English Historical Review* 104 n. 413 (Oct. 1989): 1015–16. [Review of George Holmes, *Florence, Rome and the Origins of the Renaissance*. Oxford: Clarendon Press, 1986].

Baxandall, Michael. *English Historical Review* 104, n. 410 (Jan. 1989): 204. [Review of Jonathan Brown, *Velazquez. Painter and Courtier*. New Haven and London: Yale Universtiy Press, 1986].

Baxandall, Michael. *English Historical Review* 106, 420 (July 1991): 763–4. [Review of *Art and History: Images and their Meaning*. Edited by Robert Rotberg and Theodore K. Rabb. Cambridge: Cambridge University Press, 1988].

Chapters and Articles on Baxandall:
Entries arranged chronologically

Stojkov, Atanas A. 'Possibilités et limits de l'approche sociologique en matière d'histoire de l'art'. In *Problemi di metodo; condizioni di esistenza di una storia dell'arte*. (Bologna: CLUEB, 1982): 99–104. [N.B. Series: Comite international d'histoire de l'art. Atti del XXIV Congresso internazionale di storia dell'arte].

Silver, Larry. 'The State of Research in Northern European art of the Renaissance Era'. *The Art Bulletin* 68 (Dec. 1986): 518–35.

Carrier, David. 'Theoretical Perspectives on the Arts, Sciences and Technology: Artist's Intentions and Art Historians' Interpretations of the Artwork'. *Leonardo* (UK) 19, part 4 (1986): 337–42.

Clarke McDonald, Helen. 'The Artist's Intention: Studies in Art Historical Methodology'. Ph.D Dissertation La Trobe Universtiy, Australia, 1987. [N.B. Part of this dissertation deals with Baxandall's *Patterns of Intention*].

Lord, Catherine and Benardete, Jose A. 'Baxandall and Goodman'. In *The Language of Art History*. Edited by Salim Kemal and Ivan Gaskell. Cambridge: Cambridge University Press (1991): 76–100.

Hausman, Carl R. 'Figurative Language in Art History'. In *The Language of Art History*. Edited by Salim Kemal and Ivan Gaskell. Cambridge: Cambridge University Press (1991): 101–128 [esp. 115–22].

Lastra, James Frederick. 'Standards and Practices: Technology and Representation in the American Cinema'. Ph.D dissertation University of Iowa, [N.B. Lastra uses, in part, ideas developed out of Baxandall's work].

Hennion, Antoine. 'Michael Baxandall: les elements integres d'une culture visuelle'. In A. Hennion, *La Passion Musicale: une sociologie de la mediation*. Paris: Editions Metalie (1993): 189–94.

Reviews of Baxandall's Books:
Reviews arranged alphabetically by author

Reviews of *Giotto and the Orators:*

Arenilla, L. 'When Humanists Discover Composition in the Visual Arts'. *Quinzaine Litteraire* 547 (16 Jan. 1990): 20 [French].

Gilbert, C. *Art Quarterly* 35, n. 4 (Winter 1972): 427–32.

Gilmore, M. R. *Art Bulletin* 55 (Mar. 1973): 148.

Neumeyer, Alfred. *Art Journal* 32, n. 2 (Winter 1972–73): 240.

Vertova, L. *Apollo* 96 (Nov. 1972): 4579.

Whitfield. J. H. *Italian Studies* 27 (1972): 118–23.

Woodfield, R. *British Journal of Aesthetics* 12, n. 2 (Spring, 1972): 199–200.

No author. 'Humanists and the Discovery of Composition in Painting 1340–1450'. *Histoire* 131 (Mar. 1990): 55–6 [French].

No author. *Journal of European Studies* 2, n. 2 (1972): 213.

Reviews of *Painting and Experience*

Ackerman, J. S. *Art Quarterly* 35, n. 4 (Winter 1972) 419–21.

Dubrunquez, Pierre. *Europe-Révue Litteraire Mensuelle* 64, n. 686 (1986): 218–20.

Goran, Hermeren. *Journal of Aesthetics and Art Criticism* 32 (Fall 1973): 130–2.

Mantion, Jean-Remy. *La Nouvelle Revue Française* 398 (March, 1986): 70–8.

Middeldorf, Ulrich. *Art Bulletin* 57 n. 2 (June 1975): 284–5.

Shapeley, John. *Art Journal* 35, n. 3 (Spring 1976): 294–6.

White, John. *History: The Journal of the Historical Association* 59, n. 195 (Feb. 1974): 96–7.

No author. *L'Histoire* 131 (1990): 55–6.

No author. *Journal of European Studies* 3, n. 1 (1973): 76–7.

Reviews of *The Limewood Sculptors:*

Bangs, Jeremy B. *The Sixteenth-Century Journal* 13, n. 3 (1982): 122.
Boucher, Bruce. *The Times Literary Supplement* 4056 (26 Dec. 1980): 1469.
Evans, R. J. W. *Journal of Modern History* 53, 4 (1981): 699–702.
Konio, E. 'Gesellschaft, Material, Kunst: Neue Bucher zur deutschen Skulptur um 1500'. *Zeitschrift für Kunstgeschichte* 47, n. 4 (1984): 535–58.
Landau, David. *Art International* 26, n. 1 (Jan.–March 1983): 74–6.
Langmuir, Erika. *British Journal of Aesthtics* 21, n. 2 (1981): 172–3.
Lowenthal, Constance. *Renaissance Quarterly* 36, 2 (1981): 257–8.
Mai, Ekkehard. *Das Kunstwerke* 40 (Sept. 1987): 195.
Pfister, Silvia and Wüttke, Dieter. In *Internationales Archiv für Sozialgeschichte der deutschen Literatur,* edited by Worlgang Frühwald, Georg Jager, & Alberto Martino (Tubingen: Max Niemeyer, 1986): 276–88.
Puttfarken, Thomas. *Art History* 4, n. 4 (Dec. 1981): 479–83.
Recht Roland. *Bulletin Monumental* 142, n. 4 (1984): 474–5.
Souchal, François. *Gazette des Beaux-Arts* 100, 1364 (Sept. 1982): 15–16.
Stein, Claire. *National Sculpture Review* 30, n. 4 (1981): 29.
Zerner, Henri. *The New York Review of Books* 27, n. 20 (18 Dec. 1980): 52–5.
No author. *Critica dell'arte* 45, n. 172 (July–Dec. 1980): 233–4.

Reviews of *Patterns of Intention*:

Alpers, Svetlana. *The New Republic* 195 (14–21 July 1986): 34–8.
Bann, Stephen. *Word & Image* 2, n. 4 (Oct./Dec. 1986): 384–5.
Bermingham, Ann. *Criticism* 30, n. 1 (1988): 119–24.
Black, Christopher. *The Journal of the Historical Association* (Great Britian) 72, n. 234 (Feb. 1987): 83–4.
Carrier, David. *Leonardo* 19, n. 4 (1986): 337–42.
Carrier, David. *Art Journal* 46, n. 1 (Spring, 1987): 75–9.
Danto, Arthur. *Burlington Magazine* 128 n. 999 (June, 1986): 441–2.
Gould, Cecil. *Apollo* 124, n. 296 (1986): 380–1.
Harrison, Andrew. 'Bridges in Time'. *The Times Literary Supplement* No. 4314 (6 Dec. 1985): 1384.
Iverson, Margaret. *Oxford Art Journal* 9, n. 2 (1986): 71–2.
Kemal, Selim. *The British Journal of Aesthetics* 27, n. 2 (Spring 1987): 188–90.
Kemp, Martin. *Zeitschrift fur Kunstgeschichte* 50, N. 1 (1987): 131–41.
Pouivet, Roger. *Cahiers du Musée national d'art moderne* 40 (Summer 1992): 117–19.
Rifkin, Adrian D. 'Brief Encounters of the Cultural Kind'. *Art History* 9, n.2 (June 1986): 275–8.
Mukerji, Chandra. *American Journal of Sociology* 92, n. 2 (Sept. 1986): 485–6.
Sirridge, Mary. *Journal of Aesthetics and Art Criticism* 45 (Fall 1986): 94–5.
Spurling, John. *New Statesman* 110, n. 2852 [O.S.] (22 Nov. 1985): 32.
von Holscher, Thomas. 'Das Vergnugen an der Kunst. Michael Baxandalls "Ursachen der Bilder"'. *Merkur – Deutsche Zeitschrift fur Europaisches Denken* 45 n. 9/10 (Sept.–Oct. 1991): 947–54.

Warner, Malcolm. *Royal Society of Arts Journal* 85 (Sept. 1987): 781–2.

Whitfield, Sarah. *Encounter* 68, n. 1 (Jan. 1987): 48–52.

See also the introduction to the German Edition of *Patterns of Intention* by Oskar Batschmann, introduction to Michael Baxandall. *Ursachen der Bilder. Uber das historische Erklaren von Kunst.* Translated by Reinhard Kaiser. Berlin: Dietrich Reimer Verlag (1990): 7–17.